Human–Computer Interaction Series

Editors-in-chief

Desney Tan, Microsoft Research, USA

Jean Vanderdonckt, Université catholique de Louvain, Belgium

The Human–Computer Interaction Series, launched in 2004, publishes books that advance the science and technology of developing systems which make computers and the interactive human interface easy and intuitive to use. These books are about making and using technology to deliver maximum benefit, so they present both technological and human aspects to be considered.

The HCI series covers the fields of human–computer interaction, for practitioners and researchers. It includes titles on the technology side, and for practitioners. Books published in the series are of interest to academics and industry experts, as well as to graduate students and post doctoral fellows. It offers a comprehensive perspective on practical approaches drawn from theory of practical approaches such as the techniques for effectively integrating user needs in system development, and social issues such as determinants of utility, usability and acceptability.

Titles published within the Human–Computer Interaction Series are included in Thomson Reuters' Book Citation Index, The DBLP Computer Science Bibliography and The HCI Bibliography.

More information about this series at http://www.springer.com/series/6033

HCI is a multidisciplinary field focused on human aspects of the development of computer technology. As computer-based technology becomes increasingly pervasive – not just in developed countries, but worldwide – the need to take a human-centered approach in the design and development of this technology becomes ever more important. For roughly 30 years now, researchers and practitioners in computational and behavioral sciences have worked to identify theory and practice that influences the direction of these technologies, and this diverse work makes up the field of human-computer interaction. Broadly speaking it includes the study of what technology might be able to do for people and how people might interact with the technology. The HCI series publishes books that advance the science and technology of developing systems which are both effective and satisfying for people in a wide variety of contexts. Titles focus on theoretical perspectives (such as formal approaches drawn from a variety of behavioral sciences), practical approaches (such as the techniques for effectively integrating user needs in system development), and social issues (such as the determinants of utility, usability and acceptability).

Titles published within the Human–Computer Interaction Series are included in Thomson Reuters' Book Citation Index, The DBLP Computer Science Bibliography and The HCI Bibliography.

More information about this series at http://www.springer.com/series/6033

Aaron Marcus

HCI and User-Experience Design

Fast-Forward to the Past, Present, and Future

 Springer

Aaron Marcus
Aaron Marcus and Associates, Inc.
Berkeley, CA, USA

Content originally appeared in ACM Interactions Magazine 2002–2007 as part of 'Fast Forward' by Aaron Marcus, ©Aaron Marcus and Associates 2014 – used with permission.

ISSN 1571-5035
Human–Computer Interaction Series
ISBN 978-1-4471-7386-1 ISBN 978-1-4471-6744-0 (eBook)
DOI 10.1007/978-1-4471-6744-0

Springer-Verlag London Ltd. is part of Springer Science+Business Media (www.springer.com)

I dedicate this book to the primary professional mentors of my life:

Ms. Zenaide Luhr (may she rest in peace), formerly my art teacher, Omaha Central High School, who encouraged/assisted the development of my artistic and visual design skills (1967–1961).

Mr. Gilette G. Griffin, formerly Curator, Graphic Arts Collection, Princeton University Firestone Library, who encouraged my graphic design and photography interests while being a physics major and helped me to learn about, enter, and get accepted to Yale University Graduate School of Art and Architecture's Department of Graphic Design (1961–1965).

Prof. Alvin Eisenman (may he rest in peace), formerly Chair, Graphic Design Department, School of Art and Architecture, Yale University, who encouraged my graphic design education and my involvement in computer graphics (1965–1968).

*Prof. Paul Rand (may he rest in peace),
formerly faculty member, Graphic Design
Department, School of Art and Architecture,
Yale University, who taught me about grids
and introduced me to systematic graphic
design thinking (1967–1968).*

*Dr. Emilio Ambasz, formerly Assistant
Curator, Department of Design, Museum of
Modern Art, New York City, who invited me
to take over his visual communication/design
course at the School of Architecture and
Urban Planning and enabled me to join the
faculty of Princeton University for 9 years
(1968–1977).*

*Mr. Richard Saul Wurman, formerly
Architect and later creator of the TED
Conferences, who invited me to join him in
his Philadelphia office to work on a second
(later unpublished) version of* Making the
City Observable, *which moved me along in
my shift towards information design and
visualization (1976).*

*Dr. A. Michael Noll, formerly Staff Scientist,
AT&T Bell Labs, who, together at the time
with Dr. Peter Denes (may he rest in peace),
invited me to join their group researching
computer graphics, which led to my shift to
computer-based graphic design and visual
communication for the rest of my career
(1967–1971).*

*Prof. Sheila deBretteville, now Head,
Graphic Design Department, School of Art
and Architecture, Yale University, who
invited me decades ago to become a*

Research Fellow, East–West Center, Honolulu, Hawaii, to research and design a nonverbal storytelling system for communicating global energy interdependence, which led to my fundamental shift to information-oriented graphic design and visualization (1978).

Dr. Carl Quong, formerly Head, Computer Science and Mathematics Department, Lawrence Berkeley Laboratory, who gave me an opportunity to join his team as a Staff Scientist (because they could not think what else to call me) and thereby helped to begin my career in user-interface design, information design and visualization, and user-experience design (1981–1982).

Dr. Ronald Baecker, formerly Professor, Computer Science Department, University of Toronto, who took an interest in my career, enabled me to join him in a 3-year DARPA project as co-principal investigator of new conventions for the C programming language, and was later a coauthor of our book about the project and taught me much about research and writing (1982–1985; 1989–1990).

Dr. Andries van Dam, formerly Professor, Computer Science Department, Brown University, with whom I coauthored a major paper on the future of HCI and who taught me much about technical writing (1995).

Foreword

In 1980, I attended an early SIGGRAPH conference in Seattle. My academic career was on hold as I learned about business and entrepreneurship the old-fashioned way. Our company wasn't then doing computer graphics, the field in which I did my Ph.D., but I was keen to stay current.

The session that struck me the most was the opening plenary panel keynote given by a tall, bearded, scholarly looking man—Aaron Marcus. The panel, organized by Aaron, introduced the field of graphic design to the computer graphics research community.

We spoke at length during the conference reception, held on a cruise of Lake Washington. Although trained in physics, electrical engineering, and the beginnings of computer science, I had empowered my dissertation research by collaborating with two artists and animators, most importantly Eric Martin, and so I was open to learning about graphic design.

In speaking with Aaron, I developed the sense that graphic design was key to the success of not only computer graphics and the yet-to-be-invented field of scientific visualization but to the discipline of human-computer interaction, also not yet known to be a field. Aaron spoke of outerfaces, interfaces, and innerfaces—visual methods of elucidating and enhancing function, process, and structure of information displays, user interaction, and what eventually came to be known as software visualization. He asserted that typography, illustration, sign/symbol design, layout, and sequencing were essential to unlocking the power and potential of the digital computer. The Xerox Star was then little known, and the Macintosh did not arrive until 1984. So we can see that Aaron was way ahead of his time.

I soon began to work with Aaron on methods of applying graphic design and typography to make computer program source texts more readable. We also became good friends and so I am pleased to introduce this volume of some of Aaron's recent writings.

Aaron's commentaries range broadly from metaphor to branding, from robots to dashboards, from corporate success to BabyCHI, from the out-of-box experience to the fun user experience. They betray a rich imagination, an unwillingness to be

cowed by conventional "wisdom." But here is what I find especially salient for potential readers of this book:

Aaron refers them to a broad set of additional disciplines that today's students and practitioners of HCI design are unlikely to have studied sufficiently or in some cases not even explored, for example, metaphor, semiotics, design patterns, culture, the anthropology of time, and even comics. Readers will find this volume an excellent launching point for continuing their education.

Aaron challenges us to question our assumptions, as with curriculum, and define our terms, as in thinking about users. There is no area of HCI design that is out of his scope, from babies to kids to geezers, from emotion to corporate success.

Aaron reminds us constantly to think cross-culturally. Speaking knowingly from numerous visits to Japan and China, he encourages us to enhance our design imagination, to think critically, and to ensure that our designs work as broadly as possible.

This writing is filled with neat ideas and wisdom and humor—browse, read, and enjoy!

Laboratory of Technology for Aging Gracefully Ronald Baecker
University of Toronto
Toronto, ON, Canada

Preface

This book grew out of a series of essays in a column called "Fast Forward" that I published in *Interactions* Magazine, the flagship/membership publication of the ACM Special Interest Group on Human-Computing Interaction (SIGCHI) from 2002 to 2007. I wrote the essays in a way that I hoped would make them "timeless" and give them a "long shelf life," avoiding getting caught up in the latest tools or mini-trends. The editors permitted me the opportunity to write about interests and concerns of mine regarding the past, present, and future of our profession. I focused more on the essentials of the development process (planning, research, analysis, design, evaluation, implementation, documentation, training, and marketing) and on the essential components (metaphors, mental models, navigation, interaction, and appearance) of user interfaces and user experiences.

I was seeking to educate the readership to disciplines, topics, and issues that might stretch their minds and lead them to consider their current research and design activities from a different perspective. Eventually new magazine leadership deemed it appropriate to bring this series to an end. I was grateful for the enlightened leadership of the past series of editors that allowed me to "publish at will" (subject to editorial corrections and enhancements that benefitted the texts and imagery). I am also grateful for the many emails that I received thanking me for introducing new topics into the magazine and into professional readers' minds.

I hope the reader will enjoy and benefit from being able to read through these essays collected into one document. I have not tried to revise them thoroughly with modern citations or later developments, except for a brief Postscript 2015, to quickly bring us up to date as best I can. They stand as a historical view of our professional world at the time of writing and an attempt to consider fundamental issues of computer-based interaction and communication.

I apologize for any errors I may have introduced and welcome comments and/or corrections. The original published versions are available separately in the ACM Digital Library. I am grateful to representatives of ACM for confirming that I have the right to repurpose and republish my original submissions as I retained the original author rights. This published version, with its layout and illustrations, are now copyrighted by Springer.

At the end of each chapter, I have provided a brief Postscript 2015, with comments on the topic and some bibliographic references to recent publications, as appropriate. Each chapter's topic, if it were searched for in the Internet today, would yield tens of millions of retrievals, or more, signifying the busy activity of researchers, academics, and professionals in each of these topics as these areas of analysis and design continue to grow in importance within the disciplines of human-computer interaction (HCI) design and user-experience design.

Berkeley, CA, USA Aaron Marcus
2015

Contents

About the Author

Aaron Marcus Principal of Aaron Marcus and Associates; International Professor at the College of Design and Innovation, Visiting Professor, Institute of Design, Illinois Institute of Technology, Chicago; Tongji University, Shanghai, China; Editor-in-Chief Emeritus of *User Experience* Magazine; and Editor of *Information Design Journal*, is a pioneer of computer graphics, human-computer-interaction design, and user-experience design. He has authored, coauthored, edited, and coedited 16 books and more than 350 articles. He is the former "Fast Forward" column editor of *Interactions* for 5 years and the first user-interface graphic designer to be elected to both the CHI Academy

and to the AIGA Fellows. He organized the opening plenary session about graphic design at ACM's SIGGRAPH conference in 1980. He organized and chaired two plenary panel sessions about science fiction and HCI at ACM SIGCHI conferences in 1992 and, by request of ACM/SIGCHI, in 1999, in which he invited leading science-fiction authors to speculate about the future of computer-human interaction. His computer graphics artwork and graphic design work are in the collection of the San Francisco Museum of Modern Art and the Victoria and Albert Museum, London. His first sole-author book for the computer world was *Graphic Design for Electronic Documents and User Interfaces*, jointly published by ACM Press and Addison-Wesley in 1992. His latest book prior to this one is *Mobile Persuasion Design*, also published by Springer, in 2015.

Chapter 1
Metaphors and User Interfaces in the Twenty-First Century

1.1 Summary

Future user interfaces will be more multi-modal, contextual, and associated with devices. Designing components well for users remains the primary challenge.

1.2 Introduction

(Fast Forward, *a new column of Interactions, which the editors of Interactions kindly permitted me to publish, presents an opportunity for me to think about where our profession of user-interface design has been over the past three-and-a-half*

© Springer-Verlag London 2015
A. Marcus, *HCI and User-Experience Design*, Human–Computer
Interaction Series, DOI 10.1007/978-1-4471-6744-0_1

decades in which I have worked and about its future. I hope you will enjoy and benefit from joining me in this discussion. Your feedback is welcome).

Let's begin our journey in the twenty-first century by thinking about metaphors in user interfaces. I have defined them as the essential concepts in computer-mediated communication that substitute for the underlying code and terminology of operating systems, applications, and data. Instead, concepts are communicated through words, images, sounds, and even touches (Marcus 1998). An example familiar to most computer users is the desktop metaphor that substitutes a screen depicting something like a desktop covered with documents and folders for the underlying realities of data, functions, and how users manipulate them. In the disciplines of semiotics, this communication technique, or rhetorical trope, of metaphor is an important figure of spoken and visual communication. Although others (e.g., (Carroll and Thomas 1982)) and I consider metaphor to be a fundamental component of all user interfaces, not all professionals in the user-interface design community agree.

Some years ago, in the late 1980s, during informal conversation with Jaron Lanier, one of the prime innovators of virtual reality's new paradigms, he made a characteristically mysterious, oracular, and challenging pronouncement. He said that he considered most current user interfaces inadequate and envisioned a future time in which there would be virtual reality displays (e.g., advanced versions of headsets he helped invent) working with input devices (e.g., advance versions of DataGloves ™ he helped invent) that would not require metaphors. He envisioned something like a musical instrument, e.g., a piano's keyboard on a device, which, when "played," "directly conveyed input" to displays that we, in turn, could directly experience.

I challenged him about the notion of a user-interface, a medium of communication, existing without metaphors, because I have been influenced by the likes of George Lakoff and Mark Johnson (1980) to understand that all communication requires agreement on metaphorical underpinnings; otherwise, people talk in a skewed fashion, misunderstanding basic concepts or references, or being baffled by them. If you are talking about football, and I think you're talking about soccer, or the latest marketing skirmish of our company, eventually one of us will become quite puzzled by the other, and we shall have to reconnect, *to agree upon fundamental metaphors.* The only kind of "communication" that can take place without metaphors is of a direct signaling kind. If I am foolish enough to place a lighted match below my hand, stimulus–response mechanisms are invoked that directly signal to my skin that it is facing a dangerous temperature situation. It requires some internal computation in my "wetware", but not metaphorical intervention (i.e., substitution, the key to metaphors), to convince me to move my hand.

Some future devices will certainly feature sophisticated virtual reality displays or augmented reality displays. Leaping forward a few generations and imagining direct neural input of signals, as envisioned by early cyberpunk authors like Vernor Vinge in *True Names* (Vinge 1984) or William Gibson in *Neuromancer* (Gibson 1984) one might ask: where or what is the user interface under these extreme condi-

tions? In this situation, user interfaces would be deprived potentially of any physical input devices and physical visual or acoustic display devices. What is left is a world of "pure" mental communication with *signs*. In my vocabulary, communication includes interaction. In fact, semiotics is usually predicated as a behavioristic science, asking how people behave or interact with signs in order to determine their meaning.-

What one is left with is a kind of mental theater, or mental ceremonies. For me, this is the essence of user-interface design: envisioning facts, concepts, and emotions within dynamic, interactive symbolic and iconic artifacts. One thing seems certain: metaphors won't disappear, they are essential to having any communication at all. In fact, Lakoff and Johnson argue that most of these metaphorical references are spatial in nature, e.g., in our English language expressions "things are looking *up*," and "I've been getting *into* this new topic of semiotics."

OK, so where are computer metaphors going? Many analysts, prognosticators, and pontificators, e.g., David Gelernter, Don Norman, and George Robertson (Loebl 2001) are calling for the end of the desktop metaphor. Many seem to sense that something is clumsy about fundamental notions of files and folders, of applications and data, embodied in the visual artifacts of government-surplus 1950s metal desks with manila folders stuffed in the drawers and lying in piles on top, with scattered arrays of papers, mostly full of text and an occasional chart or table.

Some have argued that this entire scheme is notoriously culture-biased. (Chavan 1994), for example, has argued that most people in India do not own desks or folders, and do not have much experience with them. They do have bookshelves, however, with books that have chapters and pages. Perhaps if some Indian researchers at the National Institute of Design in Ahmedabad originally had invented an equivalent of the Xerox Star ™ at Xerox PARC or later the Apple Macintosh ™, we might have had a completely different history of envisioning operating systems and windowing environments...ooops, if there had been any "windows" at all. If Chinese researchers at the Academy of Sciences in Beijing had invented modern computing, as the Chinese did for printing, perhaps a Chinese computer, and most others around the world, would have been displaying vertically unrolling scrolls, not Microsoft Windows ™.

Baby faces, devices with small user interfaces, invariably shrink the visual real estate and emphasize acoustic and haptic (touch) multimedia communication as well as visual. The desktop metaphor simply does not work in a size of 3 × 2 cm. We need something else conceptually and perceptually, to help us represent our key structures and processes. What might that be?

Speech interfaces (vocal user interfaces, or VUIs) offer new opportunities, but still have hierarchies of objects and navigation, even when one cannot see them. For example, one can "move" within Sports to locate the place where one can purchase baseball tickets online. Even menus are a persistent navigation concept or metaphorical construct of all user interfaces. Other key pervasive concepts include options, tasks, preferences, decisions, and contexts (as in contextual awareness).

The early personal communicators, like the Apple Newton, emphasized communication over computation as an essential computer-mediated assistant. Today, nouns and verbs of messaging associated with email functions have become essen-

tial paradigms for many people's interactions with computers and a source of new, fundamental metaphorical concepts for almost all computer-mediated communication. -

Some have argued that having to store files in separate groups related to applications that are also stored in separate groups might do as much damage to mental health, and productive time, as the harm of using the Basic programming language was supposed to cause in the 1980s. Having to store email messages and references about metaphors in a place separate from text documents about the same content seems clumsy, and a number of solutions have been proposed, such as Apple's OpenDoc™ (Apple 2002) or some offshoots of the Be Operating System (Be, later part of Palm (Be Operating 2002)), which enable users to focus on contents rather than tools.

In the future, it seems likely that visualized metaphors will focus on agents that, or who, will help us in all of our regular and even irregular tasks. Some major challenges, it seems to me, are to visualize how agents gather information from us, how we can review what they know about us, and how they report the results of their autonomous activities to us. We have significant developments ahead in inventing the metaphorical apparatus of future butlers that/who take care of many of our needs freeing us up significantly to take care of other, "more important" (harumph) tasks. We may even need metaphor management software, as the Friend21 project from Japan pioneered in the late 1980s and early 1990s (Nonogaki and Ueda 1995). This software would enable computer systems to swap metaphorical references when reconfiguring entire contexts of data and the best way to present that information to the user in his/her current context.

In any case, I do not foresee user interfaces of the future devoid of metaphors. In fact, the metaphor invention business seems likely to be busier than ever as commercial products seek to make themselves indispensible to our daily lives. One tool just published that might help us sort out these new concepts as fast as they are invented is Faith Popcorn and Adam Hanft's *Dictionary of the Future: The Words, Term, and Trends that define the Way we Live, Work, and Talk* (Popcorn and Hanft 2001). In this book, one can find the just-in-time neologisms of the wordsmiths who shape our perceptions and our conceptions. Are you *geared up* for the future (to use a metaphor)?

1.3 Postscript 2015

In recent years, metaphor analysis/design has become an essential component of methodologies seeking design innovation. One of the early analysts of metaphors, Dr. George Lakoff, author of *Metaphors We Live By* (Lakoff and Johnson 1980) went on to an illustrious career advising political groups about choosing the metaphors of their political discussions and communications in order to "frame" public discussions about their favored issues. The same basis underlies all product/service

user-experience design, including concepts, terminology, and graphics in the user interface; documentation, and marketing communications.

As smart watches and other wearables, driverless vehicles, robots, and the Internet of Things become more ubiquitous and absorbed into our lives, all of us, in the development and consumer communities, will be challenged to invent and to accommodate to new, sometimes unfamiliar and unexpected metaphors. These may vary by broad cultures or regions, as I suggest in a recent publication (Marcus and Baradit 2015) in which I suggest new metaphors may arise out of China. In the area of design innovation, Kumar (2013) also mentions metaphors in terms of frameworks and framing.

Metaphors are alive, teeming, and evolving every day, almost like living organisms.

References

Apple Computer (2002) Web URL for 2 Jan 2002: http://developer.apple.com/techpubs/macos8/Legacy/OpenDoc/opendoc.html

Be Operating System (2002) Web URL for 2 Jan 2002: http://www.be.com/

Carroll JM, Thomas JC (1982) Metaphor and the cognitive representation of computing systems. IEEE Trans Syst Man Cybern SMC-12(2):107–116

Chavan AL (1994) A design solution project on alternative interface for MS windows. Master's thesis, London Guildhall University, London, Sept 1994

Gibson W (1984) Neuromancer. Ace Science Fiction Books, New York

Kumar V (2013) 101 Design methods. Wiley, Hoboken

Lakoff G, Johnson M (1980) Metaphors we live by. The University of Chicago Press, Chicago

Loebl D (2001) Let's Kill the Hard Disk Icon, osOpinion.com December 18, 2001. See Internet URL: http://www.osopinion.com/perl/story/15357.html

Marcus A (1998) Metaphors in user-interface design. ACM SIGDOC 22(2):43–57, ISSN 0731–1001

Marcus A, Baradit S (2015) Chinese user-experience design: an initial analysis. In: Proceedings of the design, user experience, and usability conference, 2–7 August 2015, Springer-Verlag London, London, pp TBD (in press)

Marcus A, Emilie WG (2000) Crosscurrents: cultural dimensions and global web user-interface design, Interactions, vol 7, No. 4. ACM Publisher, pp 32–46. www.acm.org. July/August 2000

Nonogaki H, Ueda H (1995) FRIEND21 project: two-tiered architecture for 21st-century human interfaces In: CHI Proceedings of the conference on human factors and computing systems, Denver, Colorado, pp 160–161. ISBN:0-89791-755-3

Popcorn F, Hanft A (2001) Dictionary of the future: the words, term, and trends that define the way we live, work, and talk. Theia/Hyperion, New York. ISBN 0786866578

Vinge V (1984) True names. Bluejay Books Inc., New York

Chapter 2
Culture Class Versus Culture Clash

2.1 Summary

Future user interface developers will need to recognize and account for cultural differences in Web- and mobile- oriented products and services. Fortunately, more documents, theories, and tools are on the way.

Originally, copyright © 2002 by Aaron Marcus and Associates, Inc. (AM+A).

© Springer-Verlag London 2015

A. Marcus, *HCI and User-Experience Design*, Human–Computer
Interaction Series, DOI 10.1007/978-1-4471-6744-0_2

2.2 Introduction

The events of 11 September 2001 changed the perceptions of many people in the USA. One good result of this terrible day was increased awareness and interest on the part of USA citizens, as well as citizens of other countries, about other cultures, other religions, and other ways of thinking. We can't go back. For those who are already living outside the USA, or those in the USA who have traveled internationally extensively, many are thankful for an increased global awareness of connectivity, conflicts, and possibilities of mutual cooperation. Much of our hope relies on understanding other cultures better and communicating with people better. We can do our part. On 11 September 2001, user-interface development received a catalyst toward further maturity of its philosophy, principles, and techniques. User-interface developers may need to go to "culture class" in order to minimize culture clashes in their designs.

2.3 Culture

Cultures are evidenced at work, at home, in schools, and in families through symbols, heroes, rituals, and values. Cultural anthropologists have studied similarities and differences among cultures for decades. One theorist (Hofstede 1997) summarizes the key dimensions of all cultures this way:

- Power distance: a culture's acceptance of the differences between leaders and followers
- Individualism *vs.* collectivism: self- *vs.* group orientation
- Femininity *vs.* masculinity: merged or distinct traditional gender roles
- Uncertainty avoidance: lack of tolerance for ambiguity
- Short *vs.* long-term time orientation: the degree to which a culture takes a long-term view.

In the minds of most culture and design theorists, many professional designers across all disciplines, and some appreciative users, these kinds of dimensions pervade every human activity and every artifact, including user interfaces.

In 1989, in Japan, I heard my first personal, anecdotal evidence of something about which I had already had some suspicions. A Japanese computer-science researcher commented that he thought Japanese developers preferred software applications from Europe, specifically the Scandinavian countries of northern Europe, to those developed in the USA. The reason? According to this person, European software seemed more "elegant, sensitive, and in tune with Japanese culture" than the "impolite software from the USA, which sometimes turned out to be vaporware due to USA marketing habits." Cultural affinities and alienation were being expressed. In 1993, after publishing some culturally diverse, dialog box con-

ceptual designs (Trompenaars and Turner 1998), I organized an early CHI event, a SIG about cultural diversity.

Since that time, many papers, panels, tutorials, conferences, books, and Websites offer user-interface developers an increasing panoply of excellent choices by which to learn more about the issues, accomplishments, techniques and tools available. To its credit, CHI has relocated itself internationally, most recently in 2000 to the Hague, The Netherlands. Other conferences, like those of HCI International, regularly hop among global venues, and the more recently started International Workshop on International Products and Services (IWIPS), has featured international venues as well as focusing precisely on the topic of how to develop (i.e., plan, research, analyze, design, implement, evaluate, document, and train) for global markets. Recent discussions of user/human experience design, branding, and interaction/behavior design indicate a growing expansion of user-interface design concerns. These discussions are beginning to foster a strong intellectual relationship with many disciplines, not only anthropology and other social/cognitive sciences, but intercultural communication and marketing, which has analyzed branding and the characteristics of target markets for many decades.

Still, it is an uphill battle for some developers to get budgets for culture-oriented research and development accepted, to find/allocate the necessary human resources, and to achieve project success. Why? There are several reasons, but one of the most important is the lack of a clear return-on-investment (ROI) information resource that most user-interface developers can access, respect, and use to defend their positions. Such a document would help convince top management to make the funds, people, and time available to accomplish many wished-for projects, e.g., culture-oriented contextual analysis, development of culture databases, and culture-oriented tools. Together with such documentation, attention to culture differences needs to move more rapidly from nice-to-have to necessary.

Some companies are focusing on localization/globalization issues. In the USA, Sapient (Harris and McCormack 2000) published an excellent white paper on localization issues in 2000, but, significantly, while providing a fine summary and resources beyond translation, its content had almost nothing about culture differences. On the other hand, Microsoft understood that it must change the menu hierarchy, not just the terms, when it introduced word-processing software into Japan in order to match the expectations of that country, and it recently changed its Xbox input device to match smaller Japanese hands (Gaither 2002). As another example from Europe, mobile device manufacturers have sent user-interface developers (with or without cultural anthropologists) to distant lands to study why people do what they do and to look for insights in making future products better (Honold 1999) is an example. Many are learning, many are taking action, but others in companies large and small, don't quite get it yet.

The situation should change in the near future. Many books on culture issues in user-interface design are now beginning to appear, and more are in the works for later this year and 2003, which will provide data from actual projects, refinements to theory, and significant heuristics. Attending to culture differences in product

development should be a hot topic, become part of best practices, and eventually be incorporated into industry standards.

Newly published research on persuasion (Cialdini 2001), trust (Bailey et al. 2001), and cognition (Nisbett et al. in press), and some long-ago published work on intelligence (Gardner 2015) raise further questions about how to understand culture and how it can/should affect user interface design.

For example, Cialdini lists reciprocation, consistency, social validation, liking, authority, and scarcity as key factors that persuade us to believe or do something. He readily admits that the factors have different weightings indifferent cultures. Bailey et al. cite attraction, dynamism, activity, expertness, faith, intentions, localness, and reliability as key factors in developing trust. Bailey has commented in private communication that culture may affect which of these are more important in establishing that trust. Nisbett et al. have established that, given the same perceptual input, Western and Asian people from different conceptions: Westerners tend to think in isolated objects or concepts; Asians tend to think more in terms of relations among objects.

2.4 Conclusions

Consequently, as user-interface developers, you will have the opportunity to deal with these new challenges. Are our notions of usability culture-biased? How do culture differences relate to persuasion and the establishment of trust in Websites and Web-based applications? How do culture dimensions relate to established dimensions of intelligence and change your thinking about online help, documentation, and training? How do cultures differences provide new insight about cognition differences and change your thinking about user search strategies, mental models, and navigation? How should culture be accounted of in user-interface design patterns? All of these questions should affect our judgment as user-interface developers.

Can you confidently state, for the target cultures for which you are developing, what is usable, useful, appropriate, beneficial, and harmful in the products and services for which you may have partial or complete responsibility? Global user-interface development in the twenty-first century is really going to get interesting. Are you ready for the challenge?

2.5 Postscript 2015

As I have mentioned in recent years in my lectures and tutorials, the number of conference sessions and papers about culture-related research and development has steadily risen. Entire conferences as well as tracks at larger conferences are now devoted to this topic. Notable among many are the following:

Frandsen-Thorlacius et al.'s (2009) analysis of Danish and Chinese computer-based product users who have different notions of how fun and esthetic are intimately tied to the concept of usability (more tightly bound for the Chinese), which suggests that the exact standard definition of usability may not be universal (or at least world-wide).

Dong in her innovative Master's Thesis (Dong 2007) using eye-tracking of Web sites showed that Chinese, Korean, and US viewers look at the sites differently, with the US viewers looking in a kind of S or five pattern before quickly jumping deeper into the site, while Asian viewers tend to circulate around the surface, examining more items and in greater detail first (viewing sites in their own preferred languages). This West–east difference seems to mirror Nisbett et al.'s (Nisbett et al. in press) findings about the "geography of thought."

We have been fortunate to complete two related projects, about which we published case studies in *MultiLingual* (Marcus et al. 2011; Marcus and Gould 2011). One project involved a culture-audit of the concepts, terminology, and graphics of a software user-interface going from English to Arabic (for Saudi Arabia) to determine before translation items which should not be translated, thereby saving reducing errors, time, and money, and increasing customer satisfaction. The second project involved analyzing the culture characteristics of a multinational software developer's teams in five countries to assist the company in developing culture-sensitive teamware tools that improved communication, cooperation, and collaboration.

These brief examples suggest the increased value of considering the culture(s) of the developers as well as the consumers of computer-based products and services.

References

Bailey BP, Gurak LJ, Konstan JA (2001) An examination of trust production in computer-mediated exchange. In: Proceedings of the 7th conference on human factors and the web, Madison

Barber W, Badre A (1998) Culturability: the merging of culture and usability, HFWeb'98., http://www.research.att.com/conf/hfweb. 5 Jun 1998

Cialdini R (2001) The science of persuasion. Sci Am 284(2):76–81, www.influenceatwork.com

Dong Y (2007) A cross-cultural comparative study on users' perception of the webpage: with the focus on cognitive style of Chinese, Korean, and American. Masters thesis, Korea Advanced Institute of Science and Technology, Seoul, South Korea

Frandsen-Thorlacius O, et al (2009) A survey of how usability is understood by Chinese and Danish users. In: CHI conference 2009, San Diego, pp 41–50

Gaither C (2002) New riddle for Xbox: will it play in Japan. New York Times, 18 February 2002, 151; 52,033, Section C, 4

Gardner H (2015) Frames of mind, the theory of multiple intelligences. Basic Books, New York. ISBN 0465025102

Hall ET (1969) The hidden dimension. Doubleday, Garden City

Harris J, McCormack R (2000) Translation is not enough: considerations for global internet development, Sapient. 18 Feb 2002: http://www.sapient.com/pdfs/strategic_viewpoints/sapient_globalization.pdf

Hofstede G (1997) Cultures and organizations: software of the mind. McGraw-Hill, New York

Honold P (1999) Learning how to use a cellular phone: comparison between German and Chinese users. J Soc Tech Commun 46(2):196–205

Marcus A (1993) Human communication issues in advanced UIs. Commun ACM 36(4):101–109

Marcus A (2001) Cross-cultural user-interface design. In: Smith MJ, Salvendy G (eds) Proceedings of the, human-computer interface international (HCII) conference, vol 2, 5–10 Aug 2001, New Orleans, LA, USA, Lawrence Erlbaum Associates, Mahwah, pp 502–505

Marcus A (2002) User interface design and culture dimensions, workshop on internationalization. In: Proceedings of the CHI 2002, Minneapolis, MN, 21–24 April 2002 (in press)

Marcus A, Gould EW (2000) Crosscurrents: cultural dimensions and global web user-interface design, vol 7, No. 4. Interactions, ACM Publisher. www.acm.org, July/August 2000, pp 32–46

Marcus A, Gould EW (2011) Improving a development team through culture analysis. Multilingual, September 2011, pp 48–52

Marcus A, Gould EW, Wigham L (2011) Conducting a culture audit for Saudi Arabia. Multilingual, June 2011, pp 42–46

Nisbett RE, Peng K, Choi I, Norenzayan A (2001) Culture and systems of thought: holistic *vs.* analytic cognition. Psychol Review 108(2):291–310

Trompenaars F, Turner CH (1998) Riding the waves of culture. McGraw-Hill, NY. ISBN 0-7863-1125-8

URL Resources

ACM/SIGCHI Intercultural Issues database. www.acm.org/sigchi/intercultural/

Bibliography of Intercultural publications. www.HCIBib.org//SIGCHI/Intercultural

Cultural comparisons. www.culturebank.com

Culture resources. www.webofculture.com, www.acm.org/sigchi/intercultural/Glossary, six languages: www.bowneglobal.com/bowne.asp?page=9&language=1

HCI International (2003) Contact: Stephanidis Constantine <cs@csi.forth.gr>

Internet statistics by language. www.euromktg.com/globstats/index.html, www.worldready.com/biblio.htm

Internet users survey. Nua: www.nua.ie/surveys/how_many_online

IWIPS. http://www.iwips2002.org

Java Internationalization. http://java.sun.com/docs/books/tutorial

Localization. www.lisa.org/home_sigs.html

Microsoft Planning for and testing global software. http://www.microsoft.com/GLOBALDEV/Non%20mirror/back%20up/gbl-gen/INTREFNEW.HTM

Microsoft's global development page. www.eu.microsoft.com/globaldev/fareast/fewinnt.asp

Microsoft Windows Internationalization. http://www.microsoft.com/globaldev/gbl-gen

Simplified English. http://userlab.com/SE.html

Unicode. www.unicode.org/, IBM Unicode Glossary: www–4ibm.com/software,/developer/library/glossaries/unicode.html

Chapter 3
CHI as a Cross-Tribal Community

3.1 Summary

Computer-human interaction requires a multi-disciplinary effort. The disciplines intersect and interact in a team. For teams to develop products and services together successfully, they must know how to communicate and cooperate in an environment of mutual respect. SIGCHI is moving along these directions inevitably, with consequent enrichment of the professions involved.

© Springer-Verlag London 2015
A. Marcus, *HCI and User-Experience Design*, Human–Computer
Interaction Series, DOI 10.1007/978-1-4471-6744-0_3

3.2 Introduction

I would like to continue considering cross-cultural communication, which I discussed in the previous chapter, but now I turn inwards towards the SIGCHI community itself, which is complex intersection of professions. SIGCHI celebrated its twentieth anniversary at CHI 2002. The CHI conference featured exhibits and documents from SIGCHI's history, as the organization plans its future. I comment informally on the organization's history, its current status, and its future.

During discussions of cross-cultural communication, I am struck by analogies to the CHI community itself. We at CHI are a gathering of many disciplines or "tribes," with different symbols, heroes/heroines, rituals and values. In Flagstaff, Arizona, Native-American tribes used to gather from all over the USA each year (in what are called generally All-Indian Pow-Wows) to salute their cultures, display their skills, and exchange ideas. We do something similar at CHI conferences. The possibilities for exchange, learning, and stretching of assumptions and expectations are quite rich. CHI offers a community for multiple disciplines to meet and to learn how to work together for mutually successful projects featuring inter-disciplinary communication and cooperation.

3.3 Tribal Origins of SIGCHI

SIGCHI started in 1982 as a convening of psychologists, human factors specialists, social scientists, software developers, and some outliers, like myself, who joined in from other disciplines. The focus of our attention was primarily research, on projects related to mainframe computer systems and client-server-network development of productivity tools on workstations, and on personal computers, which were then coming into use. Over the decades, the core user-interface research areas expanded to include, among others:

- Cognitive science
- Computer science
- Graphic design
- Hardware development
- Human factors
- Information architecture
- Social science
- Software psychology
- Software development
- Web development

Some differences of philosophy emerged. For example, the Usability Professionals Association broke away more than a decade ago to focus specifically on usability issues. Other groups have been added, like the visual designers who have sponsored special-interest groups and other events.

3.4 Cross-Tribal Talk Today

In the latest growth spurts, we have seen the addition of such disciplines or professions as these:

- Anthropology
- Branding
- Culture models
- Decision support
- Experience design
- Futurists (including science-fiction writers)
- Game and entertainment design
- Information design
- Information visualization
- Mobile device and information appliance development
- Semiotics
- Sound design
- Strategic planning
- Systems science
- Usability analysis and evaluation
- Visual design

One of the key shifts has been to include many more media-*design* disciplines, i.e., practitioners, not only researchers and analysts, or scientists and engineers. Visual designers of all kinds have enriched the organization, conference, and topics of debate. In earlier years, consultants, who marketed their services, were viewed as somewhat impolite, distasteful interlopers in a community of corporate-funded researchers. Now, visual designers, design consultants, and other designers discuss topics originally "off-limits," like branding, return-on-investment, architecture-inspired pattern languages, user-experience design, etc. The net result, is that we have more to consider, more to say, and more to debate.

Perhaps I notice this kind of development more because, like many CHI folks, my own background is an amalgam of disciplines: an undergraduate education in physics, mathematics, and philosophy; graduate study in graphic design at a university art school; and a decade of teaching undergraduate and graduate courses in a school of architecture and urban planning

One of the more exotic events at CHI, besides the advent of science-fiction writers, was a breakthrough in 2001, a first-ever panel that featured marketing professionals trying to explain their approach to understanding user-interface design processes. To many old-guard CHI attendees, having marketing people participate as presenters in the conference itself (as opposed to out on the exhibit floor, of course, where they are presumably expected and tolerated) would have seemed extreme heresy and folly. The anti-marketing opinions of some CHI folks are similar to the anti-designer opinions voiced by others. Much of this suspicion, and in some cases even hostility, is rooted in ignorance of each group's humane, logical,

ethical, passionate, and compassionate objectives. Some professionals are still worried about the new tribes moving into the familiar neighborhoods.

I took part in this panel and expected fire-and-brimstone invectives, perhaps even fisticuffs. However, the specific subject areas of marketing were so narrow and the audience so polite that we didn't have to settle our debates with rolled up sleeves out in the hallway. Nevertheless, the event marked a significant point in CHI's evolvement.

These events that cross over do much to educate and sensitize CHI folks. I still hear even today comments that reveal disparagement or suspicion about all the designers (i.e., synthesizers) who float among the researchers and analysts. This dichotomy between the terminology, philosophy, techniques, objectives, and goals of research *vs.* design was even the subject of at least one panel discussion at the American Institute of Graphic Arts (AIGA) Forum, a special 2-day event held for the first time at CHI 2002.

The AIGA Forum, focusing on user-experience design, is another watershed moment for CHI. Here, for the first time, another professional organization, historically and primarily oriented to graphic design, has found a temporary home within a CHI conference to offer opportunities for communicating across established tribal boundaries. This is an exciting organizational and intellectual development. We should be thinking about how to foster this kind of interaction.

One of the essentials of cross-cultural cooperation is mutual respect, another is mutual trust. Both of these attitudes must be predicated on a partial, but shared, unambiguous, and consistent vocabulary, so that all may reliably communicate. Sharing of literature, of terminology, of concepts, brings surprising benefits. We have already seen these benefits in the absorption of psychological issues into what was originally considered a mathematical and logical arena of investigation.

3.5 Absorbing Tribal Classics

Another interesting benefit of cross-tribal communication is how CHI seems eventually to discover the classic literature of other disciplines, some of it decades or more old, and gradually to absorb these essential documents into its own profession. I realize this goes against the grain of some professionals and, specifically, publication reviewers, who generally consider that only publications within the past few years merit attention.

This transferal from one discipline to another has been part of my own techniques of discovering new ideas of value to the CHI community for the past 30 years. Here are a few of the resources that I have found especially worthwhile. Some of them derive from my continuing study of visual communication; others I encountered in the 60s and 70s when I taught in architecture and urban planning. Some of them are now becoming well known within some CHI subgroups. I hope to give a few an additional boost of recommendation, and urge Interactions readers to consider them for study as a means to stimulate vital discussions:

Consider Christopher Alexander's (Alexander et al. 1977) study of patterns of architectural form. Over many years at the University of California/Berkeley, Prof. Alexander and his colleagues compiled insights about essential structures (and implied processes) of architectural form, which he feels are universal, or at least broadly shared human experiences. This approach to pattern catalogs was developed at other institutions, also. I am aware of the work, for example, of Profs. Bernard Spring, Lance Brown, et al., at Princeton University's Center for Urban Research in the late 60s and early 70s. The technique has been much discussed in the architectural community for 30 years and has at last, over the past few years, come to the general attention of the CHI community as they develop pattern collections of user-interface design modeled on the taxonomies of this earlier work. We shall see much more of these publications in the coming years as they consider all of the components of user-interface design (metaphors, mental models, navigation, interaction, and appearance).

Ludwig Von Bertalanffy (1962) (1901–1972), was an important theoretician of the twentieth century. His research in physiology, psychology, the social sciences, and the philosophy of science led to his proposing a general systems theory, which influenced generations of system scientists and engineers of complex processes and products. His ideas published as early as the 1930s may bear fruit further in the CHI profession as today's developers come to understand the full dimensions of complexity across multiple platforms, modes of communication, and the social and psychological underpinnings of cooperative work and interactive communities.

Prof. Umberto Eco (1979) of the University of Bologna, Italy, first began promoting semiotics, the science of signs, and explaining his theory 25–30 years ago, and semiotics theory (or its French variation *semiologie*) has taken hold in most of the disciplines of communication and design. The relevance of semiotics to the world of icons and symbols in user-interfaces is immediately apparent. Deeper insights and new discoveries are likely as researchers and designer use semiotics/*semiologie* comprehend user interfaces as cultural artifacts, especially in relation to branding and user experience modeling.

Howard Gardner (1993) proposed almost 20 years ago that intelligence could be understood as 7 ± 2 dimensions of human cognition and emotion, and he examined the implications for education. His theory gives rise to issues of how computer-mediated communication might be biased toward specific modes. As the CHI community attempts to develop successful global devices and systems, these variations in methods of understanding and communicating will seem more and more relevant.

Geert Hofstede's classic work about culture dimensions in organizations (Hofstede 1997) presents the results of his study of IBM employees in more than 50 countries during the late 1970s and early 1980s. He proposed five dimensions of all cultures, which affect work, education, and family life. His approach is being used by more and more user-interface analysts and designers to improve how user-interfaces can be developed to meet the needs of specific target markets.

The linguists George Lakoff and Mark Johnson (1983) examined in their classic work the way people use language, and they discovered, among other things, funda-

mental metaphors within most human communication. Just as one cannot *not* communicate, one cannot *not* use metaphors in communication. They theorize that most metaphors are spatial in nature. The book gives insight into one of our fundamental design challenges: how we help people to understand fundamental structures and processes that computer-based systems present to users.

For insight into how human being understand complex information, consider the classic book by Kevin Lynch (1960) which is now more than 40 years old. This insightful view of how the phenomena of the urban environment can be understood is a basic to modern urban theory, which posits nodes, areas, edges, landmarks, etc., as classic elements of urban form. These same elements seem appropriate to consider for large collections of information, e.g., in Web-based documents, applications, and databases. At issue is how ordinary human beings comprehend a large mass of content and how we user-interface developers might learn from our urban experience to provide better frameworks for our cyberspace constructs.

James Miller (1985) proposed decades ago that all living systems can be understood according to 18 fundamental functions modeled on those of biological organisms, e.g., ingestion, excretion, etc. He proposed that all complex enterprises, from the scale of microbes, to those of entire civilizations could be understood more fundamentally and powerfully through this perspective. His approach might be applicable to understanding communities of information processing.

3.6 Where do We Go from Here?

These references, and the activities mentioned above, are just a start at thinking about the future of user-interface design by going back to some of the classics of other disciplines, and thinking about how, together, we can accomplish much more than we can do alone. As the many tribes of CHI gather each year, there will be more cross-cultural communication and cooperation. This *intersection* of cultures will make the CHI community continually stimulating and challenging.

Let us work toward the objective that CHI continues to be this unique place of intersection, where we can learn to communicate and relate well with each other. Through these interactions, we will learn to serve better our users, clients, employers, and profession.

Now, groups like AnthroDesign celebrate the collaboration of anthropologists and ethnographers with designers of many kinds: software, visual, interaction, experience, branding, and others. We have come a long way. The journey will become ever more interesting as the rolling credits for computer-based products and services, like the scrolling lists of movies seemingly go on forever in order to give credit where credit is due.

Fig. 3.1 Symbol for
global interdependence
designed by Aaron
Marcus, Yukio Ota, and
others, as research fellows,
East-West Center,
Honololu, Hawai"I, 1978
(Copyright © 1978 by the
East-West Center and used
with permission)

One of the main challenges of today and the future, will be to find common terminology, diagrams, processes, and language that enable all the disciplines to work together effectively to resolve disagreements, to empower each kind of contribution, and to achieve their mutual objectives. This cooperation, collaboration, and communication is symbolized in Fig. 3.1 (adapted from a previous project I led about global energy interdependence).

3.7 Postscript 2015

It would be fascinating to do a chronological study of the number and types of disciplines that comprise user-experience development teams over the past four decades. Both the kinds of disciplines have multiplied, as well as professional titles and the kinds of terminology, processes, and concepts.

I can recall in the early 1980s, when a research-laboratory software engineer was astonished to learn that there were actually people called typographers who spent their entire days designing typefaces. I can recall in the mid 1980s, when an HP software engineer marveled that the number of lines of code for input-output had grown larger than the code for the program's functionality. I can recall in the 1980s and 1990s when anthropologists crept somewhat furtively around SIGGRAPH and SIGCHI conferences, feeling a little like aliens. I can recall when I invited science-fiction writers to come to SIGCHI conferences in 1992 and 1999 to speculate on what future products-services would be like.

References

Alexander C, Ishikawa S, Silverstein M, Jacobson M, Fiksdahl-King I, Angel S (1977) A pattern language. Oxford University Press, New York. ISBN 0195019199

Eco U (1979) A theory of semiotics. Indiana University Press, Bloomington. ISBN 0253202175

Gardner H (1993) Frames of mind, the theory of multiple intelligences. Basic Books, New York. ISBN 0465025102

Hofstede G (1997) Cultures and organizations: software of the mind. McGraw-Hill, New York. ISBN 0070293074

Jordon P (2000) Designing pleasurable products. Taylor and Francis, London

Lakoff G, Johnson M (1983) Metaphors we live by. University of Chicago Press, Chicago. ISBN 0226468011

Levy-Strauss C (1958) Anthropologie structurale. Structural anthropology (trans: Claire J, Brooke GS, 1963). Basic Books, New York

Lynch K (1960) Image of the city. MIT Press, Cambridge. ISBN 0262620014

Miller JG (1985) Living systems. University Press of Colorado, Denver. ISBN 0870813633

Moles A (1968) Information theory and aesthetic perception. University of Illinois, Urbana

Von Bertalanffy L (1962) General system theory: foundations, development, applications. George Braziller Publisher, New York. ISBN 0807604534

Chapter 4
Dare We Define User-Interface Design?

4.1 Summary

What do experts in user interfaces actually design? Many definitions have been proposed, some of which may leave out key ingredients. The author proposes a general definition.

4.2 Introduction

What exactly do we mean by user-interface design? Apparently, it depends on who's asking, or who's speaking. Consider these events:

Marcus A (2002) Dare We Define User - Interface Design? Interactions 9(5) ACM Publications, New York pg 19–24

The late Bill Moggeridge, a well-known product designer, acknowledged in a keynote address at DIS 2002, a SIGCHI-sponsored design conference, that *he*, with the assistance of a fellow product designer, Bill Verplank, was the inventor of the concept of interaction design in the early 1980s. In his review of important contributors to this term that he never defined, but which seemed to include much of user-interface design, he included a number of well-known user-interface researchers as well as founders of Google, a successful Web-based information search service, and of Palm's mobile-device operating system. The term *user-interface* almost never entered their discussions.

About 2001, Alan Cooper, a well-known software designer (literally an inventor of a software language) announced in a keynote address of the Usability Professionals Association, a major usability conference, that *he* was the inventor of the concept of interaction design in the 1980s, a concept that he, too, never defined in his lecture but seemed to include much of user-interface design. He also opined that interaction design (thus, user-interface design) didn't exist until he brought it into being.

In publications of the American Institute of Graphic Arts and conferences that it has co-sponsored with SIGCHI, proponents of a concept called experience design have put forward the notion that *they* are designing something larger than, different from, and, of course, more important, than user-interface design. Attempts to define exactly what this term includes in proponents' magazines, books, lectures, and conferences remains ambiguous thus far.

During a gathering to discuss the newly formed University of California's Berkeley Institute of Design, Arnold Wasserman, a well-known corporate product designer/strategist praised the product design community for having been the first to emphasize usability rather than the human factors specialists' more narrow focus on ergonomic issues. In doing so, he seemed to overlook the typography and graphic design community's contemporaneous investigation of these same kinds of issues.

During the advent of the Web and the rise, then fall, of the dot-coms, *information architecture* seemed to be the new term to describe much, but not all, of user-interface design. Note, however, that information architects, unlike their more established cousins, are not licensed to practice. (The issue of certification for analysts and designer is a complex, thorny matter that I shall not address here.)

4.3 A Little History

When I first began writing a user-interface design manual in 1979–1980, I was already aware that there was a topic of user-interface design. Shortly after that, CHI held its first conference. Today, product reviews in the *Wall Street Journal* and the *New York Times* comment regularly on user-interface design. Apparently, these critics, and presumably the general public understand the term user-interface design.

What is going on here? Many reasonably well-educated and presumably well-meaning professionals seem to be forgetting history, rewriting history, and muddying conceptual waters rather than clarifying them.

It seems appropriate on the occasion of SIGCHI's 20th anniversary to consider how the profession defines itself, particularly in its "design" aspects. Of course, whether SIGCHI should undertake such an activity at all is debatable to some who worry about which professions are included and which are not. Others might say, let a 1000 definitions bloom; the more the better.

I take a middle road in trying to be simple, clear, and consistent in defining the terms. Much is at stake in this conceptual turf battle. Around the world, institutions of higher learning are attempting to establish clear pedagogical objectives and curricula that present a coherent, inclusive view of user-interface design. More than 10 years ago, SIGCHI itself undertook an effort to describe a user-interface analysis/design/theory curriculum for computer science departments. Now, many professions are involved in trying to define this complex, challenging topic.

One could use almost any practical term in place of user-interface design. However, without clear, consistent, agreed-upon conventions, the terminology may confuse professionals, teachers, and students, further confusing or boring the general public, and not reaching the business community effectively. Some inappropriate terms may become conventions, which sometimes impoverishes distinctions.

For example, the computer industry, unfortunately in my opinion, has gradually obliterated much of the useful distinctions of *sign*, *icon*, and *symbol*. The general semiotics term *sign* is casually equated with its sub-terms *icon* (representational, or "natural" sign) and *symbol* (abstract or conventional signs). In many professional situations of analysis and design, these distinctions are important to maintain. Alas, all of the small visual signs of user-interfaces are now loosely called icons by professionals as well as the public.

Some of the organizations who have a stake in this process of defining the terms *user interface* and *design* include the following:

- American Institute of Graphic Arts (AIGA)
- Association for Computing Machinery (ACM)
- ACM Special Interest Group for Computer-Human Interaction (SIGCHI)
- ACM Special Interest Group for Graphics and Interaction (SIGGRAPH)
- Human Factors and Ergonomics Society
- Industrial Design Society of America
- International Institute for Information Design
- Society for Technical Communication
- Society for Software Design
- Society for Software Psychology

You may have candidates to add to this list. Professionals of these and other organizations have considered one or more of these topics to be the appropriate term for essential design activities:

- Applied semiotics
- Computer-based communication design
- Computer-based theater design
- Computer-human interaction design

- Experience design
- Human-computer interaction design
- Information architecture
- Information design
- Interaction design
- Interactive media design
- Narrative design
- User-experience design
- User-interface design
- Visual design

Again, you may have additions to suggest. The terminology has always been fluid and subject to social, political, and technological shifts. Recall that *man–machine interface* (MMI) was changed to less-gendered synonyms during the late 1980s and early 1990s and that *multimedia* became a redundant term by the late 1990s. The availability of virtual and augmented reality, mobile devices, wearable computers, and less-noticeable, ubiquitous computers have all caused theorists, teachers, and professionals to rethink their terminology and definitions. It is also possible that well-designed definitions may serve during many changes of technology, if the terms are well defined.

Here is what seems to me to be a reasonable approach to defining user-interface design:

First, we should acknowledge that human beings, to paraphrase the structural anthropologist Claude Levi-Strauss (2000), are fundamentally tool- and sign-makers. As artifact makers, we are deeply connected to our wired-in capabilities; to personal emotional, cognitive, and spiritual needs/desires; as well as our socio-cultural constructs. We have been making clothes, hammers, and other physical tools for countless millenia. We also have been communicating through physical gesture, touch, sound, smell, and vision for countless millenia. Tools enable us to change our physical environment. Written artifacts, including coins, parchment rolls, and walls, carry messages across space and time in a way that physical gestures and speech and noise-making cannot.

These aspects of the history of communication are worth mentioning, because the history of computers itself is closely enmeshed with the challenge to improve input and output techniques. What we are addressing essentially is not solely physical object design, but computer-mediated human-human communication.

User-interface design could be defined from a tool, i.e., physical object, point of view or from a communication point of view. Either way, *both* definitions would include interaction as a concept. However, it is important to appreciate the full meaning of user-interfaces as communication artifacts. To call user-interface design interaction design misses some important points, as seems evident if one listens to proponents of interaction design.

In Patrick Jordan's book *Designing Pleasurable Products* (Jordan 2001), he presents a property checklist for designing a power drill. The list includes many sensory attributes, functionality, and "interaction design" which is defined else-

where as interaction sequences and protocols. The communication dimensions seem to be missing.

In the recent keynote lecture I mentioned earlier about the past 20-year history of interaction design, Bill Verplank mentioned that there was something else besides interaction design called "media design," which was essentially an "expressive" activity. By "media," I understand such terms as broadcast television, video tapes, printed books, comic books, cinema, CDs, DVDs. In previous centuries, one would mention religious and governmental architectural sculptural friezes, documents, and monuments. As communication forms, according to Moles' definitions (Moles 1968), media convey information, persuasion, and esthetics (some might add spiritual content as a fourth kind). Definitions of media by interaction designers seem to view media as only expressive or esthetic/persuasive communication, neglecting the long history of information-oriented visual communication design, with its close ties to graphic design, education, government, commerce, and technology.

Regarding "experience design," it seems that some graphic designers, media designers, Web designers, branding and business strategists, and others claim the design of the interactive experiences of a viewer, customer, visitor, resident, and/or reader. This claim seems a bit vague. What would architects of buildings or landscapes make of this? Would they not be one of the first to claim the design of interactive human experience? Those wishing to understand the work of experience designers might do well to consider the work of Disney designers, who do, indeed, control the total experience of visitors to Disney-fabricated environments (Marling 1997).

What then are my proposed definitions? I have been refining them for many years, and I present them below in a short lexicon. This philosophical perspective emphasizes communication as a fundamental characteristic of computing, one that includes perceptual, formal characteristics, and dynamic, behavioral aspects of how people interact through computer-based media. This approach acknowledges user-interface design more strongly as a set of communication design tasks, but tries, also, find places for product and architectural design. The intention has been to acknowledge the specific skills of many different artifact-design professions. Sound designers, theater designers, graphic designers, information designers often seem marginalized in the definitions that I have encountered. I have tried to formulate the definition of user-interface design in a manner that allows it to be inclusive, not exclusive. I have also tried to define terms so that they can survive the rapid change of platform technology. The eventual "disappearance" of computers and the rise of "smart" objects will always involve communication rituals. In some ways, we are back where we started 10,000 years ago with the exchange of three-dimensional tokens, but with many new magnificent twists in our computer-based media.

I hope you will find this lexicon useful. Others may propose different perspectives and terms. If we are careful in our thinking, we should be able to translate from one paradigm to another, appreciating the varying complexities and values. Discussing these world views and terminology is a healthy intellectual, professional exercise. I invite you to join the ongoing debate.

4.4 A Brief User-Interface Lexicon (of Canonical, Reserved Terms)

Appearance Appearance includes all essential perceptual attributes, i.e., visual, auditory, and tactile characteristics. Examples include choices of colors, fonts, animation style, verbal style (e.g., verbose/terse or informal/formal), sound cues, and vibration modes.

Communication The conveyance of information, persuasion, esthetics, (and some would add spiritual content) from one entity to others. Typically, people describe, explain, emote, praise, or ritually enact through their communications. The activity requires senders, receivers, messages, and media. The process assumes that some behavior indicates that the receivers have acquired the messages and understood them.

Information One level in a hierarchy of organized content to be communicated. The levels of increasing complexity are: data, information, knowledge, and wisdom, described as follows:

- Data: Organized input from the senses
- Information: Significant patterns of organized data
- Knowledge: Significant patterns of organized information with action plans
- Wisdom: Significant patterns of organized knowledge plus real-world experience gained over time.

Information Visualization A special aspect of *user interfaces* is information visualization, the means for communicating structures and processes, which may be shown in abstract or representational forms. Classically, these may be described as tables, forms, charts, maps, and diagrams. The list suggests an approximately increasing complexity of visual syntax. This term emphasizes visualization, but is intended to include other sensory means to communicate information.

Interaction Interaction includes input/output techniques, status displays, and other feedback, both locally and globally. In the computer platforms of today, local examples include the detailed behavior characteristics of equipment such as: keyboards, mice, pens, or microphones for input; visual display screens, loudspeakers, or headsets for output; and the use of drag-and-drop selection/action sequences. Global examples include context issues, usage scenarios, and task activities at a larger scale.

Metaphor Metaphors are fundamental concepts (Lakoff and Mark 1980) communicated via words, images, sounds, tastes, smells, and tactile experiences. In computer operating systems, metaphors substitute for collections or individual elements and help users understand, remember, and enjoy the entities and relationships of computer-based communication systems. Metaphors can be overarching, or communicate specific aspects of user interfaces.

An example of an overarching metaphor is the desktop metaphor that substitutes for the computer's operating system, functions, and data. Examples of specific concepts are the trashcan, windows and their controls, pages, shopping carts, chat rooms, and blogs (Weblogs, or Web-based diaries). The pace of metaphor invention, including neologisms, i.e., verbal metaphor invention, is likely to increase because of rapid development and distribution, through the Web and mobile devices, of mutable products and services. Some researchers are predicting the end of the desktop metaphor era and the emergence of new fundamental metaphors.

Mental Models Mental models are structures or organizations of data, functions, tasks, roles, and people in groups at work or play. Examples of related, but not identical versions of mental models are user models (which include concepts of personas, goals, needs, desires, roles, etc.), user cognitive models, user task models, and designer models. Mental models exhibit hierarchies of content, tools, specific functions, media, roles, goals, tasks, etc. Some professionals speak of goal-oriented design, user-centered design, task-centered design, etc., These orientations emphasize close analysis of varying mental models.

Navigation Navigation involves movement through the mental models, i.e., through content and tools. Examples of user-interface elements that facilitate such movement include those that enable dialog, such as menus, windows, dialog boxes, control panels, icons, and tool palettes.

Semiotics Semiotics is the science of signs (Eco 1979). Semiotics identifies four dimensions of "*meaning*" for information visualizations that communicate through "signs."

- *Lexical:* how are the signs produced?
- *Syntactic:* how are the signs arranged in space and time, and with what perceptual characteristics?
- *Semantic:* to what do the signs refer?
- *Pragmatic:* how are the signs consumed or used?

User Interface (UI) A computer-mediated means to facilitate communication between human beings, or between a human being and an artifact . The user interface embodies both physical and communicative aspects of input and output, or interactive activity. The user interface includes both physical objects and computer systems (i.e., hardware and software, which includes applications, operating systems, and networks). A user-interface may be said to consist of *user-interface components*. Reasonable synonyms for user interface include: human-computer interface and human-human interface. This last term seems appropriate for an era in which computers themselves disappear, leaving only "smart" ritual objects/displays, such as "smart eyeglasses," "smart clothes" and "smart rooms"

User-Interface Components *Metaphors, mental models, navigation, interaction, and appearance.*

User-Interface Design The general activity more properly should be called *user-interface development* similar to software development. *Design* focuses on the synthesis stages.

User-Interface Development User-interface development consists of these tasks undertaken in a partially parallel, partially serial, partially iterative sequence: plan, research, analyze, design, implement, evaluate, document, train, maintain, and recycle/replace.

User-Interface Platform The user-interface platform is the physical home of the user interfaced, i.e., of the hardware and software. Traditional examples include terminals, workstations, desktop computers, Websites, Web-based applications, information appliances, and mobile/wireless devices. However, in general, the platform encompasses all physical products (consumer or professional) such as chairs, power drills, tea kettles, tape measures, and physical environments, such as rooms, buildings, and vehicles.

4.5 Postscript 2015

The lexicon of computer-based product/service development has added many terms in the last decades, such as Agile and lean development, terminology associated with robotics, the Internet of Things, cloud-based services, and wearables, as well as legacy terms of the conventional platforms of past generations: desktop client–server systems, Web, mobile, appliance, and vehicle systems.

One of the more significant changes has been to incorporate all of human experience into the realm of computer-based products. Where do artifacts touch our lives? User-experience design, customer-experience design, service design, culture-driven design, coginitive-neuroscience-driven design, and allied topics have all become important additions.

No doubt as the decades progress, more, unexpected platform types may emerge. New terms may show prominence. However, the canonical terms above, for the most part, will have long-standing relevance to the work of HCI and user-experience professionals.

References

Eco U (1979) A theory of semiotics. Indiana University Press, Bloomington. ISBN 0253202175
Jordan P (2001) Designing pleasurable products: an introduction to the new human factors. Taylor and Francis, London. ISBN 0-748-40844-4
Lakoff G, Mark J (1980) Metaphors we live by. The University of Chicago Press, Chicago. ISBN 0226468011
Levi-Strauss C (2000) Structural anthropology (trans: Claire J, Brooke S). Basic Books, New York. ISBN: 046509516X

Marling KA (ed) (1997) Designing disney's theme parks: the architecture of reassurance. Flammarion, Paris. ISBN 2080136399

Meggs P (1998) A history of graphic design. Wiley, New York. ISBN 0471291986

Moles A (1968) Information theory and esthetic perception. University of Illinois Press, Urbana. ISBN 0252724852

Skutch, A. F. (1976) *Parent Birds and Their Young*. University of Texas Press, Austin.

Snow, D. W. (1976) *The Web of Adaptation: Bird Studies in the American Tropics*. Quadrangle, New York.

Chapter 5
The Cult of Cute: The Challenge of User Experience Design

5.1 Summary

User-interface design is seeking to extend its concerns beyond usability to usefulness and appeal, especially to pleasurable user experience. It is worth cautioning designers about easy solutions that appeal to fast tracks to pleasure. The emphasis on cuteness in visual communication, product design, and branding is a lesson to be learned.

© Springer-Verlag London 2015
A. Marcus, *HCI and User-Experience Design*, Human–Computer
Interaction Series, DOI 10.1007/978-1-4471-6744-0_5

5.2 Introduction

In many user-interface design-oriented organizations and publications, we learn increasingly of a concern about issues that extend the reach of the profession beyond traditional human factors and usability. I have in mind the substantive and rhetorical challenges about usefulness and appeal, particularly achieving a pleasurable user experience. It is a charming twist of history that the classical architectural design ideals of commodity, *form*, and delight proposed by Vitruvius 2000 years ago should surface again.

One sign of this interest is Don Norman's book *The Psychology of Everyday Things* aka *The Design of Everyday Things* (Norman 1988). Even the esteemed computer scientist David Gelernter has weighed in on the subject (Gelerntner 2001) of computers and happiness. Another example is Patrick Jordan's book, *The Design of Pleasurable Objects: An Introduction to the New Human Factors* (Jordan 2001), in which he uses psychological theories to propose four levels of pleasure that designed artifacts should provide us (listed below in higher-to-lower sequence):

- Cognitive/intellectual
- Social
- Psychological/emotional
- Physical

It is worthwhile, in this Dionysian rush to pursue pleasure and specifically to pursue happiness (recall that this is one of the US Founding Fathers' views of essential liberties), that we recall similar experiences from other fields of design. Computer science, and then computer-human interface design, and then human-computer interface design, has a track record of wandering with ignorance into new domains of human communication and design. For example, I recall in the early 1980s a XeroxPARC researcher asking me what I thought about styles in computer graphics. I immediately thought she was referring to the exciting future of computer-based communication in which imagery might be conveyed with the esthetic style of the Bauhaus *vs*. art nouveau. It turned out she meant: did I think that lines should be given attributes of solid, dashed, or dotted. I caught myself just in time from replying inappropriately with un-needed sarcasm or disparagement.

So, if developers of computer-based communications and artifacts in general wish to delve into this sophisticated subject matter, let them be advised to consult with expert guides on these topics, to inform themselves, and to approach some of the possible avenues of emphasis with caution.

I have in mind in particular, the likely emphasis in future user-interface design of cuteness.

5.3 Caution Signs Upon Entering the Realm of Cuteness

I bring up this topic, seemingly months, or years, in advance of its likely standing before many application and some document publishing developers in any of a number of markets (for example, general consumer, travel, finance/banking, medicine, education, etc.), because "progress" or at least change, seems to be occurring with increasing rapidity.

Since the mid-80s, I have written and lectured about quality visual design, advised developers that the future might bring genres of user interfaces, much like we now have genres of traffic school (comedy, cooking, news, etc., in which a layer of additional content is provided to the highway truant), and urged developers to hire professional comedians, not programmers or technical documentation specialists, to write the jokes for help messages. It seemed likely with the advent of CD-ROM multimedia and then the Web, that user interfaces would become increasingly complex communication vehicles, somewhat like movies, requiring the organizational and professional skills of many disciplines.

In my own experience, it was not until 1995, that a client actually told me: "I like your user interface, but could you make it a little happier?" Happier? We were working on the design of the home screen, and later on one of the key functional air-travel booking screens for Planet Sabre, a revolutionary advancement to one of the world's largest extranets (a case study appears in Marcus 2001). On the image of a planet with many "icons" representing the primary applications suite, the image of a traveler, representing the database of customer information, admittedly looked slightly weighed down from his heavy luggage. In addition, there were, I admit, somewhat dark, heavy coloring and shadows in the continents and in the curved forms of the automobile representing rental car booking. Following the maxim of "keep the client happy" particularly if it does not interfere with primary functionality of the design, we agreed to redesign the icon and coloring, producing a sprightly passenger with a bouncing stride seemingly undaunted by his featherweight luggage and Disney-like green grass on the continents of this pseudo-earth. By making the user interface happier, we had been asked, in fact, to "cutify" the image, to make a more pleasurable user experience.

I have been interested in the subject of cuteness since childhood, when I first began to practice cartooning, carefully copying the Disney characters, Al Capp's shmoo, and other adorable creatures in my extensive comic book collection. Thirty years later, I was startled to discover Japanese *manga*comics in 1982–1985 during trips to Tokyo. In addition to graphic violence and sex, these publications also contained strong streams of cuteness, which were amplified in my mind, by my introduction to Hello Kitty ™, the treasured Japanese asset of a worldwide franchising effort of this cuteness brand by Sanrio (Moss 2002). I now subscribe the Hello Kitty quarterly catalog (doesn't everybody?), in which I can view the spread of this leading cuteness virus throughout the world.

Even Japanese business men read *manga*, and I have seen North American men (well, at least one) sporting Hello Kitty backpacks. Even Hello Kitty has competitors for cuteness, like Pokémon, and the Koreans seem to vie with the Japanese in their love of cute cartoon characters. I have not read a detailed sociological, cultural, or psychological explanation of Asian fascination for cute cartoon characters (I am sure there are scores of PhD theses), but I do know of user-interface research of photo products user interfaces by Kodak that attest to the Asian interest in pictorial/visual signs. And, I have had direct "observational experience" by walking through theme stores for Hello Kitty products and its competitors in Seoul and Tokyo, which are much more extensive than anything I have seen in Europe or North America. These stores are temples of cuteness at which devotees may worship…and purchase "religious icons" endowed with some important kind of emotional potency.

Current advanced CHI research is not far away from exploring the topic of cuteness. The theme of the 2001 New Paradigms in Using Computers (NPUC) conference held annually at IBM Research Laboratory in Almaden, California, near San Jose (see http://www.almaden.ibm.com/cs/npuc2001) featured a complete agenda of games designers speaking to software and hardware researchers so that the latter might learn from the former important techniques of making more successful office, vertical market professional, and general consumer products. The advent of entire conferences devoted to entertainment computing (see, for example, the First International Conference on Entertainment Computing held in Japan in May 2002, http://www.graphic.esys.tsukuba.ac.jp/iwec2002/) attests to the strength of this direction.

Why then, do I express some caution? I myself love adorable teddy bears (I still have my own childhood companion somewhere in the attic). Like the human desire for sugar, carbohydrates, nicotine, and others substances which give us pleasure, beyond nutritional needs, there is a strong likelihood of overuse, or even abuse, which, in the hands of commercial effectiveness, leads to societal circumstances that are less than desirable (like the recent worldwide growth in obesity and its consequent medical/health implications). While clearly not as pernicious (nor yet as pervasive) as other social trends, the topic of cuteness in user interfaces deserves attention.

A dyspeptic article by Annalee Newitz in the San Francisco *Bay Guardian* (Newitz 2002) provides an engaging (not cute!), effective, and strongly biased introduction to the topic: "Why is Everything So Damn Cute? The Fluffy-Bunny Regime is Getting Ugly." She reminds us of the understandable appeal of cute creatures: they appeal to the child in each of us, and like comfort food, we seek out cute things when we need reassurance during stress, just as nutritionists inform us that we seek sugar and salt. She also ascribes North America's obsession with cuteness to an Asian-philic tendency that has forgotten how US business strategists were warning of a Japanese takeover of the US economy in the early 1990s or takeover of the US entirely in the 1940s.

One danger of cuteness includes the tendency to invoke cultural, historical, or social amnesia, as when we think of Japanese *animé* or *manga* providing a reference for Japanese culture.

Another danger is the reinforcement of some questionable aspects of gender roles, especially the tough/tender dichotomy of male/female. Cuteness sometimes seeks to turn people, especially young women, and even adults into powerless children, to smother dissent and edginess, and to create a bland consistency, with a loss of true diversity.

Considering overly conservative, homogenized, bland, even artificial, cuteness, I am reminded of a visit a few years ago to an international-theme area of DisneyWorld in Orlando, Florida, a few years ago. As I toured the separate stalls/shops of Morocco, India, France, and other countries, I realized they were all peopled by bright, smiling faces of young blond-haired, blue-eyed, fair-skinned Floridians dressed in ethnic costumes, and all the booths smelled the same, except for one (I believe it was Morocco) in which the smell of actual leather goods could not be masked. Everything else had been reduced to a safe sameness, with mild differences, that was un-nerving, even potentially frightening to me, but seemed to provide safe, secure, "useful" experiences for the visitors.

The article I cited rails against the rise of cuteness, while acknowledging some of the merits of cuteness. Nevertheless the author disparages the negative aspects of cuteness when blown out of scale. We might consider the same cautions for cuteness in user-interface design.

5.4 Conclusion

As we move away from purely "functional" "limited" design to "formal" eclectic play, much as Robert Venturi and Denise Scott-Brown urged in the architectural design community in the 70s in books like *Learning from Las Vegas* (Venturi and Scott Brown 1972), as we move from Classical and Renaissance styles in our user interfaces to Baroque, Rococco, and later eclectic, post-modern user interfaces, let us not forget that the desire for cuteness as a need for solace or reassurance in turbulent times can be helpful but it can also be mere amusement, taking us away from considering more challenging, weighty, and urgent matters.

User-interface design is transforming itself from its origins in computer science and human factors, from concerns of utility and efficiency. In one sense, to use some global travel metaphors, our trip started in Zurich, traditional home of sensible, beautiful timepieces. We seem to be headed for Las Vegas, Hollywood, or even Bollywood, the Indian film capital, traditional home of emotional sagas drenched in well-known (to its audience) cultural stereotypes and soap-operatic plots.

Cuteness is one path for providing pleasure in user-experience design, whether we are talking about applications and documents (tools and content) for desktop client–server networks, CD-ROM standalone multimedia, Web-based access, mobile devices and information appliances, and vehicle user interfaces. Cuteness can become a commodity serving relentless commercialization that in the extreme, dehumanizes user experience, driving out variation in pursuit of megahit lowest-common-denominator success. The cult of cute is not in itself bad, but we need to

be aware and thoughtful about how to use it with moderation. As Newitz comments at the close of her article, "Ultimately, the problem is not "cute," but how and when we use it."

For some of you, this commentary may seem like a bizarre, paranoic, other-world warning. Keep this document around and check it in 1 year to see how things seem then. For others, you know who you are, cutie pies, we're keeping our eyes on you... ☺

5.5 Postscript 2015

Over the past decade, I have looked with wonder and amusement as the number of cute products has multiplied, especially in Asia. Today, in China, pop-up mobile Websites suddenly become available to announce job recruitment at a hot start-up or even a major technology company. All of the screens, the cartoon-like imagery, the playful nature of the screen designs are all related to graphic novels, Asian (Japanese, but increasingly other country's) *animé*, quite unlike similar artifacts in Europe or North America.

Cuteness engineering, if I may coin a term, will find increasing importance in user-experience development strategy. Combining science and technology with psychology, culture, graphic design, animation, and other design arts, will be a natural development especially in Asia where cuteness is culturally more acceptable. Already books are beginning to consider the issues of syntax, semantics, pragmatics, as in Grau and Veigl [5].

Like it or not, cuteness is cool and here to stay…for some.

References

Publications

Aoki S (2001) Fruits. Phaidon, London
Eco U (1979) A theory of semiotics. Indiana University Press, Bloomington. ISBN 0253202175
Eco U (1967) Travels in hyperreality.Harcourt Brace and Co., New York
Gelerntner D (2001) Computers and the pursuit of happiness. Commentary 111(1):31–35
Grau O, Veigl T (eds) (2011) Imagery in the 21st century. MIT Press, Cambridge, MA
Jordan P (2001) Designing pleasurable products: an introduction to the new human factors. Taylor and Francis, London. ISBN 0-748-40844-4
Marcus A (2001) A case study of Sabre. Inf Des J 10(2):188–206, 05/2001
Marling KA (ed) (1997) Designing Disney's theme parks: the architecture of reassurance. Flammarion, Paris. ISBN 2080136399
McCloud S (1993) Understanding comics. Tundra, Northampton
Moss M (2002) Hello kitty hello everything. Abrams, New York

Newitz A (2002) Why is everything so damn cute? The Fluffy-Bunny regime is getting ugly. San Franc Bay Guardian 38(17):20–21 ff, 23–29 January 2002

Norman D (1988) The psychology of everyday things. Basic Books, New York

Venturi R, Scott-Brown D (1972) Learning from Las Vegas. MIT Press, Cambridge

URLs

http://www.sanrio.com. The source of the Hello Kitty brand/philosophy/"religion"

http://www.almaden.ibm.com/cs/npuc2001. 2001 New Paradigms in Using Computers (NPUC) conference, held annually at IBM Research Laboratory in Almaden, California, near San Jose

http://www.graphic.esys.tsukuba.ac.jp/iwec2002/. First International Conference on Entertainment Computing held in Japan in May 2002

http://www.plastic.com. A cartoony "subterranean Web site" cited by [Newitz]

http://www.slashdot.org.A "cute on the outside but…prickly social criticism and snarky anti-corporate commentary" on the inside cited by [Newitz]

Chapter 6
User-Interface Design and China: A Great Leap Forward

6.1 Summary

If user-interface design seeks to encompass human-experience design, then computer-based communication and interaction designers need to keep Asian, and specifically Chinese users in mind. With approximately one-fifth of the world's population, an economy that is growing quickly, a manufacturing system that exports a significant percentage of the goods imported into the world's countries, China needs to be considered in revising concepts of user-interface and user-experience design.

© Springer-Verlag London 2015
A. Marcus, *HCI and User-Experience Design*, Human–Computer
Interaction Series, DOI 10.1007/978-1-4471-6744-0_6

6.2 Introduction

In recognition of the Fifth Asian-Pacific Computer-Human Interaction (APCHI-2002) conference which took place in Beijing 1–4 November, and certainly influenced by my current location in China as I write these words, I want to focus on some issues of user-interface design prompted by considering China.

China, as too few Westerners know, is a vast, complex country with great challenges but with enormous opportunities to affect many dimensions of world economy, culture, and communication. The country consists of five general regions that differ enormously by economic level, spoken language, and culture (Pei 2002). The wealthiest areas are along the eastern coast, where Western businesses historically have established centers of commerce and communication. Shanghai is estimated by some to become the largest city in the world by 2015 with 27.1 million people. Currently, China's exports have quintupled in the last 10 years, and the country's manufacturing facilities now produce over a significant portion of all goods imported into the USA. China now manufactures more than 50 % of the cameras sold worldwide (Leggett and Wonacott 2002). By 2004, China will surpass the USA in the number of Internet, cellphone, and landline subscribers (BDA Consultants, Gartner, Dataquest, IDC. MII).

I shall sidestep in this essay the enormously complex social, economic, and political issues of resolving Western notions of liberty, commerce, and individual freedom with their counterparts in China. Also, I shall not address the issues of the relations among the People's Republic of China (PRC), the Special Administrative Region of Hong Kong, and the Republic of China (ROC). I would like to focus in this publication's context on challenges and opportunities for the user-interface design profession to gain a better understanding of human experience as China joins in developing computer-based devices and communication systems.

6.3 Culture Dimensions and Cognitive Differences

One analyst of culture, Geert Hofstede, had to revise his study of IBM staff worldwide (Hofstede 1997) to account for differences in Asian countries influenced by Confucian philosophy, whose principles can be summarized thus:

- Stable society requires unequal relations.
- The family is the prototype of all social organizations.
- Virtuous behavior to others consists in not treating others as one would not like to be treated.
- Virtue in relation to one's task in life consists of trying to acquire skills and education, working hard, being frugal, being patient, and being persevering.

At the top of Hofstede's list of countries with a long-term time orientation is China, with a civilization that is more than 4000 years old, willing to wait a 100

years to retrieve the ownership of Hong Kong, and willing to wait longer to see if the USA, which is only a few hundred years old, remains the center of commerce and world popular culture.

Hofstede commented that most business management books are Western oriented and, while notably successful, are potentially biased and not entirely appropriate for all cultures, especially Eastern ones. A recent book, *Asian Wisdom for Effective Management* (Pheng 2001), attempts to adjust this cultural domination by informing the English reader of sources from Asian, especially Chinese texts. As the author comments, "The general principles of Western management theories and concepts are applicable in many societies except when cultural differences negate their relevance." User-interface design publications that attempt to account for Confucian contexts have finally begun to appear in the West, e.g., (Lee 2000).

More generally, Nisbett et al. (2001) have studied Asian *vs* Western thinking and concluded, as others have asserted or surmised, that each portion of humanity exhibits fundamental differences of philosophy or ways of knowing. One way to distinguish them is holistic *vs.* analytical thinking. In their study, the researchers asked Japanese and USA observers to describe what they saw in an aquarium. The Asians described relationships among the fish, gravel, and plants. The North Americans described the individual characteristics of the fish. The difference in approach could be summarized as one of relationship-orientation *vs.* object-orientation. They explain that Chinese and Greek thought tend to differ in their emphasis on these paradigms:

- Continuity *vs.* discreteness
- Field *vs.* object
- Relationships and similarities *vs.* categories and rules
- Dialectics *vs.* foundational principles and logic
- Experience-based knowledge *vs.* abstract analysis

These kinds of fundamental, systemic differences suggest that the user-interface design profession must give careful thought to how Chinese approaches to time, space, logic, communication, and interaction might impact user-interface design principles and practice. These fundamental differences would seem to have significant implications for the design of metaphors, mental models, navigation, interaction, and appearance, indeed, user-experience design in general. A few suggestions of these implications follow.

6.4 Metaphors

At the July 2002 IBM New Paradigms in Computing conference held annually at the Almaden, California, research center, Mr. Heiko Sacher of Point Forward, Redwood City, California (www.pointforward.com), demonstrated a Sony-Ericsson PDA prototype on which they had worked. What made this project special is that the designers developed this prototype with a clear understanding of Hofstede's culture

model and intended the product to take advantage of fundamental Chinese concepts for information, organization, and communication. Consequently, they rejected Western emphasis on applications (tools) and documents (plus folders) and instead emphasized the concepts of people, relationships, and wisdom (knowledge). Their focus group studies showed an acceptance value of over 80 %, implying that users found this new approach familiar, easy to understand, and comfortable.

6.5 Mental Models

In a study of Chinese and USA users, Choong and Salvendy (1999) noted significant differences of mental models between the two user groups. Through simple tasks of describing the contents of a house, they found that these Asian users tended to emphasize relationships, contexts, classification by interdependence within wholes, reliance on subjective experience without sharp differences of self *vs*. others or facts *vs*. concepts. These Westerners tended towards inferences, categories, classification by functions, analysis of components and inference of common features. Very interestingly, when they gave Chinese users mental models favored by the USA users, they found that the Chinese users would require longer performance times and were more likely to err. Similar results were found for USA users attempting to use Chinese organizations.

6.6 Navigation

Although the *Proceedings* of the APCHI 2002 conference contain many different articles on navigation and browsing/search strategies suitable for the Web and for hand-held, mobile devices, no specific paper focuses on specific differences of navigation strategies between typical Chinese and other groups. Nevertheless, these are likely to emerge in upcoming reports of research and practice. Kirstin Röse, who has published several papers studying intercultural differences (Röse et al. 2001, 2002; Röse and Zühlke 2003) comments that one difference in Web navigation seems to be a preference for many major destinations to be given at once up front, rather than a more step-by-step revealing of menu selections.

6.7 Interaction

Among other significant differences of user-interface design are the importance of tone-based spoken languages, such as Chinese, which place specific emphasis on the rising, falling, up-down-up, and "flat" tones of each sound representing the spoken form of characters. Recognition and display systems must account for these

auditory characteristics; in addition, experiments are being carried out to mark and display the emotional content of speech in addition to the basic tonal inflections (Tao and Jiang 2002).

Zhao et al. studied Chinese attitudes toward time using the culture model of (Hall 1969), which predicts that such Asian people are polychronic, that is, doing many things at once. They note that four factors influence Chinese workers in their attitudes toward tasks: individual character (introverts tend toward monochronic orientation and extroverts tend to polychronic orientation), traditional social systems, task types, and working environments. They found that the Chinese were more complex than predicted by previous classical models and that their behavior seems to be task dependent.

6.8 Appearance/Presentation

Many analysts of visual communication have noted significant differences in color associations and typographic reading strategies among the Chinese in comparison with Western counterparts. Chinese characters, long ago derived from pictographic signs, contains complex marks within a square format for each complete character. The writing system, which until recently was predominantly written in top-to-bottom, right-to-left sequence, has recently begun to change. The government has decreed that left-to-right, top-to-bottom, is preferred, and major newspapers have recently switched.

Dr. Wangli Yang, is Director of the Usability Research Center, Legend Holdings, Ltd, the largest Chinese information technology company, with 20,000 employees. At a special workshop she helped to organize at APCHI 2002 on usability issues, she commented that Legend has been studying cultural differences among Chinese users and has noted significant differences among five geographic regions of China: north, south, east, west, and central. She noted that users in Sichuan, a southern province, preferred stronger, more vibrant colors for products, while users in a northern province like Hebei, near Beijing, preferred more subdued colors. Detailed anthropological/cultural studies exist in China of the various regions, but these generally are published in Chinese and currently are not readily available to Westerners.

6.9 Conclusion

Major differences between Western and Asian, and specifically Chinese, ways of communicating and interacting pervade all aspects of daily life. It seems likely that studies done in China eventually will become known to Westerners. Western countries, eager to do business with the Chinese, will continue to investigate differences among Chinese, Western, and other Asian countries, as Siemens, Kodak, and Nokia, among others, have been undertaking. The monolithic mono-dimensional picture of

the Chinese, which has figured in many Western studies, will give way to more nuanced understanding that reflects the diversity and extent of Chinese culture.

In the late 1970s, I had an opportunity to work on a project to diagram global econometric planning models at the East–west Center in Honolulu, Hawaii, a center for technology and cultural exchange of Pacific Basin countries. I was astounded to learn that most of the models of the world's economy did not consider the economies of the Soviet Union and China, because at that time so little information was known, and the economies of these two great Communist superpowers were closed within themselves. Today, 25 years later, the world's economies are tightly intertwined. As many business and technology publications make clear, we cannot ignore the inter-relation of China with the rest of the world.

Likewise, the user-interface design community increasingly will need to exchange information with Chinese counterparts and take their experience into account when philosophizing, analyzing, and designing the computer-based human experience. Already, a SIGCHI China group is forming. Interested readers can contact Prof. Zhengjie Liu, Dalian Maritime University (liuzhj@dimu.edu.cn), for more information. This century will certainly see major shifts in knowledge, culture, commerce, communication, and interaction. The journey with China involved as a key player will be an exciting and rewarding adventure in the future history of user-interface design.

6.10 Postscript 2015

China: When I first looked out at this country in 1975, from a perch on an observation platform at the north end of Hong Kong, then a British colony on loan from China, who could have predicted the enormous changes in politics, economy, technology, and society that have prevailed in the following four decades? Well, apparently researchers and theorists were already at work peering into the future. When I became a Research Fellow at the East–west Center, Honolulu, in 1978, there were already many publications and pronouncements that the twenty-first century would center around the Pacific Ocean, not the Atlantic Ocean, and there was much prescient talk of the coming role of China. And so it was.

Today, many major developers in North America, South America, Europe, India, eastern Asia, and elsewhere always give some attention to China as a market, and as a competitor. What remains to be seen is whether Chinese developers will take the challenge of strong leaders like Prof. LOU Yongqi, Dean of the College of Design and Innovation, Tongji University, Shanghai, who are urging them to lead, not follow; to take advantage of China's long history, diverse peoples, and unique challenges, to innovate solutions in design as well as manufacturing. From this effort may emerge unique approaches to Chinese user-experience design. This very topic is covered in a paper by myself and a co-author (Marcus and Baradit 2015).

References

Blackman C (2000) China business: the rules of the game. Allen and Unwin, Crows Nest, NSW. ISBN 1-86508-230-9

Carroll JM (1999) Using design rational to manage culture-bound metaphors for international user interfaces. In: Proceedings of the international workshop on the internationalization of products and services (IWIPS 99), Rochester, New York, pp 125–131

Chao, Chen, Pocher, Thomas, Xu Y, Zhou, Roungang, Liu, Xi, Liang, Sheau-Farn M, Zhang, Kan (2002) Understanding the polychronicity of Chinese, In: Dai G (ed) Proceedings of the fifth asian-pacific computer-human interface conference, vol 1, Beijing, China, pp 189–196, 1–4 Nov 2002

Choong Y, Salvendy G (1999) Implications for design of computer interfaces for Chinese users in Mainland China. Int J Hum Comput Interact 11(1):29–46, Amsterdam: Elsevier

Hall E (1969) The hidden dimension. Doubleday and Company, New York. ISBN 0385084765

Hofstede G (1997) Cultures and organizations: software of the mind, intercultural cooperation and its importance for survival. McGraw-Hill, New York. ISBN 0-07-029307-4

Lee O (2000) The role of cultural protocol in media choice in a confucian virtual workplace. IEEE Trans Prof Comm 43(2):196–200

Leggett K, Wonacott P (2002) Surge in exports from China jolts global industry. Wall Street J, 10 October 2002, p A1ff

Marcus A (2002) Globalization, localization, and cross-cultural communication in user-interface design. In: Jacko J, Spears A (eds) Handbook of human-computer interaction. Lawrence Erlbaum Publishers, New York

Marcus A (2003) User-interface design and culture. Chapter In: Aykin Nuray (ed). Cross-cultural interface design [working title]. Lawrence Erlbaum Publishers, New York (in press)

Marcus A, Baradit S (2015).Chinese user-experience design: an initial analysis. In: Proceedings of the design, user experience, and usability conference, 2–7 August 2015, Springer-Verlag London, London, pp TBD (in press)

Nisbett RE, Peng K, Choi I, Norenzayan A (2001) Culture and systems of thought: holistic vs. analytical cognition. Psychol Rev 108:291–310

Pei M (2002) China's split personality. In: The five faces of China, World economic forum special issue of *Newsweek*, Fall-Winter 2002, pp 6–13

Pheng LS (2001) Asian wisdom for effective management. Pelanduk Publications, Selangor Darul Ehsan, Malaysia, 181pp. Web: www.pelanduk.com, ISBN: 967-978-746-X

Röse K, Zühlke D (2003) User requirements for human-machine interaction in Mainland China: an empirical study. In: Aykin N (ed) Cross-cultural interface design [working title]. Lawrence Erlbaum Publishers, New York (in press)

Röse K, Zühlke D, Liu L (2001) Similarities and dissimilarities of German and Chinese users. In: Johannsen G (ed) Preprints of 8th IFAC/IFIP/IFORS/IEA symposium on analysis, design, and evaluation of human-machine systems, Kassel, pp 24–29, 18–20 Sept 2001

Röse K, Zühlke D, Liu L (2002) Intercultural user-interface design for Mainland China: cost structure, localization model, and language issues. In: Dai G (ed) Proceedings of the fifth Asian-Pacific computer-human interface conference, vol 1, Beijing, China, pp 460–471, 1–4 Nov 2002

Schell O (2002) The coming collapse, Red Herring, November 2002, pp 34–35

Schell O (2002) Red star rising, Red Herring, November 2002, pp 44

Smith A, Chang Y, French T (2002) eCulture: quantifying cultural differences in website usability—two empirical case studies of Chinese and British users, In: Dai G (ed) Proceedings of the fifth Asian-Pacific computer-human interface conference, vol 1, Beijing, China, pp 210–221, 1–4 Nov 2002

Tao J, Jiang D (2002) Prototype of environment awareness emotional Chinese speech synthesis. In: Dai G (ed) Proceedings of the fifth Asian-Pacific computer-human interface conference, vol 1, Beijing, China, pp 693–98, 1–4 Nov 2002

Chapter 7
Universal, Ubiquitous, User-Interface Design for the Disabled and Elderly

7.1 Summary

User-interface design seeks to improve all human-computer communication and interaction. Increasingly, solving challenges for the disabled and elderly must be accounted for. Experience gained can help solve fundamental challenges for the general population of user. A recent international conference in Japan, Universal Design, catalogs the accomplishments and work to be done in this worldwide arena.

© Springer-Verlag London 2015 47
A. Marcus, *HCI and User-Experience Design*, Human–Computer
Interaction Series, DOI 10.1007/978-1-4471-6744-0_7

7.2 Introduction

How many of you have friends or relatives that are seriously disabled or of advanced age? Chances are you know someone or may be in frequent contact with someone in either category. In the CHI community, we often tend not to make either a center of study; we focus more typically on youth, speed, early adapters of constantly changing technology, etc. Yet, some occasions in life remind us or awaken us to pay more attention to more diverse groups of people. I had such a "wake-up call" through the fortunate circumstance of being invited to participate in the First International Conference for Universal Design in Japan, 30 November – 4 December 2002, which took place in Yokohama (Universal Design Japan Conference).

For the first time ever in my own experience at a major design gathering, and certainly for user-interface design gatherings, there were many, many people, whose physical movement, physical senses, were dramatically compromised. My own reactions to being in their presence covered a typical gamut and sequence: nervousness, embarrassment, pity, then awe, respect, and after a while, simply the enjoyment of being in their presence and the gradual "normalization" of communication and interaction through greater familiarity.

The conference, organized by Dr. Satoshi Kose, Senior Research Fellow, Building Research Institute, Japan, and his committee, is a follow-on to several previous international universal design conferences in 1998 and 2000 sponsored by Adaptive Environments, an educational non-governmental organization. The next universal design conference will be in Havana, Cuba, January 2004 (for further information, contact Adaptive Environments (Universal Design Japan Conference)) and will focus on relating technology to developing nations, where 80 % of the people with disabilities live.

7.3 What Is Universal Design?

The topic of universal design, in this context, user-interface design for the disabled and elderly, is not a new one in *Interactions'* and CHI's record of concerns. However, time and technology make this a fitting moment to focus our attention. The Universal Design conference in Japan, attended by more than 500 people from 30 countries, was notable, among other things, for its having the full personal, and thereby governmental support, of Crown Prince Tomohito, and for its citing 29 corporate sponsors, an enviable list that CHI and other conferences would appreciate, including Fuji Xerox, Fujitsu, Hitachi, Mitsubishi, National/Panasonic, NEC, NTT DoCoMo, Ricoh, Toshiba, Toyota, and Victor/JVC. Clearly, these corporate groups have heeded the call and recognized the economic good sense of paying attention to the needs of these user groups.

I want to focus on some facts and issues of user-interface design for the disabled and the elderly prompted by considering the presentations at this conference. I refer

to remarks of several invited speakers because their presentations do not appear in the prepared *Proceedings* CD-ROM available from the conference organizers.

Two keynote speakers Valerie Fletcher, Executive Director of Adaptive Environments, Boston, and Roger Coleman, Head of the Helen Hamlyn Research Center, Royal College of Art, London, surveyed trends from a North American and European perspective and included global data in their remarks. Although data are hard to cross-compare among nations because of different definitions of disabilities and/or lack of data collection until relatively recent times, some important observations nevertheless could be made.

In the past, it seems, Scandinavia and Japan have been leaders, along with some groups in the USA, in calling attention to design for the disabled and elderly. The universal design movement started in the USA; in Europe, the movement is called universal access or usability for all. However it is called, considerations of demographics alone will bring this subject inevitably, and unavoidably, to the front burner of professional attention elsewhere. The heritage of better medicine and relative world peace means that people are living longer in many countries. Today, Japan leads the world in the percentage of senior citizens, about 25 %. By 2050, about 30 % of Japanese may fall into that category, and other countries in Europe and North America will be where Japan is today (India is estimated to be an exception, with only 15 % elderly). Several effective presentations about the elderly at the conference included a dramatic visual display of the inevitably increasing number of disabled among a population as age increases. No wonder Japanese corporations are concerned about developing mission statements, philosophies, principles of practice, and lines of products/services targeted to the disabled and elderly.

A basic economic message promoted by the universal design movement is that goods designed inclusively for all people inevitably lead to products and services that benefit not only the original target markets but other, mass markets as well, meaning that the price of the products and services can drop dramatically. An Assistant Director of MITI, the Japanese governmental agency responsible for promoting and managing technology development in Japan, spoke about how Japan's industry is internationally famous for making products smaller, cheaper, lighter, and faster. MITI is now committed to helping Japan manufacturing produce easier products to use for all people. MITI funds R + D to measure the human senses in ways that support manufacturing, and it explores means to facilitate development processes that help produce products and services that do not make people feel inferior or embarrassed.

In the past, universal design has focused on "barrier-free" design, but several speakers spoke about promoting a wider and deeper approach that brings universal design concerns more into the realm of most designers for most people, not just exotic techniques for a specialized target market. One of the primary challenges for universal design seems to be to sell the return-on-investment (ROI) so that it makes sense to mainstream manufacturers of software and hardware. With some attention, it seems likely that one can make this case effectively building on previous ROI work (see my recent article summarizing the ROI literature for user-interface usability as a start).

Intriguing products were to be found in the exhibit area, including a working NTT DoCoMo mobile phone that automatically displays Japanese hand-sign communication based on a conversion from spoken or written input Japanese text using software developed by Hitachi. Other exhibits showed unique, high legibility and readability fonts and mobile phone with large-size fonts, all of which are designed for those with limited vision, such as persons with macular degeneration.

7.4 Section 508

Mr. Ken Nakata (Nakata), Senior Trial Attorney at the US Department of Justice, Washington (ken.s.nakata@usdoj.gov), another invited speaker at the Universal Design Japan conference has worked extensively on litigation, investigations, and policy involving the Americans with Disabilities Act (ADA). His presentation summarized US disability rights, laws, and information technology.

The ADA laws affect private businesses as well as governmental organizations, while Section 508 affects only the Federal government. However, the fact that Section 508 affects the development, maintenance, and procurement of all electronic and information technology (EIT) used by the Federal government has made it snap to the full attention of software and hardware developers who hope to sell to the Federal government. The Federal government alone buys 10 % of all EIT produced in the USA. Of importance is that complaints and discrimination lawsuits are now filable by citizens regarding technology procured after 21 June, 2001. Such lawsuits may require replacement of expensive technology. He cites these examples in a presentation handout:

Example 1 A large Federal agency buys a new email and electronic document system for $100 million before June 21, 2001. The system is completely inaccessible to people with disabilities, and the agency has an employee who cannot use the system for her job. Assume it would cost less to replace the whole system with another $100 million system than to make it accessible. The agency would probably not have to fix the system as a "reasonable accommodation" to the employee, but it may have to provide individual assistance to the employee.

Example 2 Same facts as Example 1, but the system was procured after June 21, 2001. In this case, Section 508 may authorize a lawsuit to replace the entire system.

Mr. Nakata also provided some detail about the relation of Section 508 to ADA and provided some case examples to clarify what might/might not be covered in relation to Website design. The opinions of the US Department of Justice, that the Internet activities of private business are subject to the ADA, is available on the Web, as noted in the Bibliography.

In general, Section 508 creates a strong incentive to make more usable, useful products. The hope of government planners is that section 508 requirements will

become familiar to most developers and become mainstream attributes of accessible, usable products and services, to the benefit of all consumers.

7.5 Other Resources

If you moved to inform yourself about all of the opportunities and challenges, there are many resources to which to turn. You may wish to begin with a search through the *Proceedings* of the Universal Design Japan conference as well as past issues of *Interactions* and CHI conference *Proceedings*. Consider, also, relevant proceedings from previous Universal Design conferences, and those of the well-known and well-attended California State University at Northridge conferences for the disabled, which regularly attracts about 4000 people. Also, check the appropriate chapters of compendia such as the two separate *Handbooks of Human-Computer Interaction* edited by Helander et al. (1997) and by Jacko and Sears (2002), in addition to *User Interfaces for All*, edited by Stephanidis (2001). Naturally, a Web search engine query will return you countless hits, but these are good places to start with a focus on user-interface development issues. One other more general resource in the USA to note is the Berkeley Center for Independent Living, which has been a pioneer in enabling the disabled to live full lives and in the process has pioneered many innovative social and technological techniques. All of these specific resources are cited in the Bibliography.

7.6 Conclusion

In her moving remarks at the conference, Valerie Fletcher commented that universal design must come to mean design for all people, not just "special" people with unique needs. We are all vulnerable at some point in our lives, we are all going to age, and many of us will become significantly limited in our physical and mental abilities in that process. She states that the only realistic stance toward inclusion for people with disabilities is to identify a design framework that applies to *everyone*. Special solutions are inevitably too costly and potentially discriminatory. Universal design anticipates diversity of ability and results in sensible, efficient, and realistic solutions for user-interface design. She urges sharing awareness and information now, so that we will have an opportunity to avoid perpetuating discrimination by design and integrate solutions into development.

Time is flying, technology is marching onward relentlessly toward ubiquitous, networked, "smarter" objects and associated services for communities of all kinds. It's not too late to start now to inform yourself and to get to work developing the future of ubiquitous, *universal* user-interface design. Consider it an investment in your own future self, as well as profitable and beneficial activity for humankind.

7.7 Postscript 2015

As our population continues to age, with more and more people exhibiting conditions that require special treatment, it seems likely that solving successfully user-experience design challenges for the less able population will continue to flourish. More than likely, also, is the benefit to the majority of the population from solutions for the minority with special needs. In the other direction, solutions may become popular for the general public that make things easier for the less-able population.

One interesting area of development is the rise of voice-operated systems, which, with verbal replies, replace, for the moment, graphical user interfaces, or GUIs. The decades-old graphical user interface has always been a stumbling block for those with limited vision. Apple's Siri-related functionality, which was developed initially at Stanford Research Institute (SRI) in a US Defense Department-funded (DARPA) effort, has popularized this approach. We can expect to see more, especially in relation to the management of robots, wearables, vehicle systems, and home appliances.

References

Adaptive Environments. http://www.AdaptiveEnvironments.org

California State University/Northridge (CSUN) Center for disabilities and conference proceedings. http://www.csun.edu/cod/

Center for Independent Living. Berkeley, California, USA. http://www.cilberkeley.org/

Helander M, Landauer TK, Prabhu P (eds) (1997) Handbook of human-computer interaction. Elsevier Science, B.V, The Hague. ISBN 0-444-4828-62

http://www.csun.edu/cod/conf/2002/proceedings/csun02.htm

Jacko J, Andrew S (2002) Handbook of human-computer interaction. Lawrence Erlbaum Publishers, New York

Marcus A (2002) Return on investment for usable UI design. *user experience*, usability professional association's magazine, 1:3, Winter 2002, pp 25–31. http://www.upassoc.org

Nakata K, Mr., Senior Trial Attorney at the US Department of Justice, Washington (ken.s.nakata@usdoj.gov). Briefs related to internet, the ADA laws and private business are to be found at http://www.usdoj.gov/crt/app/briefs.htm

Stephanidis C (ed) (2001) User interfaces for all: concepts, methods, and tools. Lawrence Erlbaum Associates Publishers, New York, p 728. ISBN 0-8058-2967-9

The Helen Hamlyn Centre. Royal College of Art. http://www.hhrc.ac.uk

Universal Design Japan Conference. http://www.ud2002.org/en/program/prog.htm

Chapter 8
Icons/Symbols and More: Visible Languages to Facilitate Communication

8.1 Summary

Graphical user-interfaces rely on visual signs, that is, icons and symbols, to speed communication, take up less visual space, and provide a distinctive visual style for products and services. Are icons/symbols being used effectively? Can they help improve human communication? Some proposed systems, like LoCoS, seek to develop additional forms of universal communication, like a visual Esperanto. What is the future for icons and symbols? Read on…

© Springer-Verlag London 2015

A. Marcus, *HCI and User-Experience Design*, Human–Computer
Interaction Series, DOI 10.1007/978-1-4471-6744-0_8

8.2 Introduction

Icons and symbols have been part of the user's experience of computing for decades, and many people tend to take them for granted as part of graphical user interfaces. But they weren't always there. The Apple Macintosh popularized "icons," as the slightly incorrect term for these visual signs, and by the mid-1980s they became part of the graphical user interface paradigms and associated with the desktop metaphor. Windowing environments like the Macintosh, Windows, Open Look, Motif, Next, and other desktop/workstation platforms all adopted variations of the Trash icon, Folder icons, Document icons, and specific Application icons. Today, most work or play environments include (some might say are littered with) 50–100 icons. As I write these words, in fact, I counted about 75 such visual signs currently on my screen. Is this good or bad? As user-interface designers, I think we care about their quality and use as part of our user-interface development responsibilities. I think they will be increasingly important in the years to come. Let's take a closer look at their current status and probable future.

8.3 What Are the Differences Among Signs, Icons, and Symbols?

I've mentioned icons, symbols, and signs. What's the difference. It depends on which definitions you adopt. For decades, I've used a set of terms adapted from semiotics (see Eco 1976; Peirce 1933; Marcus 1992), which might be summarized as the following:

- *Icons:* signs that are self-evident, "natural," or "realistic" for a particular group of interpreters, like a photograph of a person, a "realistic" painting, or a right-pointing arrow to indicate something should move or is to the right.
- *Ideograms:* symbols that stand for ideas or concepts, for example, the letter "i" standing for "information" or "help desk" or "information available"
- *Index:* a special semiotics term for signs that are linked by cause-and-effect in space and time, like a photograph representing a scene, or a fingerprint on the coffee mug at the scene of the crime.
- *Lexics:* the attributes of how one produces signs, for example with color or black-and-white raster-scan displays.
- *Pictogram:* an icon (or sometimes symbol) that has clear pictorial similarities with some object, like the Person or Men's Room sign that (for some interpreters) appears to be a simplified drawing of a (specifically, male) human being.
- *Phonograms:* symbols that stand for sounds, for example, the letter "s."
- *Pragmatics:* the uses of signs by receivers, including their emotional, cognitive, and behavioral characteristics, for example, how memorable or appealing the signs are.

- *Semantics:* the reference of a sign to some object, structure, process, or concept; often referred to popularly as its "meaning," like a dictionary definition, or its denotations and connotations.
- *Semiotics:* the science of signs. One might call designing icons and symbols "applied visual semiotics."
- *Signs:* perceivable (or conceivable) objects that convey "meaning."
- *Symbols:* signs that are usually meaningful by convention, and are often abstract, like the very letters of this sentence, or a national flag.
- Syntax: the arrangement of signs in space and time, especially their visual attributes such as color, size, shape, etc.

These terms may seem a bit daunting, but they allow us to talk about signs, icons, and symbols in a more straightforward, unambiguous way.

8.4 Signs of the Times

Looking backwards, let's recall that the Macintosh began with a corporate suite of approximately 250 icons. In the early 1980s, many software developers did not understand enough about the sign development process to realize that they would eventually have a significant visual-assets management challenge. During 1982–1985, when we first started designing icons for computer-aided design and manufacturing applications, it was not unusual for companies to brag that they had somewhere between 5000 and 15,000 signs (they sometimes were not sure of the exact number and had no easy way to find out) in their suite of tools. Keep in mind that Basic Chinese is approximately 3000 signs, and that set of signs developed over millennia. Software developers were designing two to five times this number in a few years. It doesn't take a rocket scientist to figure out that many of these signs were poorly designed. To be more specific: illegible, unreadable, with poor usability (efficiency, effectiveness, and satisfaction) with poor internal system-consistency (visual syntax, semantics, and pragmatics).

In general, we calculated that it would take 3–4 h to design a single sign, depending upon its semiotic complexity. Often our clients thought it should take about half an hour from the price they were willing to pay for sign design. In fact, I recall that Digital Equipment Corporation did an in-house study of how much it cost to develop one sign in the late 1980s and found that a reasonable cost, including all those involved in planning, analyzing, designing, evaluating, implementing, etc., was $2000 per sign. If it really had taken a short time to design them, this would have implied a very luxurious hourly rate then indeed.

Gradually the status of icon and symbol design in the industry has improved and become more sophisticated in terms of multimedia aspects and extent of use of signs. High-resolution color displays capable of animation and sound have made icons and symbols multimedia extravaganzas in some cases. Many specialists have

emerged. Blattner et al. (see Blattner et al. 1989; Bly 1982; Gaver 1986, 1989) were among some of the early CHI researchers in the 1980s who investigated and wrote about the use of sound and specifically "earcons," that is, auditory signs associated with visual displays. In some cases, these sound characteristics have become routine experiences for mobile phone user-interfaces and corporate branding (think of the elaborate ringing melodies to distinguish different callers and the Intel "Pentium Inside" four-note signature).

Today, icons and symbols are pervasive across most platforms (client-server, Websites, and Web-based applications for workstations, desktops, mobile devices, appliances, and vehicle systems). For better or worse, most computer users must master as novices an astonishing array of signs. Undoubtedly analysts have studied how many signs an average consumer must know, how many they understand well, and how many they can remember and use well in a given context, and how these metrics change across age, gender, language skills, education, culture, emotional stress level, among other factors. There are many factors that are worth studying further, and I call attention to the humble icon or symbol as a subject deserving of further study, with a likely return on investment.

Some current trends and issues that I have noticed with current icon/symbol design are the following:

Their pervasive use, especially in small sizes, has tended to result in many icons having highly informative parts that are too small to be easily recognized or distinguished. A miniaturized document sign may be part of another more complex sign, all of it being displayed within approximately 16×16 pixels. Even with significant color depth, the resulting visual form is too demanding of our eyes and mind, especially for older viewers.

Another trend is large, overly complex signs that are somewhat overdone. As an example, I have in mind the Apple Macintosh X icons/symbols, that almost seem swollen or bloated in their visual design qualities, a far cry from the sleekness of Apple products in the past and minimalist styling of the Titanium series of portables. The Macintosh X "icon bar" actually does swell with animation as the cursor rolls over a particular sign. Together with other visual characteristics of user-interface elements such as window detailing, scrollbars, buttons, etc., the overall effect is one of obesity. Perhaps this is a hold-over of the excesses of the dot-com era of the late 1990s. The "lean and mean" 2000s may bring us an entirely different style harking back to some of the styles of earlier decades.

Still another interesting trend is the emergence of widely used "emoticons" among Japanese users of mobile phones, who are quite happy to select from a complex palette to enhance their text messages beyond the Japanese or Roman letterforms that typically are used. This trend takes the smiley face to the next level. We already see the use of creative text usage, like "U R Cute 2" to enable youthful paramours to communicate effectively. The widespread use of what I have called "baby faces," that is, user-interfaces with small screen displays, makes the space-saving, denotation- and connotation-rich use of new kinds of signs like these emoti-

cons naturally desirable and effective. The likelihood is that written language will move "fast forward" to a form of the past, the rebus, which is a mixture of alphanumeric and other visual signs.

The likely value of advanced visual sign systems for professional users in health/ medicine, finance/banking, travel/transportation, and education/training, among other markets, seems self-evident. Many professionals already use specialized sign systems, like the electrical engineer, architect, medical pathologist, or stock-market analyst. The challenge with widespread, ubiquitous small-scale, portable mobile displays to take advantage of well-designed new sign systems, especially in conjunction with information visualization forms (tables, forms, charts, maps, and diagrams) is daunting, but also enormously invigorating for both the developer and the user.

8.5 Universal Sign Systems

As we move forward to the future, it is worth taking a look at the past, and at other cultures. Many intriguing experiments or actual exotic systems in use may prove extremely useful, practical, and appealing. In some ways, these may be forms of, well, if not "killer apps," then "killer sign systems."

Let's not forget the standards proposed for worldwide mass transit and mass communication systems. These have been codified and published widely (see AIGA 1981; Olgyay 1995; Ota 1987, among others). In addition to the current technical sign standards proposed by the International Standards Organizations based in Geneva (International Standards Organization) and the various national organizations in the USA, Japan, Germany, and elsewhere, there are international designed standard signs available from many manufacturers and published in various media (see Pierce).

One particular set of design inventions are those of universal visible language sign systems, that is, systems intended to supplement (or zealots would say replace) traditional systems of writing, which tend to be quite idiosyncratic amalgams of signs, except for a few more rational approaches that have occasionally occurred in history. An example is Korean Hangul, which was created in the 1700s by fiat of the emperor, who grew tired of his people using Chinese symbols to represent Korean speech sounds and commanded to be developed a system that "even a fool could learn in a short period of time." He succeeded.

Throughout history, developers of language systems have been intrigued by universal writing systems, called pasigraphy. These universal sign systems were especially popular after the Renaissance. Books detailing the many attempts to design and implement these systems exist (see Wilkens and Harrison). More recent examples of proposed universal, visible-language sign-systems include the inventions of two innovators, who sought to develop something like a visual Esperanto (a previ-

ously proposed and partially implemented universal spoken language). These visible language systems provide systematic means of depicting nouns, verbs, adjectives, adverbs, numerical, spatial, and temporal components, more or less like natural spoken languages. They may, or may not have systems of pronunciation.

C. K. Bliss from Australia in the early 1940s (Bliss 1965) invented his Blisssymbolics, a system he called Semantography, a "logical writing for an illogical world." He tried, but failed, to get the United Nations to recognize his system. Bliss symbols have been incorporated into interactive computer-based systems that are able to help mentally disabled patients communicate better, for example, those with aphasia, who have difficulty communicating using words.

Another example is that designed in the 1960s by Yukio Ota, a Japanese graphic designer, who invented the system called LoCoS, standing for Lovers Communication System (Ota 1973), a charming reference to one of the hopes for both of these inventors: improving human communication among those who do not speak the same natural spoken language, thereby helping to reduce misunderstandings and promoting world peace.

Mr. Ota has demonstrated around the world over the past decades that his system can be learned in one day and has published books and many articles about the system, although most of the publications are in Japanese. Because of my interest in this system, our firm has arranged with Mr. Ota to mount a Website devoted to his system. If you are interested, you can visit http://amanda.com/locos/ where you can find information about the inventor, the sign system, and see examples of its use.

8.6 Conclusion

I believe that novel and systematic approaches to the use of visual sign systems are needed to help make baby faces successful, especially for the emerging wrist-top devices. Fossil, a well-known manufacturer of wristwatches has ported the Palm operating system to one, and IBM announced some time ago their porting of Linux to a wrist-top device. To be truly useful, these small devices will need to master the use of small areas of display and to combine that skill with the use of sound for input and output and of hard buttons on the body of the device.

Another major new area for sign development is vehicle user interfaces. A revolution has begun in the world-wide platform for automobiles, trucks, and other vehicles as they acquire advanced telematics, become hubs for communication, are connected to the Web, mix informational with other forms of communication (persuasive and esthetic/entertainment), and have flexibility of visual display unlike anything preceding it. New forms of visual signs are likely to play a role for status

displays and information visualization in general, as we have indicated in a recent article (Marcus 2002).

The signs, if you will excuse the pun, are everywhere for the increasing importance for good visual sign development. In the future, all phases of planning, research, analysis, design, implementation, evaluation, documentation, and training, especially regarding information visualization and localization per language group and culture, will provide some exciting opportunities. Perhaps someone's name will go down in history as the developer of a breakthrough approach that becomes named after her or him. Nowadays, you don't have to be an emperor to have this happen, you just need to be a winner in the commercial marketplace of ideas, products, and services.

In the meantime, through visible language systems, if we help improve the chances for world peace through better visual communication, well, that's not too bad, either, on your resumé. Perhaps you may also get a Nobel Peace prize for good visual communication in user-interface design.

8.7 Postscript 2015

As with the topics of other chapters, the growth in the number of visual signs, icons, and symbols (to cover all kinds) continues unabated. Keep in mind that there are also acoustic or sonic signs as well, which continue to flourish, like the sound of a vehicle backing up to warn pedestrians in its path, or some sonic warnings at crosswalks to advise the hard-of-seeing whether the light is green or red. On mobile devices, sonic cues, as well as tactile cues, advise us of SMS messages, email messages, or phone calls arriving.

The use of these signs may vary for different ages of users, cultural preferences, technology platforms, even gender differences. I recall a local newspaper's articles and letters from readers debating whether grown men should include many emoji's (emotional, playful signs) in their business and personal communication. I believe the consensus was that it was OK, and perhaps desirable to get the men to be more expressive... ☺ ...

It would be interesting to track the growth of new signs, including age, gender, national, cultural, and religious differences/similarities, and to display the results visually in some kind of chart, map, and/or diagrams. Perhaps someday big-data resources will make such information practical to collect and to communicate, so that we can watch our own usabe of these usable, useful, and appealing signs (Fig. 8.1).

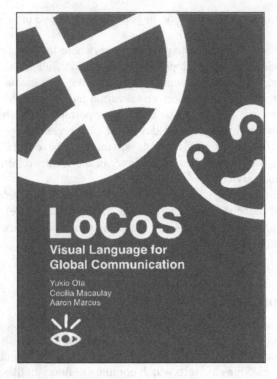

Fig. 8.1 Cover of recently published English version of Ota's LoCos (Ota 1987) (Source: Image and cover design by Aaron Marcus and Associates)

References

AIGA (American Institute of Graphic Arts) (1981) Symbol signs. Hastings House Publishers, New York

Blattner M'e, Sumikawa D, Greenberg R (1989) Earcons and icons: their structure and common design principles. Hum Comput Interact 4(1):11–44

Bliss CK (1965) Semantography. Semantography Publications, Sidney

Bly S (1982) Presenting information in sound. In: Proceedings, human factors in computer systems conference, Gaithersburg, 15–17 Mar 1992, pp 371–375

Buchler J (ed) (1955) Philosophical writings of peirce. Dover Publications, New York (Chapter 7 of this book summarizes Peirce's theory of semiotics.). ISBN 0-486-20217-8

Eco U (1976) A theory of semiotics. Indiana University Press, Bloomington. ISBN 0-253-35955-4

Gaver WW (1986) Auditory icons: using sound in computer interfaces. Hum Comput Interact 2(2):167–77

Gaver WW (1989) The SonicFinder, an interface that uses auditory icons. Hum Mach Interact 4(1):98–110

Harrison RK (2002) Bibliography of planned languages (excluding Esperanto). http://www.invisiblelighthouse.com/langlab/bibliography.html. 3 Mar 2003

International Standards Organization. Geneva, Switzerland. http://www.iso.ch/

Marcus A (1992) Graphic design for electronic documents and user interfaces. Addison-Wesley, Reading

Marcus A (1996) Icon and symbol design issues for graphical user interfaces, Chapter 13. In: del Galdo EM, Nielsen J (eds) International user interfaces. Wiley, New York, pp 257–270. ISBN 0-471-12965

Marcus A (2002) Advanced vehicle user-interface and information-visualization design. Inf Vis J 1:2, 9 Sep 2002, Palgrave Macmillan, United Kingdom, pp. 95-102

Marcus A, Smilonich N, Thompson L (1994) The cross-GUI handbook for multiplatform user interface design. Addison-Wesley Publishing Company, Reading

Olgyay N (1995) Safety symbols art. Van Nostrand Reinhold, New York

Ota Y (1973) LoCoS: lovers communication system (in Japanese). Pictorial Institute, Tokyo

Ota Y (1987) Pictogram design. Kashiwashobo, Tokyo. ISBN 4-7601-0300-7

Ota Y, Macaulay C, Marcus A (2013) LoCoS: visual language for global communication (in English). eBook, Amazon.com

Peirce CS (1933) Existential graphs. In: Hartshorne C, Weiss P (eds) Collected papers of Charles Sanders Peirce, vol 4, The simplest mathematics, Book 2, Chapters 1–7. Harvard University Press, Cambridge, pp 293–470

Pierce T (1996) The international pictograms standard. Design Pacifica International, Portland, 218 pp (book and CD-ROM).. ISBN 0-944094-22-8

Wilkins BJ (1614/1672) Developed a universal writing system. http://victorian.fortunecity.com/vangogh/555/Spell/wilkins.htm. 3 Mar 2003

Chapter 9
What Do UI Designers Think About Protecting Their Designs?

9.1 Summary

User interfaces are intellectual property that can be protected. Do designers know what the rules are? Do they care? A survey of professionals looks at what they think.

9.2 Introduction

As more and more computer-based products and services become available to global markets, intellectual property (IP) protection of user interfaces (UIs) appears likely to become more challenging. IP protection for UIs was once a hot topic in the CHI community, and a CHI 1989 plenary panel debated the topic. Professor Pamela

© Springer-Verlag London 2015
A. Marcus, *HCI and User-Experience Design*, Human–Computer
Interaction Series, DOI 10.1007/978-1-4471-6744-0_9

Samuelson, chair of that panel and now a teacher of IP protection at the University of California at Berkeley, tutored and lectured at CHI conferences. Lately, however, the topic appears to have dropped from the attention of designers just as the Internet has made it easier to copy others' IP, and as the legal and business development departments of corporations have taken over most of the activities of IP protection, maintenance, litigation, and bartering of patents via cross-licensing. I reviewed approximately 5,500 pages of conference proceedings from ACM SIGCHI's CHI 2001 and 2003, Human-Computer Interaction International's HCII-2001, ACM Special Interest Group on Graphics and Interaction's SIGGRAPH-2001, and Interact 2001. Almost *no* papers, tutorials, or panels on the subject of IP protection appeared in *any* these proceedings. Nevertheless, attention to IP protection remains crucial to businesses and designers wishing to protect their efforts. Just look at the music industry.

Intellectual property protection of UIs in the United States consists primarily of patent and copyright protection. Patent protection consists of function patents and design patents. Function patents concern the protection of utilitarian ideas only, and design patents protect not only a functional invention but certain appearance characteristics (primarily visual) that are inherent to the artifact's novel invention. Copyright refers to protection of the actual textual, graphical and visual, and sonic attributes or expression of the words, images, and music of artifacts. Although registered design patents exist and are available on the Web from the U.S. Patent and Trademarks Office (USPTO), examples of rights being exercised and legal actions or court precedents under those design patents are more difficult to find.

As a part of its then ongoing objective to improve its own patent examination and award processes, the Japan Patent Office (JPO), Tokyo, Japan, through the Institute of Intellectual Property (IIP), Washington, DC, contracted with my firm to survey current UI designers, mostly in the United States, about UI design patent protection. The survey sought to include a variety of orientations to vertical markets, user communities, platforms, technologies, and sizes of design groups. Questionnaires were sent to approximately 55 recipients. Below are summaries of the nine replies.

In the following questions, "image designs indicated on a display screen" include user-interface components such as status displays and controls. Others might refer to these items as *composite examples of metaphors, mental models, navigation, interaction,* and *appearance.* Excluded are specific typefaces (font design protection was not being considered) or particular pieces of content such as a game or a movie.

Selected questions follow, along with summary comments. The full replies appear as a white paper available at http://www.AMandA.com.

9.3 Respondents

The respondents varied in backgrounds and current employment, from academia to industry, from small firms to large firms.

- Michael Arent, Manager, Web Customer Experience, Adobe Systems, Inc.
- Nuray Aykin, Senior Consultant, User Interface Design Center, Siemens Corporate Research, Inc.
- Prof. Ron Baecker, Professor of Computer Science and Director of the Knowledge Media Design Institute, University of Toronto (at the time of the survey, also President, Expresto Software, Inc.)
- Tony Brown, Ph.D., Founder and Director of Usability Engineering, SoftPlex, Inc.
- Hugh Dubberly, Principal, Dubberly Design Office
- Jim Faris, Principal Designer, Design Hat
- Austin Henderson, Director, Systems Laboratory, Pitney Bowes, Inc. (at the time of the survey), later, President, Rivendel Consulting and Design, Inc.
- Paolo Malabuyo, User-Interface Lead, Xbox Group, Microsoft Corporation
- Anonymous Respondent, Usability Researcher, U.S. Corporation

9.4 Survey Questions

9.4.1 Question 1: Screen Examples

Please state concrete, current, or recent examples of image designs indicated on the display screen on which you have worked or about which you know significant details of development.

The respondents provided a wide range of examples. Some respondents felt that emphasizing images alone seemed a limited, or "weak," approach to capturing the creative input of designers. This factor seems to be an inherent weakness of design-patent philosophy: Visual form and associated behavior is understandably emphasized, but the nature of the behavior, as well as other perceptual and conceptual attributes, are sometimes not well captured in individual images, text descriptions, and even patent documentation. Specifically, the user-interface components that may be used as essential conceptual constructs to describe user interfaces (metaphors, mental models, navigation, interaction, and appearance) seem to be underserved by the current orientation of design-patent terminology.

9.4.2 Question 2: Creating the Designs

Who creates image designs indicated on the display design: designers exclusively belonging to your company and/or your engineers, or do you outsource the design process?

The respondents who replied were split almost evenly between in-house staff and outsiders. Naturally, in-house staff as well as outsiders must be covered by appropri-

ate employment contracts, which usually stipulate that designs become the property of the employer. In many cases, corporations give some acknowledgment or even grant outsiders co-inventor status in patent applications (as noted by Arent), but they are often excluded from any specific financial remuneration.

9.4.3 Question 3: Planning for Protecting Images

Do you plan for protection of image designs indicated on the display screen?

Most respondents who are members of small design or consultancy service firms remain outside the intellectual property protection task or phase, which is usually handled by their corporate clients. One respondent (Faris) refers to assisting the client in the application process. In fact, some corporate clients attempt to bind small design or consultancy firms to obligations to provide necessary documents for or spend time preparing intellectual property protection applications (notably for utility patents or design patents), although no respondent specifically refers to this matter. Respondents who are members of corporate firms stated that their corporate firms took appropriate action, presumably business and legal departments, although this was not specifically stated.

No respondent referred to being asked to participate in patent searches as part of the design process. Although it cannot be strictly logically inferred, it seems likely (as is the case for my own firm) that designers are not asked to do such searches and are not paid to do such searches or to cause them to be done. It may be the case that the outside designers may have been subjected to liability clauses in their contracts even though the client does not support the budget to determine if some infringement might be likely. Instead, designers are often assumed to be developing new, innovative material not infringing on others. In my experience, some corporate contracts try to include outside contractors in legal liability as "partners" should something go wrong, but deny them the financial benefits should the product or service be successful (that is, no royalties, reuse benefits, or other success-based remuneration is established).

Also, no outside firm mentions being included in a royalty payment agreement related to ownership of the designs, and hence increased liability and likelihood of desire for intellectual property protection by the outside design firm.

9.4.4 Question 4: Image Imitation

Are there any cases that you are aware of in which your image designs indicated on the display screen were imitated?

Almost half the respondents have experienced some form of copying. Only one of these cases seems to have reached legal or financial settlement (in Faris's example, out of court). It appears likely that some in-house designers, most external

designers, or designers who have moved on from their earlier positions, might not be aware of the actual legal history of their designs, unless they become unusually newsworthy.

9.4.5 Question 5: Design Protection Under Design Patent

Do you think that image designs indicated on the display screen are properly protected under design patent?

Many respondents seem to have little or no detailed understanding of design patent protection or the process of applying for and maintaining protection. Some designers feel that such protection may be difficult or counterproductive to industry development or to the benefit of users. A few appear to favor some protection but are not sure how best to accomplish this protection.

Dubberly's comments are noteworthy: "I'm not familiar enough with design patents to speak about the extent or appropriateness of their protection. I will say that I'm not entirely comfortable with allowing patents for [user] interface design. I'm not convinced that within the framework of a limited system such as a windowing environment or a Web page that much real innovation takes place. Even if it did, limiting use seems to hurt the society as a whole. For example, the notion that Amazon 'owns' one-button checkout is absurd. Society is harmed by restricting that system to Amazon. Conversely, Amazon has no claim to right by virtue of special development effort. Clearly, Amazon did not expend large amounts of time or money to come up with the idea. Not patenting it would not reduce the efforts of others. What's more, granting patents has not resulted in a flurry of research. The result has simply been richer lawyers."

If any extrapolation could be made to the design community, most designers have become ignorant or uncaring of the process because it seems to be in others' hands, over which they have little control. Alternatively, it seems that some education of designers might be desirable from the perspective of a patent office and that some vigorous debate about the merits of protection, some view of the historical record in the industry, and some attempt to describe likely short-term future implications of the current status of protection might be desirable, useful, and valuable. However, promoting this awareness would require specific actions by a patent office or interested parties (such as legal organizations or SIGCHI).

9.4.6 Question 8: Evaluating Your Protection

How do you evaluate the present legal protection for the image designs indicated on the display screen, especially the protection under design patent?

Most respondents expressed insufficient knowledge of the topic to be able to respond usefully. Some refer or would refer the matter to legal associates or in-

house legal departments. Some expressed concern, cynicism, or doubt about the merits of the current process.

If one can extrapolate to the design profession, there seems to be a feeling of inadequate access to facts; insufficient understanding of the process and issues, from a designer's perspective; and suspicion or cynicism about the quality of patent awards in the past, about the use of their design contributions, and possibly about their ability to affect the current process. Considering actions that can lead to improvements in the laws is at least as important as evangelism for the involvement of more designers and probably should precede such calls to action.

9.4.7 Question 9: Aspects Needing to Be Protected

In your opinion, what is the subject to be protected for ensuring protection of an image design indicated on the display screen: the image design itself, the image design as a "pattern" of an object or artifact, the software representing the means displaying the image design, that is, the software that implements the UI, etc.?

The respondents are divided in their opinions. Some feel that the image is the protectable artifact; others believe that software, processes, and even terminology need to or should be protected. Because many firms now trademark parts of their products or services and even processes, all IP techniques should be considered. Extrapolating from this limited survey, probably there is a need for some kind of a glossary of terminology, with visual, dynamic, interactive, and acoustic or haptic examples to assist designers (and most certainly lawyers, judges, and patent examiners) in order to make further discussion possible. It seems likely that many designers have widely varying or only roughly determined interpretations of primary concepts and attributes. If such debates occur among patent examiners and legal teams and in the courtroom (I know about the last two from having served as an expert witness on several occasions), it seems even more likely that the design community needs some clear definitions, paradigms, and examples to point to in order to manage debate among themselves and with legal/governmental representatives about what, from the designer's perspective, should be protected and how.

9.4.8 Question 10: Future of Image Designs

How will image designs indicated on the display screen change in the future? That is, what is the trend or direction of change?

Understandably, all of the respondents are unusually informed, articulate, and forceful in their predictions about the future of user-interface designs. These predictions differ radically in how designs will, for instance, change according to appro-

priate context; exhibit animated, multimedia, three-dimensional, and acoustic attributes; or show few or no traditional screen attributes but instead rely on voice or physical device manipulation.

Most of these suggestions point to the increasing limitations of current design patent applications documents; the artwork accompanying them; textual descriptions; search criteria available to examiners, lawyers, designers, and the general public; and subjects of protection. I believe that many of the drawings are inadequate and inconsistent across patent documents; the titles, classifications, and terminology are inconsistent, confusing, and in some cases inappropriate, bordering on chaotic and dysfunctional; and the concepts of the design patent are rooted, understandably, in a previous age that knew nothing about software, electronics, ubiquitous computing, or distribution and publishing systems that are two-way webs, not tree structures that emanate from controlled centers of one-way communication.

The responses to this question alone seem to merit further attention to the future state of design-patent protection. The essential issue is what could be protected (as opposed to what should be protected).

9.4.9 Question 11: Necessary Protection

Do you think it will be necessary to protect image designs indicated on the display screen in the future?

Some respondents seem, almost nostalgically, to feel the importance of protecting something, although many admit the difficulty in determining a fair and efficient process that is not made ludicrous by the pace of technology change. A few (such as Dubberly and Henderson) take the opposite viewpoint, that protection does not assist the end user and is impractical, as already demonstrable in the commercial marketplace, except for powerful corporate or monopoly-like interests.

9.4.10 Question 12: Means of Protection

Assuming you think it will be necessary to protect them, how should image designs indicated on the display screen should be protected in the future?

Again, the respondents who feel comfortable responding are articulate and forceful. Either some version of current protection, including design patents, seem appropriate, or the entire process seems inadequate or inappropriate, from either the designer's or the end-user's perspective. Clearly, the respondents have strongly divergent views. This seems likely to reflect the differing opinions to be found in the design community.

9.5 Conclusions

The survey attempts to explore the opinions of the design community about the value of one IP protection technique, user-interface design patents, by examining the opinions of several representative professionals. The results of this survey, geared specifically at designers in the United States, point to the need for informing the design community further about IP protection in general and debating again carefully some key issues that were discussed a decade ago, when desktop WIMP (windows, icons, mouse, pointer) UIs ruled, and Web and mobile devices were in their respective infancies. The survey, in its limited time and scope, uncovered useful grounds for further study, discussion, and action. In particular, based on the survey, the UI design community needs to accomplish the following in the short term:

* Arrange for a seminar, tutorial, or panel about intellectual property protection again, especially about design-patent protection, at an appropriate designers-oriented venue. Speakers should represent the patent office, attorneys, and several realms of the UIdesign community.
* Convene a one-day conference workshop or focus group that would explore these survey questions in greater detail. The workshop could be similar to the workshops held every year in conjunction with the CHI conferences. One goal would be to encourage greater preparation by participants and to provide a much longer time to discuss each item.
* Prepare for the design community an updated white paper about intellectual property protection, especially design patents. The white paper should include a glossary, visual examples, discussion about current issues, bibliography, and available Web resources. The document should be visually attractive so that it appeals to and successfully communicates to visually oriented designers. This aspect is not a trivial matter; appearance counts to serious visual designers.
* Research and publish a document about the future of user-interface design and its potential impact on intellectual property protection, especially design-patent protection. This document would benefit from the detailed knowledge of the design community and expose issues that the patent office community ought to consider in planning for the short- and long-term changes in the intellectual property protection process, especially for design patents.

I hope this survey stimulates further discussion about who, or what, should own the UI and who should benefit from successful solutions for complex UI design challenges.

9.6 Postscript 2015

In the past decade, more and more litigation in the US revolves around intellectual property infringement. I myself occasionally serve as an expert witness in such cases, and I have taken sides for and against major, well-known companies, as well

as smaller firms, depending on the circumstances. Some of these cases have revolved around details of user interfaces, even the use of certain so-called icons, as well as fundamental interaction techniques. As in the past, most of the cases involve larger companies, ables to withstand the costs of protecting functionality and design patents, and the costs of guarding their property and pursuing infringers.

This is a topic that seems to lie primarily in the realm of those with enough wealth to maintain their position in the present system, despite the growth of many Kickstarter and similar projects that can launch products/services at low cost. Intellectual property protection has a distinctive and high-cost character.

Acknowledgements Thanks to Mr. Hirokazu Kobayashi, deputy director of the JPO, for allowing me to publish information from the survey on current UI designers. Also, my appreciation to the respondents, who granted me permission to use their names and statements in this chapter.

References

Marcus A (1996a) Intellectual property issues in user interface design (in Japanese). J Jpn Pat Off Tokyo Jpn 186:8–14
Marcus A (1996b) Intellectual property: the issues for user-interface design. Statements 11(2):13–17, Chicago, IL: American Center for Design
Marcus A (2001, February) Intellectual property issues in user interface design. ID News. Published by the International Institute for information Design, Vienna, pp 4–6
Marcus A (2003) "What do UI designers think about protecting their designs?" "Fast forward" column. Interactions 10(5):28–34

Chapter 10
When Is a User Not a User? Who Are We? What Do We Do?

10.1 Summary

Our profession is debating hotly our professional objectives, techniques, and terminology. User-interface design speaks of users, design, and computer-based systems. Are there terms that would be more helpful to convey the right meaning of users, design, and user-interfaces? For that matter, what should we call ourselves and what we do?

© Springer-Verlag London 2015

A. Marcus, *HCI and User-Experience Design*, Human–Computer
Interaction Series, DOI 10.1007/978-1-4471-6744-0_10

10.2 Introduction

The CHI community seems to be in purposeful, creative turmoil. Besides discussing the challenging economic circumstances, where new revenues might be found, and marveling at the flood of people returning to universities to pursue or renew academic studies, many professionals are proposing theories about the profession itself—its key concepts, processes, and terms—and debating the appropriate organizational memberships and alliances with other organizations. Let's take a look at some basic terms by which we describe our profession. I began this topic in an earlier essay, and some of the definitions I proposed have been challenged. The topic seems worth further consideration. Let's give it another whirl.

10.3 What Is the Correct Term for *User*?

At a recent special conference about information design, usability theory, and design practice at the Illinois Institute of Technology's Institute of Design, Dirk Knemeyer, president of Thread, Inc., made an impassioned appeal to reject the term *user* in discussions of user-interface design and computer-mediated communication. He proposed instead that we refer to *participants*. Knemeyer argued that the term *user* is outdated, emphasizes one-directional usage, arises from an era when user interfaces were slow and not intuitive, and is not appropriate for circumstances that enable people to work or play quickly and almost without awareness of the user interface as an intermediary. In addition, the term *user* has many negative connotations, including *being used*, *being used up*, and *illegal drug use*. He felt that, instead, today's emphasis on interactive communication and customization suggests a term that implies more active involvement by the person in contact with machines and communication media. Knemeyer commented that if a person who goes to the gym is a gym-goer, or a "doer" with gyms, then our term for the human beings involved should evoke a more active, "mover and shaker" paradigm, suggesting doing things and thinking things. He recommended the term *participant*.

Another perspective is that systems in the past have been focused on an individual working with a computer system, not groups working collaboratively in real time or asynchronously, local or global, to accomplish mutual objectives. Also, there are others affected by the human-computer system, so-called "secondary users," who, as with second-hand smoking, receive the benefits or harm of computer systems.

Who, then are these people who work with, play with, interact with, or in other ways use computer-mediated products and services? Should one generic term describe them? What should we call them? What is implied by that noun or noun

phrase? Upon reflection, there are many terms floating around in the industry and its literature, conferences, and hallways. Some readers may have heard or read one or more of the following examples:

- **Actors:** At one point, the metaphor of theater was proposed for computer software. The term survives in discussions of behavior-oriented analysis. Also, interactive systems imply an "inter-actor."
- **Addicts:** For better or worse, some marketers and business owners have actually stated their objective of making applications or Websites not merely "sticky" but addictive.
- **Consumers**: Popular among marketers and business analysts.
- **Customers:** Clearly popular for business-to-consumer (B2C) Web sites and Web applications, and for all popular software applications, of growing importance to customer-relationship management (CRM).
- **Guests:** Popular with many savvy chains of stores and hotels who have trained their staff to see to their customers' needs and wants and to give them a good "guest experience."
- **Human beings:** Sometimes shortened to the informal noun *humans*; survives in the European and engineering-oriented "human-machine interface" (HMI) concept. The term remains important and viable among human factors and ergonomics professionals.
- **Learners:** Novices, intermediates, and experts are all on the path of learning how to use the functions and data provided.
- **Men:** Survives in the outmoded, gender-biased "man-machine interface" (MMI), which is still occasionally encountered in the literature.
- **Objects:** At the ends of links are nodes; the flip-side or relationship-based theories are entity- or object-oriented theories, not only of software, but of general collections of attributes about the users, their behavior, preferences, attitudes, values, rituals, symbols, beliefs, practices, etc. This term is popular among researchers and theorists.
- **Occupants:** Popular with architectural, environmental, or other behavior-oriented applications.
- **Participants:** Suggests activity, involvement, games, enrollment.
- **Persons**: Implied in the "personal digital assistant (PDA)" and other products and services targeted to highly customized applications and content.
- **Patients**: Suitable not only for medical/psychological systems, but perhaps for certain classes of general users.
- **People:** Seems one of the most general and usable terms.
- **Players:** Often used among game application developers.
- **Readers:** E-books and other content-oriented products and services emphasize these people.
- **Subscribers:** Useful for the enrollment and registration of locked-in consumers of products or services.

- **Stakeholders:** Popular among branding and business professionals.
- **Subjects:** Popular among research, evaluation, and testing professionals to describe those studied and tested.
- **Targets:** Sometimes used or implied in marketing and sales discussions.
- **Victims:** Sometimes used jokingly for the recipients of poorly designed user interfaces.
- **Viewers:** Popular among mass-media-oriented applications, content, products, and services.
- **Visitors**: Popular among developers of architectural applications, kiosks, and Web sites.

Of course, specific user classes are based on demographics, such as infants (yes, even infants have their own computer applications); toddlers; children; tweeners; teenagers; college kids; double-income, no-kids couples (DINKs); yuppies; men; women; parents, and seniors. However, no popular general term is in use for such demographic user groups. No one is likely to call users "demogs" or "demographic user communities." There are also the specific professional user groups based on their respective vertical markets (for example, health, wealth, finance, education, manufacturing, military, or government), with their attendant doctors, nurses, para-medics, executives, managers, clerks, attorneys, paralegals, teachers, students, oper-ators, generals, soldiers, administrators, clerks, and citizens. Most of these terms depend on context and refer to what customers, buyers, and users, and their long-term relationships the makers of products and services seek to attract.

Bear in mind that some people drop the term *"user"* from *user interface* and simply refer to *interfaces*. Sometimes this single word seems to emphasize mere screen design, not metaphor, mental-model, navigation, or interaction design. For those discussions, *users* might or might not be emphasized at all in the relations that people have with products and services. Do people interact with them, play with them, work with them, participate in them, or use them? All seem reasonable at times.

Because there are machine-machine or computer-computer connections with "interfaces," I have tended in my own writing to emphasize the important point that we are focused on systems that must communicate and interact with human beings, not machine or computer systems.

In one way, the very debate about the term is evidence of a profound change in the profession that focuses increasing attention on user-centered design, user pro-files, and use scenarios. In a way, we can celebrate this debate as a sign of victory. Conversely, which term is the right one to use?

One approach is to say that there is a general term but that user-interface-development professionals should be aware also of the correct term to use in different contexts. This approach is especially important for establishing good team relationships with fellow designers, analysts, evaluators, planners, researchers, mar-keters, business owners, engineers, and so on. Likewise, there is a need to use the correct term with clients and users themselves. We need ourselves to be sensitive to the cultures of the people we work with and our relationships with them. One false step can confuse or even alienate one's colleagues, clients, and customers. Perhaps we

need to publish a "Guide to the Perplexed" to help everyone understand the possibilities and recommended best practices. The foregoing glossary is offered as a start.

Although many of the terms above are quite insightful and prompt one to think about nuances of user experience, for me, the old reliable but flawed *user* still seems usable and useful, if not always desirable. I suspect, however, that within this decade, the term will fade, to be replaced by another that gains maximum usage among user-interface development professionals, the business community, and the general public.

10.4 Who Are We? What Do We Do?

Other debates concern what we should call ourselves and the name of our profession. I have seen almost all of the following professional terms under a person's name on a business card over the past 30 years. These debates, in turn, lead to discussion about which professional organizations and conferences to attend, especially in the light of restricted budgets. Some candidates for terminology, organizations, and conferences appear listed below. Space does not allow for further elaboration and analysis, but keep these in mind as you think about what to call the people who use the results of our practice; what to call ourselves; and what to call what we do. Again, a longer, comparative guide and glossary with attributes called out, contact data, and commentary would be useful for all of us. If you think this would be useful for a future publication or Web site, or you know of an exceptional Web address already, please let me know and I'll try to use this information in a future installment of "Fast Forward."

10.4.1 Terms for Ourselves

- Analyst
- Architect
- Arranger
- Artist
- Bricoleur
- Coach
- Designer (interaction, sonification, user-interface, visual, etc.)
- Diplomat
- Documenter
- Editor
- Educator
- Engineer
- Expert
- Explorer

- Evaluator
- Evangelist
- Fundraiser
- Gatherer
- Genius
- Guide
- Guru
- Hunter
- Hypothesizer
- Idealist
- Ideationist
- Informer
- Inventor
- Logician
- Magician
- Manager
- Marketer
- Master
- Pattern arranger
- Planner
- Politician
- Practitioner
- Professional
- Programmer
- Researcher
- Salesperson
- Semiotician (applied)
- Synthesizer
- Tester
- Trainer
- Visible language designer
- Visualizer
- Wizard

10.4.2 Terms for What We Do

The following terms focus on the synthetic task of user-interface development, which is sometimes the "highest profile," has the highest caché, or is most familiar to the general public:

- Application design
- Applied semiotics

- Communications design
- Content design
- Document design
- Information architecture
- Information design
- Instructional design
- Interaction design
- Multimedia design
- Product design
- Service design
- Software design
- Usability design
- User-experience architecture
- User-experience design
- User-experience engineering
- User-interface design
- User-interface engineering
- Visible language programming
- Visual design
- Web design

10.4.3 Professional Organizations

The following are, for the most part, U.S.-oriented organizations, with parallel national organizations in other countries. Their contact data, objectives, and activities may be found through Web searches.

ACM	Association for Computing Machinery
AIA	American Institute of Architects
AIGA	American Institute of Graphic Arts
HFES	Human Factors and Ergonomics Society
ICOGRADA	International Council of Graphic Design Associations
ICSID	International Council of Societies of Industrial Design
IEEE	Institute of Electronics and Electrical Engineers
IDSA	Industrial Designers Society of America
IIID	International Institute for Information Design
SIGCHI	Special Interest Group on Computer–Human Interaction, a unit of ACM
SIGGRAPH	Special Interest Group on Graphics and Interaction, a unit of ACM
STC	Society for Technical Communication
UPA	Usability Professionals Association

10.4.4 Conferences

The following are, for the most part, U.S.-oriented conferences of major professional organizations, with parallel national conferences in other countries. Many are sponsored by one or more of the organizations listed previously. Their contact data, agenda, schedules, and costs may be found through Web searches.

DIS	Designing Interactive Systems, jointly sponsored by ACM and others
DUX	Designing the User Experience, formerly jointly sponsored by ACM and others
DUXU	Design, User Experience, and Usability, Annual Conference held in conjunction with HCII conference
HCI	Human–Computer Interfaces, United Kingdom
HCII	Human–Computer Interfaces International, annual conference held in international locations
HFES	Human Factors and Ergonomics Society
HICSS	Hawaii International Conference on System Sciences
IWIPS	International Workshop on International Products and Services
SIGCHI	Special Interest Group on Computer-Human Interaction
SIGGRAPH	Special Interest Group on Graphics and Interactive Techniques
STC	Society for Technical Communication
UIST	User Interface Software and Technology
Visualization	visualization research, sponsored by IEEE, among others

10.5 Conclusion

Many of the basic terms of our profession are being discussed and debated today in panels at workshops and conferences, in chat rooms, and by the water cooler. Whom do we serve? What shall we call ourselves? What do we call what we do? These terms show up on our business cards and e-mail signatures; the underlying concepts pervade our thinking, talking, and actions.

 Some user-interface designers or newcomers to the profession decided in the late 1990s to call themselves information architects or visual designers to represent more specific expertise. Some professionals are now calling themselves usability experts, user-experience designers, or simply experience designers. With the rise of usefulness and desirability, appeal, and emotion, some professionals are calling themselves "desire designers." These are trends reminiscent of movements in consumer product branding and marketing in decades past, of which the computer-related industries are now becoming aware. Note that AT&T has had a corporate department of "user-experience engineering" since 1997 and that other major corporations are considering shifting some of their corporate internal nomenclature to user-experience engineering.

These shifts in terminology are signs of significant changes in the professional landscape. The debate also suggests that there may be realignments of the organizations to which we belong, which conferences we attend, which literature we look at to continue our lifelong professional learning, and to which publications and theories we subscribe. We live in interesting times. Stay tuned for the latest developments.

10.6 Postscript 2015

Our profession, and the stakeholders we serve, have both been frothing and fermenting vigorously in the past decade, and continue to evolve. It is interesting that I neglected to include "innovate" as one of our key activies and "innovator" as one of our key roles. Also missing are references to design thinking, a somewhat vague, but often-used industry and marketing term. Other activity-terms that I might now include are metaphor design, mobile design, wearables design, and related platform changes.

As with other chapters, it would be interesting to chart the growth and decline of all of these terms over time, over decades, and to note regional differences, perhaps due to age, gender, culture, nationality, religion, and other factors. Much like charts of baby-naming popularity, we would see the rise, dominance, and eventual decline of many such terms.

It always seems usable, useful, and appealing to keep up with the latest popular/professional glossary to educate oneself, and to improve the ability to communicate with one's peers and stakeholders.

Chapter 11
The Emotion Commotion

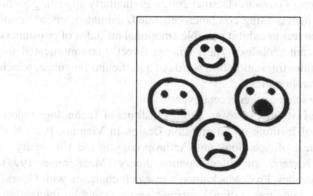

11.1 Summary

The computer–human interaction (CHI) community's interest in emotions is heating up. Beyond usability, professionals are taking part in provocative discussions of appeal, desire, pleasure, even frustration—and, no doubt, pain. Before we get carried away, let's review the territory.

© Springer-Verlag London 2015
A. Marcus, *HCI and User-Experience Design*, Human–Computer
Interaction Series, DOI 10.1007/978-1-4471-6744-0_11

11.2 Introduction

A tidal wave of interest in emotions is brewing among user-interface professionals. Have you heard the rumblings of this oncoming tsunami?

At ACM SIGCHI's CHI 2003 conference a few months ago, Prof. Jodi Forlizzi, of the Human–Computer Interaction Institute and School of Design at Carnegie-Mellon University, organized a well-attended panel discussion about emotions in user-interface design (see program details at www.acm.org/sigchi/chi2003). I am indebted to her for promoting the discussion of this challenging topic and the opportunity to co-present at the panel discussion, which prompted this essay.

The speakers, and the questions posed after the panel discussion, raised powerful issues. Of particular note was one of the speakers, Pieter Desmet, University of Delft, whose dissertation research in emotions and product design are summarized in his publication *Designing Emotions* (Desmet 2002). Particularly appealing to the audience were his experiments using computer-generated, animated, visual "puppets" or cartoon-like creatures to exhibit possible emotional attitudes of consumers to product designs (like automobiles). These images directly communicated the emotions and did not require translation into words of a particular language, which always introduces some ambiguities.

This CHI event follows some other recent events:

At a conference at the Institute of Design, Illinois Institute of Technology (sponsored by the International Institute of Information Design in Vienna), Prof. Neil J. MacKinnon, Department of Sociology and Anthropology at the University of Guelph, presented his research on affect control theory (MacKinnon 1994). Conducted over many decades, Prof. Mackinnon's research contrasts with George Herbert Mead's classical cognitive, rational perspective on symbolic interaction. Prof. MacKinnon demonstrated an affective-attributes database in several languages covering many different concepts. With his computer-based tool, it is possible to construct scenarios of events and explore the likely emotional impact on participants. The capabilities seemed just a few steps away from allowing product and service developers to create use-case scenarios and exploring the likely emotional "meaning" of the artifacts and the interactions among people using them.

At the Usability Professionals Association 2002 conference, Patrick Jordan of the Contemporary Trends Institute in London presented his tutorial "Pleasure with Products: Beyond Usability." His tutorial expanded the themes he introduced in his *Designing Pleasurable Products: An Introduction to the New Human Factors* (Jordan 2000). In his book he identifies four levels of pleasure in products and services: physiological, social, psychological, and ideological. These levels are intended to provide a basis for moving beyond usability to usefulness and pleasure.

Given the widespread interest emerging in many conferences, companies, universities, and professions, it seems appropriate to take a moment to survey the emotional landscape of human-computer communication and interaction.

11.3 Background

The study of emotions dates thousands of years. The early philosophers and drama-tists, most notably Aristotle, considered what emotions exist and how artistic arti-facts of words, images, or sounds, among other media, might affect viewers, listeners, or participants. Much more recently, French Encyclopedists in late-eighteenth-century Europe carried out thorough taxonomies of the emotions and how they might be expressed through facial gestures, hand gestures, and other non-verbal signs. Similar studies have been made in India and China.

More recent theories of emotion are abundant. Several sources, which include the James-Lange theory (1884), John Broadus Watson's Behaviorism theory (1913), the Cannon-Bard theory (1915), and Sartre's Phenomenological theory (1939), are detailed by Jordan (Jordan 2003). Buck (2002) presents the following typology of emotions in 2002:

- Biological emotions (such as arousal, reward-punishment, fear and anger, and love and bonding): based on specific neuro-chemical systems
- Social emotions (such as pride and guilt): based biologically on attachment
- Cognitive emotions (such as interest, boredom, and curiosity): based biologi-cally on expectancy
- Moral emotions: based on a combination of social attachment and expectancy

Concerning "practical" approaches to analyzing emotions, in recent times one can point to the work of Paul Ekman, Professor of Psychology, Department of Psychiatry, University of California Medical School, San Francisco (see Ekman 1982), who has studied facial-gesture details for more than 30 years and what they betray of emotions, making it, in his view, easy to determine if one is telling the truth or lying.

In the world of computer-based communication and interaction, it has been an unstated human-factors-oriented assumption for most of CHI's history that com-munication and interaction take place in a somewhat neutral emotional state. Occasionally research on interaction is conducted in control rooms under alarm conditions, medical emergency-response systems, or fighter-aircraft cockpits dur-ing combat. Most consumer and professional systems have assumed that developers, and users, exhibit the calm demeanor of the proverbial lab scientist in a white coat and pocket protector.

Nevertheless, researchers like Prof. Rosalind Picard of Media Lab's Affective Computing Research Group at MIT, have, for years undertaken studies of human emotions, sensing human affect signals, recognizing patterns of affective expres-sion, understanding and modeling emotional experience, synthesizing emotions in machines, affective computing applications, user interfaces with affective comput-ers, affective communication, and affective wearable computers (Massachusetts Institute of Technology). A special issue of *Interacting with Computers* (Cockton 2002) features three papers, all of which she co-wrote. One of the more stimulating

titles is "Frustrating the User on Purpose: A Step Toward Building an Affective Computer." This approach seems to fly in the face of conventional usability theory.

Meanwhile, in another realm, as the ACM SIGGRAPH conference ably demonstrates each year at its justly famous theater presentations, SIGGRAPH animators are coming closer and closer to completely synthesized actors and actresses who can move whatever virtual facial muscle necessary to convey innumerable and perhaps unnamable nuances of emotions. We are probably only a few years away from Arnold Schwarzenegger, whatever his political future, licensing his detailed body-base measurements and other attributes to provide a completely synthesized producer- and/or consumer-activated Terminator to be used for whatever purpose market forces permit.

Today, consumer product and service developers—from mobile devices to music services to vehicles to wearables—all "just wanna have fun," or at least think that consumers who are having fun, or being amused, will be more persistent purchasers, more productive practitioners, and more satisfied, stickier, word-of-mouth testifiers, returning for more, for ever more.

In my lectures and tutorials of about 15–20 years ago, I predicted the stage of user-interface development (UID) that would see genres of UID emerge, just as they have in literature and cinema. I foresaw that we might have funny UIs, sad UIs, gentle UIs, matter-of-fact UIs, even in-your-face UIs, depending on user preferences, moods, and circumstances. In those days, I likened the development of UIs to movie production and cautioned developers to hire professionals, not to let application programmers, or even user-interface designers, write the jokes for extremely funny menu hierarchies.

Now it seems the times have caught up with us; the moment is at hand to open the door widely to emotion. Before we get too giggly with our delight in all this commotion, let's pause for a moment and consider some issues that may challenge our cognitive, esthetic, and ethical abilities and skills in the coming years.

11.4 Issues

Among other questions already being considered and others waiting for investigation are the following:

- What is the relationship of culture to emotion and particularly to pleasure? How should our product and service UIs respond?
- Considering pleasure, to what extent is Maslow's (see Maslow 1968) hierarchy of needs (physiological, safety, belonging and love, self-esteem, and self-actualization) actually culture-biased and perhaps not as universal as some might consider.
- Will manufacturers move toward a simple, lowest-common-denominator, short-term pleasure-principle, guaranteeing that our products and services will have all the edifying substance of the latest television reality shows? If so, how fast will this movement take place? What viable alternatives are there?

- What exactly do we mean by fun? Are there 7 ± 2 dimensions of fun, as there are for persuasion, trust, and intelligence? What are these dimensions? How can we develop templates for these dimensions? Keep in mind that according to some French intellectuals, there are exactly 18 levels of humor, Paulos (1980) has developed theories of the geometry of humor, and books like that of Prochnow (1942) have, for decades, guided presentations of humor, in this case listing almost 2000 jokes, jests, wisecracks, epigrams, and amusing definitions.
- How can one reliably assess, measure, and compare pleasure, as opposed to the usability-oriented term "satisfaction"?
- Will all products and services eventually become rated according to the "pleasure" they provide, as Amazon.com and others now guide book purchases according to statistics of who "liked" a book, or who "benefited" from a book, as opposed to what critics think, or who purchased the book?
- How can emotional involvement of the user, as opposed to moods or sentiments, consciously focused by the designer, improve attention, memory, performance, and assessment? How is this approach similar to or different from the practices of advertising in marketing? Ekman (1982, 2003) proposed 7 ± 2 basic emotions expressed through facial cues: anger, disgust, fear, happiness, sadness, and surprise. How do these map to particular states, or attributes of user-interface components (metaphors, mental models, navigation, interaction, appearance)? Can one construct a mapping tool or a database of patterns or case studies? Note that other researchers (e.g., Ulich and Mayring 1992) refer to 24 emotions developed by other theorists.
- Are visual, musical, verbal, or physical cues to emotions more effective for certain groups of people under certain conditions? What are the variables and the conditions?
- Which emotions are appropriate or ethical for user-interface designers to manipulate? Should some kind of professional ethical review committee exist to determine what is appropriate?
- To what extent should computers track the emotional states (i.e., appropriate data) of users? To what extent is it appropriate or ethical for the manufacturer or computer to inform the user that these data are being tracked or that emotions are being manipulated? Consider the uproar decades ago over subliminal advertising that placed consciously unobservable messages (e.g., "you will buy more coffee") into communications.
- How accurate must emotion-recognition (like speech-recognition) be in order to be useful? Legally monitored or sanctioned?
- Will emotional communities arise that wish to interact according to particular palettes of emotions?
- What are the most appropriate metaphors of emotion? For example, anger is sometimes described in terms of its being a hot fluid in a container: "blood boils," "inflammatory remarks."

11.5 Conclusion

Many resources, such as theories of emotion, of humor, of fun, abound, to keep the interested researcher and practitioner busy. Theories must eventually translate into practice.

The struggle some analysts and designers will face seems likely to be to persuade business managers, marketers, and heads of product and service development to timely and efficiently address some of the more exotic, ethical issues. An argument oriented to return on investment (ROI) seems in order. Who will step up to the plate to prepare it?

With or without such an examination, it seems likely that the emotional temperature of the design community has been raised. Soon we'll be sizzling. Are you ready for fun?

11.6 Postscript 2015

As with other chapters, the increase of attention to emotion-based human-computer interface design and user-experience design, including so-called affective computing continues as an unflagging trend. New products and services emerge almost daily that are designed to affect our emotions and to affect our behavior. Centers of research and development, like Dr. Pieter Desmet's in the Netherlands, have flourished, and publication, journals, and books on the topic are numerous, e.g., as summarized in Dr. Desmet's and Paul Hekkert's editorial on the topic (Desmet and Hekkert 2009).

The subject is of increasing importance in the world of robotics, also, which seeks to make these creatures more human. The subject has been included as a themes in several recent science-fiction movies, such as *Her, Chappie, and Ex Machina*.

Acknowledgment I am pleased to acknowledge the assistance of AM+A Design/Analysis Intern Carmen Doerr, of Germany, who conducted initial research during June-July 2003 on the study of emotions in design, product and service development, culture, and user-interface development. I am also indebted to Brave and Nass (2003) for several of the issues they raise in their chapter.

References

Brave S, Nass C (2003) Emotion in human–computer interaction. In: Jacko JA, Sears A (eds) Handbook of human–computer interaction. Lawrence Elrbaum, Mahwah, The chapter contains an excellent bibliography

Buck R (2002) Typology of emotions. Available at http://wattlab.coms.uconn.edu/ftp/users/rbuck/UConn9-00/sld001.htm. Accessed Apr 2002

Cockton G (ed) (2002) From doing to being: bringing emotion into interaction, vol 14, Special issue of interacting with computers. Elsevier, Amsterdam

Desmet PMA (2002) Designing emotions. Doctoral dissertation, Delft University of Technology, (ISBN 90-9015877-4)

Desmet PMA, Hekkert P (2009) Special issue editorial: design & emotion. Int J Des 3(2):1–6

Ekman P (1982) Emotion in the human face, 2nd edn. Cambridge University Press, New York

Ekman P (2003) Contains extensive bibliography. Available at www.paulekman.com/. Accessed 1 Sept 2003

Fussell SR (2002) The verbal communication of emotions: interdisciplinary perspectives. Lawrence Erlbaum, Mahwah

Gage D, McCormick J (2002) Prada: the science of desire. Available at www.baselinemag.com/article2/0,3959,772305,00.asp. 16 Dec 2002. The article is a case study of Prada's use of advanced technology in its first Epicenter store: transparent doors on fitting rooms that are supposed to become opaque when customers step in

Griffiths PE (2002) Basic emotions, complex emotions, machiavellian emotions. Available at http://philsci-archive.pitt.edu/archive/00000604/

Jordan PW (2000) Designing pleasurable products: an introduction to the new human factors. Taylor and Francis, London

Jordan C (2003) Classical theories of emotion: a seminar of psychology. Available at www.mmi.unimaas.nl/leermiddelen/internetsite/0203_b11_p10_url_Classic%20Theorie%20of%20 Emotion.htm. Retrieved 14 Aug 2003

MacKinnon N (1994) Information and affect control theory. Available at www.indiana.edu/~socpsy/ACT/index.htm. Contains extensive bibliography; includes data and downloadable software

Maslow AH (1968) Toward a psychology of being. D. Van Nostrand Company, New York

Massachusetts Institute of Technology. Media lab, affective computing research group. Available at http://affect.media.mit.edu/AC_affect.html. Contains extensive bibliography

Norman DA (2004) Emotional design: why we love (or hate) everyday things. Basic Books, New York

Paulos JA (1980) Mathematics and humor. University of Chicago Press, Chicago

Prochnow HV (1942) The public speaker's treasure chest: a compendium of source material to make your speech sparkle. Harper and Brothers, New York

Ulich D, Mayring P (1992) Psychologie der emotionen. Available at http://www.abebooks.com/ Psychologie-Emotionen-GrundriÃ-5-Dieter-Ulich/6799432819/bd. Retrieved 14 Feb 2014

Chapter 12
The Next Revolution: Vehicle User Interfaces

12.1 Summary

Imagine having to think about safety, usability, and esthetics issues for the user interface of a two-ton mobile device hurtling through space at 100 km/h. Now you get the picture.

12.2 Introduction

We're just a few years away from a revolution—a dramatic shift in technology similar in its implications to that of the introduction of personal computers on office desktops during the 1980s. Powerful computer hardware, software, networks, and wireless communication capabilities are being embedded in vehicles that transport

© Springer-Verlag London 2015
A. Marcus, *HCI and User-Experience Design*, Human–Computer
Interaction Series, DOI 10.1007/978-1-4471-6744-0_12

people everywhere in the world. Vehicle user-interface (VehUI) design, including, specifically, information visualization, sonification, and tactilization are fundamental challenges to developers. In addition to the traditional human factors challenges, to the more recent challenges of branding, cultural diversity, and emotional appeal, there is one additional, inescapable factor: life and death are at stake.

Another significant difference from desktop and mobile device contexts is that VehUIs represent a context in which the user experience is significantly controllable. Good VehUIs can improve both performance and preference, but VehUI developers must give their tasks of planning, research analysis, design, implementation, evaluation, documentation, and training careful thought and consummate skill. The context of communication will be not only information, but also persuasion (advertisements) and entertainment.

The computer-human interaction (CHI) community, representing user-centered, user interface design, has an important role to play, but CHI professionals are going to have to be politically and socially sensitive to other professional communities as all attempt to provide their skills to multidisciplinary challenges. At CHI 2003 and at HCII 2003, I organized panels on vehicle user-interface design to explore some of the differing viewpoints and potential contributors to successful solutions. Here are some key stakeholders.

- **Vehicle manufacturers:** They are concerned, are sometimes uncertain about what to do, and depend heavily on system suppliers and the industry's traditional service providers: human factors specialists and product designers. They are also used to traditional cycles of product development, which may take 6 years, a scenario quite different from consumer electronics, which has taken a few years, or the now constantly emerging products and services cycles of the mobile phone, personal digital assistant, and Internet industries. Some vehicle manufacturers are attempting to shorten development time significantly, but even roll-outs in half the time are still much longer than for the components provided by others.
- **Vehicle system suppliers:** They include manufacturers of sound systems, instrumentation, navigation, and media communication. Examples include Alpine, Bose, Bosch, Harmon Kardon, Fujitsu-Ten, and Qualcomm. Some suppliers may or may not have user interface (UI) development groups with the requisite skills required for newer, more complex vehicle telematics data (such as tire pressure, brake condition, fuel consumption efficiency, preventive maintenance scheduling, electrical or electronics system status, or road conditions) or for the rich amounts of phone, Internet, e-mail, video, and other audiovisual persuasion or entertainment sources that already exist in some vehicles but will soon be in almost all.
- **Human factors specialists:** these skilled analysts have worked in the automotive industry for decades. They have amassed impressive compendia of knowledge related to safety and ergonomics in general, that is, in many areas of usability, but some may not have a background in usefulness and appeal.

- **Product designers:** these designers and analysts have a long history of automotive styling, interior design, and some experience with dashboard design. However, as with many product designers working in the user-interface realm, they may have less experience with the complex communication, interaction, and storytelling of large collections of content or "industrial-strength" functions that are typical of advanced software applications or multimedia content collections such as those found on Web sites, CD-ROMs, or DVDs. Some firms have proposed prototype designs modeled on video games, arguing that for vehicles to appeal to a youth market, the instrumentation should look—and feel like video games. One hopes that making the designs more game-like has positive performance results and is not a catalyst to emotions and behavior that prevail in today's games that emphasize unreal, extreme action, and often revolve around death and destruction. Making the dashboards game-like might make the driver more prone to forget reality and deal with driving like playing with a race-course game in which a spectacular crash is merely a visual experience, with no personal, physical, economic repercussions.
- **User-experience designers, analysts, and engineers:** A wide range of disciplines and professional groups stand ready to provide guidance for "the user experience," however that is defined. Terms, concepts, and methods differ among professions, but inter-professional, interdisciplinary groups have formed at CHI, the American Institute of Graphic Arts (AIGA), and elsewhere. Among others, graphic designers, interaction designers, information designers, information visualizers, and, in general, user-interface designers and analysts are all able to provide significant expertise and experience. One ought to mention as well the Usability Professionals' Association (UPA, now called User Experience Professionals Association, UXPA), whose flagship publication's name, *User Experience*, already signifies a set of concerns that can be applied to vehicle matters.
- **Usability analysts:** In general, these researchers and analysts stand ready to evaluate vehicle systems with methods that are similar to human factors specialists, but also different. Their focus groups, user profiles, use scenarios, user testing, and heuristic evaluation methods have matured in the realm of consumer applications, entertainment media, search engines, as well as radio knobs and door handles.
- **Documentation and training specialists:** One version of a driver manual for an advanced vehicle user interface is approximately 300 pages long. This is only the beginning of the increasingly complex online and offline training, documentation, and help that drivers and riders will require (in addition to simpler, more effective user interfaces), if there is any hope at all for any of us to become competent in the new systems about to be installed in our vehicles. Documentation and training specialists may be able to help.

As you can see, many other disciplines may join CHI professionals to collaborate on or compete for overlapping, desired or required skill sets. To become more effective, CHI professionals may need to learn more about the standards, specifications,

issues, and concerns of the vehicle manufacturers as well as attend some of the showcase automotive conferences that take place each year in Detroit, Tokyo, and elsewhere. In addition, knowing basic sources of information is helpful. One place to start is the activities and publications of the University of Michigan's Transportation Research Institute (UMTRI), which for decades has produced vital studies and recommendations on vehicle systems, telematics, and human-computer communication and interaction. One of its steadfast researchers is Paul Green, who has worked in this field for many years.

In 2000, BMW asked my firm to investigate much of the public literature about the driver experience (as opposed to the rider experience), and kindly gave us permission to publish a summary. Some of these key ideas may sound familiar and seem almost self-evident. However, remember that in the automotive vertical market, user-centered design has sometimes taken a back seat to technology and marketing, or has focused on a narrower range of concerns. Bear in mind, also, that many UI designers do not have to consider safety and life-and-death circumstances as part of their typical decision-making matrix of issues.

Here are the maxims we synthesized from the material we studied with a brief description:

- **Design for safety:** Displays must be readable at a one-second glance. Most tasks should be completed in two glances. Users should be able to complete most other tasks in a 15-s period during conditions when the vehicle is stationary. All must be designed to avoid driver distraction, which means most tasks must be broken up into small steps. The use of a cell phone increases the risk of a crash by factor of five. The design implication: Simplicity must be emphasized to increase clarity and driver confidence. For example, a small detailed map diverts more cognitive focus than simple, direct navigation instructions.
- **Reduce complexity:** Developers first should offer helpful, rather than powerful, features. They should emphasize output leading to vehicle actions and displays, services, and automation, rather than the user's input and control. Rather than offer users full control, the VehUI should emphasize useful defaults, for which the default choices cover the most frequently (approximately 80 % of the time) desired results. The designs should focus foremost on driving-related functions. Developers can accomplish this objective by using task analysis to eliminate "function bloat," determine the most useful features, and concentrate on providing simple VehUI solutions first for most drivers, then enable greater complexity for those who desire or require it.
- **Use a graphical user interface only when necessary:** Graphical UIs are less direct, less dedicated. For example, many clicks in a graphical UI may be required for simple tasks, like selecting desired music. Graphical UIs should be used for dynamic content and can be powerful means to summarize complex situations through charts, maps, or diagrams. The right choices require careful consideration of trade-offs.
- **Use physical controls appropriately:** Physical controls dedicated to a single function are often more direct, and similar actions produce similar results (like

brake and accelerator pedals). Muscle memory, physical access, and multimodal input often may be the most powerful attributes that create a safe, efficient, and satisfying experience. Developers should retain physical controls for urgently needed and frequently needed functions. Other functions need to be evaluated for physical *vs.* graphical UI optimization.

- **Avoid cognitive and sensory overload:** The point of diminishing returns is being reached in VehUIs, because attention is a limited resource and cognitive costs are cumulative. In addition, age has a dramatic effect. Consider that many applications may not have special versions for both teenagers or seniors yet, but VehUIs must immediately provide for seniors and their special needs, in which older users require 60–120 % greater time for learning and decision making. Developers must consider workload management and overall cognitive capacity, in which strategic tasks (for example, choosing destinations and routes), maneuvering tasks (reactions to drivers, conditions), and control tasks (basic, automatic processes), must all be performed well. Testing designs with users is likely to be more extensive than for office desktop systems or home entertainment systems. Safety-centered design focuses on reducing distractions and finding an optimal balance of sensory, cognitive, and time-critical demands. Remember: Most drivers will begin as novices with VehUIs but must begin performing well almost immediately.
- **Allow customization of information:** Customization of the VehUI itself is risky but can be considered if that customization enables drivers to successfully accomplish their tasks in shorter time. It is also likely to be a consumer demand. To know how to customize, developers must follow a driver-centered design process, especially as cognitive issues become more important than physical. Remember: users are quick to abandon difficult software if alternatives are available.
- **Follow a user-centered design process:** Much of the literature points to the need for a user-centered UI development process:
 - Determine user profiles
 - Determine goals
 - Define scenarios
 - Design prototypes early
 - Evaluate alternatives
 - Iterate the design

This is not exactly hot news for the CHI community, but for some vehicle and system manufacturers, it places different emphasis on what has been often a technology- and marketing-driven context. These maxims suggest that the CHI community has a strong educational challenge ahead. The preceding has emphasized a traditional human-factors orientation and traditional UI development process, which emphasizes that VehUI development centers should consider the following:

- Adopt a user-centered design process.

- Work with UI and information-visualization experts to develop centers of competency.
- Plan systematic series of projects to improve UIs.
- Test existing (and competitive) systems.
- Test actual performance, not only focus groups.
- Conduct detailed UI audits, observe drivers and riders, analyze tasks.
- Design prototypes based on alternate controls and displays, such as heads-up display, touch screen, multiple displays, auditory cues.
- Develop specific vehicle UI rapid-prototyping tools.

12.3 New Challenges for the Design of Vehicle User Interfaces and Information Visualization

While all of the foregoing focusing on human factors and ergonomics is extremely important for the success of VehUIs, other challenges are emerging for developers, just as they are emerging in other fields such as desktop and Web applications, information appliances, and mobile devices. Among other new issues are the following:

- Intelligent or "smart" vehicles will have significantly new hardware and software. For example, large LCD or multiple-LCD display screens enable dynamic, unconventional displays quite different from the electromechanical displays of past vehicle systems. Sensors and wireless Web connectivity imply the possibility of fundamentally new content.
- In addition to usability, usefulness and appeal have increased in importance for drivers' and riders' experiences. Among other human factors analysts, Jordan expresses this concept in the title of his recent book: *Designing Pleasurable Products: An Introduction to the New Human Factors*.
- As in many realms, the content for vehicle displays will include not only informational, but also persuasive and esthetic, communication. Especially important are the issues of branding, and more likely, co-branding of information providers.
- With increased commuting times, vehicles will become a temporary mobile work and home place for both drivers and riders, with additional communication and interaction of the following kinds:

 - Information about one's own identity
 - Entertainment
 - Relationship-building and maintenance (communication with others)
 - Self-enhancement (including education and health monitoring)
 - Access to information resources (travel information, references, and other databases)
 - Commerce

For example, riders and drivers may experience virtual presence in other spaces, play games with other vehicles' drivers and passengers, review status or instruction concerning driving and parking maneuvers, repairs, or parts reordering.

Globalization and localization of product development will require increased attention to cross-cultural communication and other dimensions of difference of groups as well as individuals. As I have commented elsewhere, beyond culture, issues of trust, persuasion, intelligence, and cognition itself may cause vehicle UI developers to consider new kinds of metaphors, mental models, testing techniques.

12.4 Conclusions

Innovative vehicle UI thinking, cross-cultural analysis and design, and exploration of human factors and visualization issues beyond the traditional concerns of usability will need to be considered more integrally in vehicle UI development. Developers will need new kinds of checklists and guidelines to assist them in their work. Having a better understanding of fundamental human factors—the relationship of VehUIs to culture and other issues—designers can make better decisions about usability, usefulness, esthetics, and emotional experience. Ultimately, better, more powerful, and more appealing vehicle user interfaces and information display will emerge. The road ahead is a wide and challenging one.

12.5 Postscript 2015

In the last 10 years we have seen significant progress in vehicle user-interface design, even with the mis-steps of Ford in making major improvements that turned out to be less than optimal. The recent announcements of Tesla that it is planning to download changes to its large vertical-screen vehicle dashboard is impressive. Meanwhile, Google's self-driving automobiles have captured the attention of the general population, as well as of governmental bodies and legal professionals, concerned about public safety and liability. Also more in the news are heads-up displays that convert the dashboard to a projected image on the windshield. Perhaps it is only a matter of time that Google's glasses, now illegal in California, will resurface as a desired option for augmented-reality displays to show current vehicle systems status.

The number of additional functions available in vehicle systems continues to grow, as social media, vehicle-to-vehicle communication, voice-driven systems, texting, multimedia, and other systems are added to the growing capabilities of on-board vehicle computation and communication systems. I feel certain this alarms some vehicle HCI/UX design professionals worried about too much complexity, driver distraction, and consequent challenges to driver safety. Perhaps someday a convention for a "Vehicle-Siri", an on-board driving assistant, will emerge as a cross-vehicle, government-authorized/certified standard way to keep track of all this information, much as we have standard red, yellow, and green traffic lights and worldwide standards for roadway signage.

Also of interest is the large number (about 16) of vehicle manufacturers that have set up offices in Silicon Valley near Google and Apple, which have their own vehicle-oriented product/service offerings already established or in the works (see [Ramsey] in the Bibliography). Ten years ago, there seemed to be half that number.

One thing seems certain: vehicle HCI/UX offerings will continue to grow more complex, challenging, beautiful, appealing, and, hopefully, continue to remain usable and useful (Figs. 12.1 and 12.2).

Fig. 12.1 Sample screens designed by AM+A for Motorola during 1989–92 for one of the first advanced GPS mobile navigation devices, a prototype product called ADVANCE. The project was reported on in a case study published in Information Appliances and Beyond (Marcus 2000a, b), and also in an article about advanced vehicle information displays (Marcus 2002a, b) (Source: Designs by Aaron Marcus and Associates, Inc., now in the public domain per US DoT/Motorola agreements)

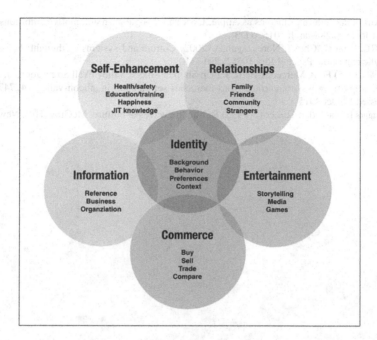

Fig. 12.2 AM+A's diagram of user-experience spaces, originally developed for Samsung to explain possible future product development spaces in 2002, revised in 2012 (Source: Design by Aaron Marcus and Associates, Inc.)

References

Cialdini R (2001) The science of persuasion. Sci Am 284(2):76–81

Green P. University of Michigan Transportation Research Institute. www.umtri.umich.edu

Hofstede G (1997) Cultures and organizations: software of the mind. McGraw-Hill, New York

Jordan PW (2000) Designing pleasurable products. Taylor and Francis, London

Marcus A (2000a) International and intercultural user interfaces. In: Stephanidis C (ed) User interfaces for all. Lawrence Erlbaum Associates, Mahwah, pp 47–63

Marcus A (2000b) User interface design for a vehicle navigation system. Chapter 6. In: Bergman E (ed) Information appliances and beyond. Morgan Kaufmann, San Francisco, pp 205–256

Marcus, A (2002a) User-interface design, culture, and the future. In: De Marsico M, Levialdi S, Panizzi E (eds) Proceedings of the working conference on advanced visual interfaces, Trento, Italy, 22–24 May 2002, pp 15–27

Marcus A (2002b) Information visualization for advanced vehicle displays. Inf Vis 1(3):95–102

Marcus A Mapping user-interfaces to culture. In: Aykin N (ed) International user-interface design. Lawrence Erlbaum Associates, Mahwah (in press)

Marcus A (2007) User-interface design and culture. In: Sears A, Jacko J (eds) Handbook of human-computer interface design. Lawrence Erlbaum Associates, Mahwah

Marcus A, Gould EW (2000) Crosscurrents: cultural dimensions and global web user-interface design. Interactions 7(4):32–46

New nexus of car industry emerges as Apple, Uber and Google push automotive ambitions. Wall Street Journal, 28 March 2015, p D3

Nisbett RE, Peng K, Choi I, Norenzayan A (2002) Culture and systems of thought: holistic vs. analytic cognition. Psychol Rev 108(2):291–310

Ramsey M (2015) Ford, Mercedes-Benz Set Up Shop in Silicon Valley. Wall Street Journal, 27 Jan 2015. http://www.wsj.com/articles/ford-mercedes-set-up-shop-in-silicon-valley-1427475558. Accessed 17 Oct 2015

Trompenaars F, Hampden Turner C (1998) Riding the waves of culture. McGraw-Hill, New York

Chapter 13
Patterns Within Patterns

13.1 Summary

Design patterns enable people to envision the future: not only developers, but all stakeholders.

© Springer-Verlag London 2015 101
A. Marcus, *HCI and User-Experience Design*, Human–Computer
Interaction Series, DOI 10.1007/978-1-4471-6744-0_13

13.2 Introduction to Design Patterns

In past essays of "Fast Forward," I have written about the computer-human interaction (CHI) community being a gathering of tribes from many disciplines and incorporating wisdom from diverse fields. One example of cross-disciplinary fertilization is the adaptation of architectural design patterns to user-interface (UI) design patterns. As a former faculty member in a university's school of architecture and urban planning during the late 1960s and early 1970s, I was aware of Christopher Alexander's (Alexander et al. 1977; Alexander 1977) pioneering work at the University of California/Berkeley in establishing underlying paradigms for built form that are more general than specific solutions or standards but more specific than principles and guidelines. There were other practitioners of the time, like the Princeton University's Urban Research Center, exploring "user-centered design" (we called it "participatory design" even then), and I had wondered in the first decade of SIGCHI whether CHI community professionals would rediscover architectural and urban planning concepts, terms, and principles that could be adapted to UI development. They did. In fact, the process is currently under way, thriving, and gaining adherents…and Alexander's writings about design patterns have gained new currency in the CHI community.

Design patterns are formalized descriptions of proven concepts that express nontrivial solutions to some design challenge. Design patterns consist of a set of contexts, common challenges (called problems), descriptions, enumeration of forces on the general resolution of the forces, and their impact on the final solution. In the original theory, architectural design patterns were relevant at all scales of built form, from parts of rooms to buildings, neighborhoods, and entire urban areas. In UI theory, design patterns are applicable for all user types, applications, platforms, content, and markets. The objective of using design patterns is to increase the quality of well-designed UIs with improved usability, usefulness, and appeal.

As one group of theorists put it, a primary goal of patterns is to create an inventory of solutions to help UI designers resolve challenges that are recurring and difficult (Loureiro and Plummer 1999). Another theorist commented that patterns provide good solutions to common design challenges within specified contexts by describing invariant qualities of all those solutions (Tidwell). An important idea is that design patterns capture the essence of a general solution in a way that enables other people to design, evaluate, and build it more easily and successfully.

So, what are the benefits of using UI design patterns? Well, for one thing, they are supposed to supplement existing documentation by providing background reasoning for the solution, which guidelines and standards may not. Of special importance is the ability of design patterns to serve as a means for exchanging ideas among different disciplines and stakeholders, making it possible for engineers, designers, evaluators, marketers, funders, and, yes, even users, to communicate more effectively with each other. Design patterns capture knowledge, promote reuse, and require only hours to apply, even though they may have taken many years to create. As such, they are valuable intellectual property.

13.3 Pattern Parts

To understand patterns better, consider the way their basic parts are described:

- *Name:* The name or title of a pattern expresses its benefit (like "Non-Stop Shopping" for a commercial Web site). The name should be easy to remember and use. Keep in mind that others, including you, will be looking through large collections of patterns searching for something that may have an unusual moniker and you might have difficulty finding the right one if the name is obscure or too witty.
- *Context:* The context identifies the user's specific goal or primary goals. The context must be focused, clear, precise, and easy to comprehend.
- *Problem:* This part of the description captures the objectives or intent of stakeholders, especially the user. The challenges facing the developers as well as the users can be included. This part describes the designer's goals.
- *Forces:* Any context is made from a set of forces. This part describes those relevant concerns and how they inter-relate. A design pattern resolves conflicts among these forces to reduce stress and to provide a general configuration that can be recognized, used, and reused. Poorly designed patterns fail to contain these forces, and tension, or unresolved forces, tends to spill into neighboring patterns within a complex field or set of hierarchically related patterns.
- *Solution:* This part describes how to realize the desired outcomes.

If this terminology sounds a little confusing, or mystical, well, it is. Alexander describes qualities of form that seem quasi-religious or cultish and are perhaps culture-biased. As a result, some professionals criticize the theory. However, his goals are to create forms that make people feel more active, happy, and satisfied. To that extent, it sounds somewhat like achieving usability, usefulness, and appeal.

13.4 An Example

To give a concrete example of design patterns from a Web UI context, consider how to move from one page to another:

- *Name:* Paging controls
- *Context:* A list may contain too many items to fit on one page. An example: the results of a search.
- *Problem:* Users need a way to browse through a long list of items.
- *Forces:* The number of items that can be returned may be limited by system performance. Users need to directly access positions within the list.
- *Solution:* Group items into pages. Provide paging controls above and below the list. Rationale: Dividing a list into shorter, manageable pages makes it easier to view and navigate the constraints. Users are given ways to navigate the list easily.

Notice that the design pattern does not provide detailed descriptions or advice about a specific solution with a particular browser, query application, and specific contents. Rather, the design pattern seeks to allow a reader to understand essential components and relationships.

13.5 Pattern Patter

Design patterns are associated with events and spaces. A typical architectural pattern was the seat of a bay window, which was comfortable for sitting and reading, or watching the world go by. What repeats in the patterns are not specific elements, but relationships—among the seat, the window, the light, the size of all elements, the location within a room, and so on.

Design patterns are different from design standards and from traditional UI documentation. They are solutions to recurring challenges for a specific context. They do contain information about users, context, and tasks and therefore can serve as guides for usability, usefulness, and appeal. They also point to other patterns in a hierarchical network of patterns. They are intended to support, not replace, other forms of documentation.

To design collections of design patterns is itself a challenge. There should not be too many, making it difficult to find the right kind. They should be organized well, and with as few conflicts in their approach, nomenclature, and descriptions, as possible. They should not point to a specific solution; that is *not* their purpose. They do require some experience to apply well, but with rapid development of technology and markets, they enable new techniques and constructs to be covered that are not adequately documented in the "classic" texts. In general, design patterns are discovered, not invented, not created by fiat or committees. They result from commonality in many examples of actual use that work well or feel right or are judged successful not only by professional juries but by users in the marketplace.

One special quality of design patterns is that they have the capacity in a large, well-organized collection, to work together as a kind of language, that is, a rich set of signs and a grammar for combining them. A subset can even define a style, like southern Greek island houses versus northern California Victorian houses versus northern North American igloos. Variations will exist, even within a subset. Yet, these design patterns, related patterns, subsets, and supersets provide a rich set of ways in which human experience can be enabled. In our profession, that means human communication and interaction is enabled.

Design patterns have value for both designers and non-designers. Design patterns serve people who have a basic understanding of design principles and, in a professional sense, are "responsible for" or "own" the design. Professional designers may need to find references when designing for an unfamiliar context outside their immediate domains. Challenging contexts include those in which they may lack experience in particular topics, like searching; those with the constraints of particular platforms or medium, like handheld devices or Macromedia Flash; those

in which they need to learn or be reminded of key points; or those in which they must pass on, as experienced practitioners, lessons learned to someone new to the territory.

Non-designers also can use design patterns; that is, they serve people who do not have a formal design background but are stakeholders. These stakeholders include engineering, business, marketing, and pure usability specialists, researchers, and, of course, users. For many of these people, their goal, more than performing an analysis, is getting to a solution. They need patterns within their known domain, and it may be nice but not necessary to have analysis included. The patterns must reinforce usability principles, encourage adherence to standards, and promote best practices. In this way, patterns are like an informal toolkit. Users can look through a design pattern catalog and say, "oh, yes, I definitely need one of those, now that I understand what it does," even if they don't know the proper name of what they are examining.

13.6 The Future of Patterns

UI design pattern collections are available both in print and on the Web (for example, (Tidwell; UI interaction patterns; Welie Web design patterns)). Software engineering has embraced design patterns, also. As the number of items in the UI design pattern collections grows larger, the organization of content becomes more important; otherwise, the collections may become difficult to use. Hong et al. (2002) published a large, broad collection of Web site patterns. Common Ground (1999), another provider, organized its collection around the following categorical questions:

- What is the basic shape of the content?
- What is the basic shape of the actions taken with the artifact?
- How do the content or available actions unfold before the user?
- How does the artifact generally use space and the user's attention?
- How is the content or action organized into working surfaces?
- How can the user navigate through the artifact?
- What specific actions should the user take?
- How can the user modify the artifact?
- How can the artifact be made visually clear and attractive?
- How else can the artifact actively support the user?

Many UI design pattern collections seem focused and, thus far, best suited for concrete, tangible elements, like paging controls, use of tabs, L-shaped screen layouts, shopping carts, and so on. Dealing with more abstract components, like disabling irrelevant controls, or providing persistent customer sessions seems to require problem statements that are too general, require unique analysis, be harder to organize, and be domain specific. Recall that the original architectural design patterns were about concrete, differentiated space hierarchies, like rooms, building, neigh-

borhoods, regions, and cities. Interaction patterns describe both space and time, and the temporal dimension is related strongly to principles of human behavior. The subjects of cognitive psychology, persuasion, customer service, and so on may inevitably involve principles that are not so neatly hierarchical and thus may be harder to describe in the conventions of patterns. Nevertheless, attempts are being made to broaden patterns to all aspects of what I have defined in the past as primary UI components: metaphors, mental models, navigation, interaction, and appearance.

The nomenclature of patterns may become more complex in the process and may involve some of the typical elements of large bodies of content: version and status; authors or editors; summaries; introductions for readers; glossaries of terms; and varieties of pattern names, including technical or scientific, popular, and alternate professional.

As UI design pattern catalogs become ubiquitous and enlarge to become giant compendia, in order to remain useful across disciplines—one of their key strengths—they must remain domain specific and, in the users' language, not overly formal. Remaining so may enable UI design pattern collections to become a *lingua franca* by which CHI professionals from many tribes can communicate, enabling all interested parties to smoke a peace pipe and achieve harmonious, desirable solutions that benefit users while achieving other stakeholder objectives.

13.7 Postscript 2015

A Google search returns about 93 million hits for the term "design patterns" on 15 March 2015, a bit more than the 88 million for "emotion design". Clearly the general population and professionals are adding to the stores of knowledge about design patterns. Interestingly, the top hits refer to software-design solutions, rather than HCI/UX design solutions, a tribute to the growth of interest into that field from its origins in architectural design.

Having HCI/UX design-pattern solutions seems ever more important in the current age of extremely fast (2-week cycles) of software development stages for products/services, where, under Agile or lean methods, it seems ever more crucial to have at hand quick guidance for general solutions that are more likely to be usable, useful, and appealing.

References

Alexander C (1977) A timeless way of building. Oxford University Press, New York. ISBN 0195024028

Alexander C et al (1977) A pattern language; towns, buildings, construction. Oxford University Press, New York

Borchers J (2001) A pattern approach to interactive design. Wiley, New York. ISBN 0-471-49828-9

Common Ground (1999) UI patterns. Available at http://www.mit.edu/~jtidwell/common_ground.html

Gamma J, Helm V (1995) Gang of four software design patterns. http://hillside.net/patterns/DPBook/GOF.html

Hong JI, Landay J, Van Duyne D (2002) The design of sites: patterns, principles, and processes for crafting a customer-centered web experience. Addison-Wesley, Boston, 0-201-72149X

Lafreniere D, Granlund A (2004) Describing and using patterns for UI design. In: Usability Professionals Association (UPA) annual conference, UPA extended proceedings

Lafreniere. http://www.gespro.com/lafrenid/patterns.html

Loureiro K, Plummer D (1999) AD patterns: beyond objects and components. Research Note # COM-080111, Gartner Group

Patterns and software. http://www.enteract.com/~bradapp/docs/patterns-ointro.html

Tidwell J. Common ground: a pattern for human-computer interface. http://www.mit.edu/~jtidwell/interaction_patterns.html

UI design process patterns. http://c2.com/ppr/ui.html

UI interaction patterns. http://www.pliant.org/personal/Tom_Erickson/InteractionPatterns.html

Welie Web design patterns (Amsterdam collection). http://www.welie.com

Chapter 14
User-Experience Planning
for Corporate Success

14.1 Summary

Good news for the CHI community: Behind the scenes, corporations are re-organizing to achieve user-centered products and services.

© Springer-Verlag London 2015
A. Marcus, *HCI and User-Experience Design*, Human–Computer
Interaction Series, DOI 10.1007/978-1-4471-6744-0_14

14.2 Introduction

In past chapters, I pondered the semiotics of the term "user experience." Meanwhile, corporate groups worldwide have been busy carrying out activities under different colors of this banner according to their own interpretations of the concept. At present, many different tribes of the CHI community are merging, re-organizing, and restructuring, to achieve a more efficient, productive, and successful development of user-centered products and services, the byproduct of which is a standard for future design.

At IBM Canada, long-term user-advocate, Karel Vredenberg, Program Director of Corporate User-Centered Design and User Engineering, recently published his approach to the problems of interface design today (Donoghue 2002). One such approach – on corporate responsibility in user-interface design and now available on IBM's intranet – not only exemplifies the trend toward consensus and refinement of user-interface design principles, but also demonstrates a trend in corporate validation of the practice.

Similarly, corporate commitment to the user-experience is expressed at the highest levels at HP, where CEO Carly Fiorina has made the concept of achieving a quality user experience the hallmark of her approach. As her Web bio proclaims, "Under her leadership, HP has returned to its roots of innovation and inventiveness and is focused on delivering the best total customer experience."

However "user-experience" is ultimately defined, corporations worldwide are rethinking their objectives, structures, and processes to achieving excellent design. This is good news for the CHI community, but it also means challenges and competition with other disciplines for executive budgets and mindshare. Here are just a few of the groups that might be centralized, decentralized, matrix-managed, blended, merged, and/or purged:

- Branding
- Experience design
- Graphic design, visual communications
- Hardware design, engineering
- Human factors, ergonomics
- Industrial design, product design
- Industrial engineering
- Marketing communication
- Software engineering
- Technical documentation
- User engineering
- User-centered design
- User-interface design, development
- User-experience design, engineering

CHI's own Internet discussion recently focused, in part, and significantly, on how to organize and manage user-experience groups. Many are asking critical ques-

tions, and managers with different areas of expertise and experience have generously shared their views. I have been monitoring this traffic and summarize here what seem to be the critical issues for success.

In an era in which usability, usefulness, and appeal all vie for attention, corporate managers face the complex task of educating and working with executives, management, staff, third-party vendors, customers, and users across many disciplines. Their objectives are complex, but revolve around best practices, development processes, and organization to achieve success in terms of bottom line, sales, costs, technology, customer satisfaction, and brand. The following is an initial organization of issues for those strategizing a winning user-experience, be it in development, design or engineering.

14.3 Best Practices

- How do/should you promote best practices? Intranet, publications, workshops, proselytizing, and/or convince the CEO?
- What would/should your internal customers say is the value proposition your group brings to the: company, the external customer, the development process?
- Are you viewed as a strategic resource, or a service organization? Why/why not? Is this good or bad for your future role?
- How do/should you create, store, make available, monitor, and maintain best practices? Paper, digital, and/or other media? Committees, watchdog groups, and/or roving unannounced inspections by the user-experience police?
- What are/should be the topics of best practice? Where does it stop, *e.g.*, do you include marketing advice/requirements for designers who are placed in decentralized offices?
- What technology/techniques support best practices: Intranet? Extranet? Collection of documents? Paper publications such as newsletters or periodicals? Special group of evangelists? Tutorials? Executive workshops?

14.4 Branding

- Are/should you push beyond usability and product design into the realm of branding and brand management?
- Do you think there is/should be a tight mapping or natural transference of user experience skill sets to brand management?
- Is branding a good field in which to expand the influence and impact of user experience development on a company? Why/Why not?
- What are the opportunities, challenges, and risks of user-experience staff assuming branding tasks, or claiming/performing branding skills/tasks?

14.5 Development Process

- What development process do/should you follow?
- What are the main phases or steps called?
- Who develops/authorizes/maintains/monitors the process?
- What impact do/should international, regional, local differences have on this process?
- How might people be organized better to "work this process?"

14.6 Evaluation

- Does/should your group utilize any type of metrics to gauge successes? Which? How?
- Have you/should you benchmark current or past practice?
- How can return-on-investment (ROI) be communicated to ensure budgets for this activity?

14.7 Funding/Budgets/Charging

- How does/should a group get funded?
- Do you charge your client for your work? How do you invoice? How do you get paid?
- Where can one go to get advice, history, metrics, and best practices on getting funding?
- Where can one get ROI data to support initiatives?

14.8 Hot Topics

- What are/should be the hot topics of user experience?
- How can/should they drive allocation of resources, markets, best practices *vs.* next practices?
- What role does research play in your group and exploration of hot topics?

14.9 Management

- How do/should you manage your group?
- Centralized? Decentralized? Matrixed? Virtual?

- Do you have an oversight group to monitor, manage, promote best practices?
- How can you/should you manage funding, budget allocation, political relations across functional groups and disciplines?

14.10 Models

- What models do/should you use for your organization?
- What unique models are people trying/should be tried besides the traditional ones?
- Have you considered/should you consider an organization based on teams focused on user models and/or user types (profiles, personas)?
- Is there/should there be a concerted effort to define user types corporate-wide? How can you get buy-in to this approach?

14.11 Organization

- How is your team organized? How could/should it be? Are you centralized or decentralized? Matrixed? Should you be?
- What do big/small companies need?
- What is the impact of position, corporate culture, and level of support for user-experience-oriented development?
- Where in the organization does the group reside? Should it be so?
- Is the corporation/your own organization fundamentally aligned with the need for user-centered design?
- Does the group have a champion that is in a position of authority, accountability, and influence to support the group? If not, how can you develop such a champion?
- How many people need to be in a proper small team to be successful?
- As the organization grows does it become easier to do high-gain projects (e.g., improved methodologies, internal standards, process improvement support, etc.)?
- As the organization grows, do you /should you drive strategically important projects (i.e., be assertive in getting involved as opposed to just being responsive)?
- What can guide the evolution of organization? Evaluation procedures? Best practice documents?
- Is it possible to semi-decentralize?
- How many people are/should be in your group for maximum effectiveness?
- To whom do/should people report? How? How often?
- What are the types of disciplines involved in your group?
- Should engineering be involved in cross-disciplinary teams? Why/Why not?
- Should marketing be involved in cross-disciplinary teams? Why/Why not?

- Should business/product managers be involved in cross-disciplinary teams? Why/Why not?
- Should representative user-managers and/or users themselves be involved in cross-disciplinary teams? Why/Why not?
- What are the numbers of people (distinguished by management, professionals, and administrators) in each of the discipline groups?

14.12 Outreach

- How do/should you market and sell your work?
- Do you offer training as well as professional services? What kind? What subjects? How often? How charged? How managed?
- How do you work with third parties to complete client projects? Send out work? Bring staff on your site? Bring staff onto client site?
- Are you planning for off-shore provision of services? How? With whom?
- Does your group actively sell/promote its work to your internal customers? How?
- How do you evangelize?
- Do you know who your key stakeholders are? Are they generally recognized and communicated with in your organization?

14.13 Outsourcing

- What disciplines are best kept within your own area to preserve core expertise?
- What tasks are best given to others?
- To whom should one assign the outside tasks?
- How can one set up an efficient process to certify and monitor outside resources?

14.14 Tools

- What tools for calendar, project planning, timesheets, invoicing, reporting, *etc.*, are/should be used? (Design groups have long complained that applications designed/built for engineering and business do not serve their own needs, and vice-versa.)
- What tools for research, analysis, design, implementation, evaluation, documentation, training, maintenance are/should be used?
- Specifically, what tools for prototyping are/should be used? Does your group manage/maintain these tools?

14.15 Conclusion

The industry is rapidly evolving new paradigms for doing business under ever tighter constraints of budget and increased demands for metrics, accountability, and well-managed processes. It seems likely that within a year or two, many major corporations will have significantly re-organized their groups, developed best-practice resources, and retargeted their focus. Giving attention now to asking the right questions and taking time to explore their answers will give CHI-community professionals enhanced competence and status in leading the groups that produce better user experiences in the decades ahead.

14.16 Postscript 2015

In recent years, the rise of Chinese competitors to Western development centers has continued to cause re-organization and search for unique innovative design solutions that can maintain market dominance. This pressure continues to make the issues cited above relevant. Of course, within China, they are even more pressing, as companies quickly encounter the same challenges. It remains to be seen what the outcome will be in 10–20 years. One somewhat harmonious, peaceful scenario would be simply that China, South Korea, Japan, India, Europe, and North America would all compete with improved methods in a somewhat balanced, continually shifting market place. We shall see...

References

Donoghue K (2002) Built for use: driving profitability through the user experience. McGraw-Hill, New York

Fleming J (1998) Web navigation: designing the user experience. O'Reilly and Associates, Sebastopol

Garrett JJ (2002) The elements of user experience: user-centered design for the web. AIGA and New Riders, New York

Gilmore JH, Pine JB II (1999) The experience economy. Harvard Business School Press, Cambridge, MA

Hiltunen M, Laukka M, Luomala J (2002) Professional mobile user experience. IT Press, Edita, Helsinki

Kuniavsky M (2003) Observing the user experience: a practitioner's guide to user research, Morgan Kaufmann Series in Interactive Technologies. Morgan Kaufmann, San Francisco

Microsoft Corporation (1999) Microsoft Windows user experience. Microsoft Press, Redmond

Vredenburg K, Insensee S, Righi C (2002a) User-centered design: an integrated approach, Software Quality Institute Series. Prentice Hall, Upper Saddle River

Vredenburg K, Stanney KM, Salvendy G, Oshima M (eds) (2002b) Designing the total user experience at IBM: an examination of case studies, research findings, and advanced methods. Lawrence Erlbaum Associates, Mahwah

Chapter 15
Insights on Outsourcing

15.1 Summary

Outsourcing: What's in it for us? For them? Where are we headed?

© Springer-Verlag London 2015
A. Marcus, *HCI and User-Experience Design*, Human–Computer
Interaction Series, DOI 10.1007/978-1-4471-6744-0_15

15.2 Introduction

We are living in historic times. Some might say we are living in interesting times. I'd like to think that the rapid international changes of the past decades and those currently underway portend global improvements, not degradations. Who but a few could have imagined 50 years ago a dismantled Soviet Union, a unified Germany, Chinese astronauts, Indian technology growth, and a European Community of some 450 million people and growing? Some of these large-scale global developments may seem like distant rumblings to the local interests of individual CHI communities in North America and Europe, but, for some researchers and practitioners, they have serious and immediate, consequences.

A topic of considerable interest and concern to many of us is the outsourcing of professional jobs from the West to India, China, and elsewhere in Asia and South America. Articles in almost every major news publication—*Business Week, The Financial Times, Forbes, Fortune, The New York Times, Time Magazine, The Wall Street Journal,* and *Wired* have commented on the trend in depth. What is happening? How do we understand it? And what can we expect in the future?

Having had an opportunity to lecture at the Asia-Pacific CHI conference (APCHI 2002) in Beijing, China, and recently at the Fourth Annual South-India CHI conference (*Easy4* 2004) in Bangalore, India, it seems appropriate to reflect on what I have learned and to share my thoughts. They focus to a large extent on my more recent experience in India and my observations on outsourcing as it relates to our professional concerns.

15.3 The Current Situation

Newspapers, magazines, television, and the Internet have been buzzing about the significant numbers of high-technology jobs going off-shore. One estimate is that the U.S. lost 400–500,000 jobs (out of 130 million) to foreign markets in 2003 (Dolan et al. 2004). In early 2004, the top US employers in India were General Electric (17,800 employees), Hewlett-Packard (11,000), IBM (6,000), American Express (4,000), and Dell (3,800) (Pink and Daniel 2004). These numbers are expected to grow. Currently, the number of information technology (IT) professionals in India is somewhere between 140,000 and 500,000 according to varying estimates, and these figures could double within a few years. The trend is not new, but the attention is. As early as the 1980s, software centers in Singapore provided products to western PC manufacturers, and made software development a matter of national priority. Now analysts predict that by 2050 the economies of China and perhaps India will outgrow the U.S. economy (Sachs et al. 2004).

In the past few decades call centers and software development centers employing thousands have sprung up across India. By early 2004, the Indian economy was expanding at a rate of 8 %, second only to China, with the largest of these companies, Infosys Technologies, Wipro, and Tata Consultancy Services continuing to

absorb smaller ones. The situation has become more complex recently because companies like IBM are now buying Indian companies like Daksh eServices, the third-largest Indian call center and back-office service provider, while more U.S. companies are expected to follow suit.

Much of the news about Indian high-tech development has focused on Western developments in Bangalore. Already the population of Bangalore, the pre-eminent "Silicon Valley" city of South India, has doubled in 2 years to about seven million people. The last period of doubling took 40 years. Increased business and consequent population have brought the predictable traffic jams and pollution to what was once a quieter, lovelier city with many tree-lined streets, and a pleasant climate. Now, job-hopping young professionals who inhabit cubicles—much like their counterparts in Santa Clara, California, or other high-technology centers in North America or Europe—consider the latest announcements for positions where 200 new-hires per day per company are advertised.

The orientation to outsourcing business processes seems to continue unabated, even though some companies have expressed concerns about some problems of quality and have actually taken back call centers to the U.S. These Indian call centers face attrition forces that require them to hire more people than needed, investing in repeated training and recruitment, with consequent dips in productivity, efficiency, and quality. Keep an eye on this phenomenon as the kind of jobs migrating involves more than call centers and back-end software development and maintenance.

Most of the focus on IT development has centered on custom software development, software maintenance, IT documentation, IT telephone support, remote network monitoring, software re-engineering, systems management, and IT administration and operations. What is significant to the CHI community, from my experience in both China and India, is the push not only for these "back-end" tasks, but also for higher-value "front-end" tasks that are considered by many Western professionals to be secure because they are the more "creative" parts of product and service development. These include such CHI–oriented "user-experience development" tasks such as the associated technology research, usability analysis and evaluation, including testing, conceptual design, and even detailed visual design.

Salaries in India for programmers might be $8,000 per year while skilled visual designers might earn $4,000 per year. (The call center staff members start at $200–$300 per month or $2400–$3600 per year (Friedman and Thomas 2004), which is itself a better salary than other non-IT possibilities). If the pay rates for usability professionals in India are one tenth to one half those in the U.S., this difference poses a serious challenge to Western professionals. Will CHI/UPA-type jobs disappear to offshore locations, too?

15.4 The Story Becomes More Complex

What I learned both in China and India is that the user-interface design and usability analysis/evaluation professions are also growing.

At APCHI 2002 in Beijing hundreds of Chinese professionals from many of the Western companies located in a half-dozen locations throughout China who knew of and/or were comfortable with SIGCHI/UPA, convened at the conference, as well as at smaller independent usability and design offices. The numbers are small now, but they will inevitably grow. Already, savvy professionals and academics like Zhengjie Liu, at Dalian Maritime University in China, are offering to partner with foreign companies for mutual benefit. The local offices of companies such as Microsoft or Siemens in Beijing are small and serve their parent companies, yet it seems likely that entrepreneurial employees will soon set up their own independent services and seek other corporate clients. The same pattern appeared in Japan and Korea in previous decades. Twenty years ago our firm arranged for a Ricoh employee to spend a month working at our site on a user-interface design manual for office products, a new development at the time. Shortly after, he left Ricoh and started his own firm which competed with ours for Ricoh's business. His approach was somewhat bold and unusual in the corporate culture of Japan at the time, but it was a harbinger of current entrepreneurial spirit among user-interface designers and analysts in these countries.

In India, the CHI-South India conference attracted 120 people; the attendance was already 50 % larger than last year, and I fully expect it to attract many more attendees in the future. Keep in mind that this conference brought together professionals primarily from South India, i.e., Bangalore and Chennai (formerly Madras), two of the major centers in South India. Other centers will probably offer their own gatherings. In addition, suburban centers around New Delhi (Noida and Gurgaon), as well as centers in Mumbai (formerly Bombay), Kolkata (formerly Calcutta), and other locations have sprung up. According to Reena Choudhary (2004), the most IT-inclined city is the northern city of Hyderabad, which has the largest budget allocation for IT in India, followed by Mumbai. All of these centers will be growing professionals in user-interface design and analysis, as well as software engineering. In fact, even though the country has only 3.7 million personal computers, it has the largest number of software professionals outside of California in the world and exports software worth about $8 billion in 2003–4, much of it to the US (Sood and Aditya 2004).

A steady stream of professionals is being produced at India's universities, including the famous Indian Institutes of Technology, which are located in several major cities throughout India. I am told that students consider Harvard University a second choice if they cannot enter the IITs, for which competition is intense. Many design schools also exist in India, with the National Institute of Design in Ahmedabad being one of the best known internationally. Coupled with Indian Institutes of Management, it seems likely that there will be no lack of professionals in business, engineering, marketing, and design to enable India to continue its advancement of full-service provision.

Discussions in the press have focused on software and call centers, but what is of interest to the CHI/UPA community is the demonstrated ability of Indian firms to take on the new development of products and services. While I was in Bangalore, I visited one software development firm that was currently engaged in new product

development of mobile telecommunications applications for a world leader in mobile devices. What I witnessed was not only back-office software development, but also state-of-the-art new-product development for demanding consumer-oriented global markets. In two other cases, I interviewed members of high profile usability and design groups, one from the Indian R+D office of a major U.S. corporation, another, a local Indian software firm that had achieved significant growth. To my surprise, I saw in their analysis and design portfolios, for two very different product categories, examples of work that my own firm had failed to win. It seemed clear that these Indian firms had already presented formidable competition for the kind of analysis and design work that outside consultants, analysts, and designers, like us, might provide. What might there be left to do if many of these tasks go offshore?

This shift is not limited to India. In China, I encountered companies like Legend, now renamed Lenovo, which has been a primary supplier of software to IBM. The company's white, gleaming, steel and glass headquarters in Beijing looks like any high-tech development center. At APCHI 2002, Legend/Lenovo hosted a one-day usability workshop where participants exchanged reports on their profession in China, Japan, Europe, and North America. Legend/Lenovo reported on the company's growth and its plans to become a significant force in product development—not merely a back-end engine. Clearly it will have to focus on usability for its offerings to flourish.

15.5 The Future

At least one usability firm has taken the bold step to make a significant effort to grow its own service-engine in India. Human Factors International, based in the US, now has 60 people in Mumbai and expects to hire many more in the coming year. Their services will be primarily oriented to servicing clients in North America and Europe.

Discussions about the effects of outsourcing on the future of our professional lives seem to be binary. Some dismiss the likelihood that offshore design and usability professionals will loosen North American and European professionals' hold on product and service development. Others seem anxious and pessimistic about the impending collapse of jobs and markets for their services. Both speak of "core competencies" in Western businesses. But what are these exactly? Of the basic user-interface development tasks, which ones are impervious to cheaper overseas labor: planning, research, analysis, design, implementation, evaluation, documentation, training, or maintenance?

It seems risky to think that Indian, Chinese, and other distant service centers will not be able to compete for more of the "creative" tasks of product and service development. Already one country, Singapore, has made commitments to becoming a "design center" not just a center for software programming and technical excellence. Of course, it remains to be seen how quickly these transformations will occur.

Nevertheless, many Asian countries have demonstrated remarkable progress in acquiring Western usability-oriented design and analysis skills.

The challenge of competition for jobs from abroad, and user-interface development in particular, gives us the opportunity to reflect on what exactly are our core competencies. For some, it is having particular knowledge of our own culture and our own customer market, whether it is general consumers or specialized operators of equipment. Consequently, one of the areas in which we might expect to maintain a hold is in planning and in detailed evaluation and design for our own "local" markets. (Keep in mind that in the future some North American businesses may be smaller, local branches of companies headquartered in China, just the opposite of today.)

Another potential position is in mentoring, training, and relating to the off-shore providers of services. Many professionals know how much this kind of project management is required for large, complex, multi-location projects, in which teams of people must be coordinated to maintain close attention to client and user needs. Given the great geographic and cultural differences involved, this task will be all the more important.

Finally, providing in the West (still a major target market) a local face to project teams and contact with key corporate customers is an important role that is unlikely to disappear. Local customers in the West want to have people on-site in the West who understand their context and objectives, as well as their language and culture.

All of these developments seem to indicate a continuing role for Western professionals while more and more positions are outsourced in an inevitable search by business executives for lower-cost resources.

One other development seems likely: Asian centers may develop local solutions to their own needs for technology that are better suited to their countries and their own diverse cultures. This thought was raised explicitly at the South-India CHI 2004 conference. Remember: although India possesses the world's largest democracy, it also has the world's largest middle class. In a land with 110 languages, 14 national languages, at least two major religions (Hinduism and Islam) and birthplace of a third (Buddhism), the country is a vast, complex web of cultures and should not be thought of as a monolithic group. The same applies to China. Both are sometimes erroneously viewed by Westerners as "single-culture" entities. Viewing Europeans as a single entity-cultural group would be a similar mistake.

Seeking local product and service solutions focused on inherent cultural orientations is already underway. In 2002 Sony-Ericsson developed a prototype for a PDA based on Chinese Confucian principles, or *Wukong*, which prefers context and relationship over application and folder organization. This project benefited from LiAnne Yu, a Chinese-American anthropologist, being part of the development team.

Another example of a culturally oriented solution is the recent announcement of an "Indian" handheld computing device. The availability of a $200, simple, easy-to-use "Simputer" is intended to solve specific challenges for use in rural India, though the device may have a significant market elsewhere in the world. It remains to be seen what local professionals will discover for their own communities by taking the

best of Western usability principles and merging them with their own interests and needs to produce innovative solutions.

The future will certainly see dislocations in the services industry for design and analysis, but there will emerge opportunities for the curious, eager, innovation-oriented professionals to contribute to a revolution, or at least to an inevitable evolution in the industry of computer-human interaction and communication.

15.6 Postscript 2015

The world is ever changing. Who might have predicted that the Euro would reduce its value to near parity with the dollar, as it was more than a decade earlier after its introduction? Who would have predicted the lowered cost of oil as new methods or extraction increased US supplies and pushed down prices? These factors, as well as increased political and economic instability in many areas of the world have affected the world of outsourcing (from the US to other countries). Some companies have returned their call centers to the US, both for financial savings and because of customer dissatisfaction with non-local representatives attempting to solve problems. For others, relocating remains a viable option. Mixed solutions are probably the norm in the coming decades.

One project we have been involved with in the past few years is to conduct a culture audit of multiple-location offices of a multinational software-development firm based in Silicon Valley trying to improve communication, cooperation, and collaboration (Marcus and Gould 2011) among its many offices. This objective represents an enlightened approach to dealing with outsourcing and improving the performance of all participants because of a respect for culture differences that can affect the delivered user experience to customers. It seems likely that such enlightened approaches will flourish, and in fact will be required in the years ahead.

References

APCHI (2002) In: Proceedings of the 5th Asia Pacific conference on human computer interaction): user interaction technology in the 21st century, Beijing, 1-4 Nov 2002

Baker S, Manjeet K (2004) Software: will outsourcing hurt America's supremacy? Business Week, 1 March 2004, pp 84–90

Chavan A (2004) The usability scene in India. User Experience 3(7), pp. 4–6.

Choudhary R (2004) IT's everywhere & more's on the way. The ET CIO survey, The Economic Times Bangalore (India), 30 March 2004, p 5

Clark D (2004) Another lure of outsourcing: job expertise. The Wall Street Journal, 12 April 2004, p B1

Dolan KA, Meredith R (2004) A tale of two cities. Forbes 2000/Offshoring, 12 April 2004, pp 94–98ff.

Easy 4 (2004). In: Proceedings. Bangalore, India. ACM/SIGCHI.

Friedman TL (2004) 30 little turtles. New York Times, 29 February 2004, pp Op–Ed, Weekend 12

Henderson CE (2004) Culture and customs of India. Greenwood Press, Westport
Luce E, Khozern M (2004) Outsourcing: 'the logic is inescapable': why India believes commercial
 imperatives will help it beat the offshoring backlash. Financial Times, 28 January 2004, p 13
Liu Z (2003) Where East beats West. User Experience 2(4):8–13
Marcus A (2004) The ins and outs of outsourcing. User Experience 3(6):2
Marcus A, Gould EW (2011) Improving a development team through culture analysis. Multilingual,
 September:48–52
Pink DH (2004) The new face of the silicon age: how India became the capital of the computing
 revolution. Wired, February:94–103
Sachs J (2004) Welcome to the Asian century. Fortune, January:53–54
Sood, AD (2004) Guide to ICTs for development. The Center for Knowledge Societies, Bangalore,
 India, info@ict4d.info
Thottam J (2004) Is your job going abroad? Time, 1 March 2004, pp 26–31ff

URLs

Center for Knowledge Societies: Mr. Amit S. Pande, amit_s_pande@yahoo.co.in, www.ict4d.info
CHI South India: Mr. Pradeep Henry, HPradeep@chn.cognizant.com, www.acm.org/sigchi
Chinese Center of the European Union's UsabilityNet: Zhengjie Liu, Dalian Maritime University,
 China; liuzhj@dlmu.edu.cn; http://usability.dlmu.edu.cn
Human Factors International, Mumbai Office: Dr. Eric Schaeffer, CEO, eric@humanfactors.com,
 www.humanfactors.com
Media Lab Asia (originally a partnership with MIT's Media Laboratory): Venkatesh Hariharan,
 Assistant General Manager; Mumbai, India; http://www.medialabasia.org
National Institute of Design in Ahmedabad: Prof. Darlie O. Koshy, koshy@nid.edu, www.nid.edu
Simputer: Simple computer for under $200: Vinay L. Deshpande, Director, Encore Software, Ltd.,
 Bangalore, India; vinay@ncoretech.com; http:www.ncoretch.com
Srishti School of Art, Design, and Technology: Geeta Narayanan, Director, Bangalore, India;
 srishtischool@vsnl.net; artdesign@vsnl.com; www.srishtiblr.org

Chapter 16
Branding 101

16.1 Summary

What's branding all about? Why do we have to care?

16.2 Introduction

In 2001, CHI featured an unusual panel session: Marketing people were actually invited to come to CHI to explain what they did and why it was important to the objectives of SIGCHI. Boyd de Groot, Peter Eikelboom, and Florian Egger

© Springer-Verlag London 2015

A. Marcus, *HCI and User-Experience Design*, Human–Computer
Interaction Series, DOI 10.1007/978-1-4471-6744-0_16

organized the session in which I was privileged to participate. I am pleased they made this effort. As they remarked about how extraordinary it was to have dedicated marketing professionals at CHI, especially in presenter roles (I agree), the comments being exchanged among CHI professionals gave me the feeling that I was in a "Dilbert" comic strip, listening to the amusing, outrageous jibes of those characters.

The antagonism and misunderstandings are familiar, from both sides of the fence. In one recent Internet discussion, a CHI professional asked plaintively if we were actually going to have to include the branding people in our design process. Well, CHI folks, it turns out that branding, a key aspect of marketing, is also a key aspect of the success of user-interfaces. Not that usability, visual design, information design, and the like are not important; *au contraire*, they are crucial. It's just that branding has a definite role to play, and user-interface developers who ignore marketing departments—especially branding groups and their market research studies—do so at their own peril.

It's easy to poke fun at marketing and branding by picking on some of the people who may lead departments or carry out corporate projects. However, I know that one can find equally ill-suited people in charge of usability, product development, software development, and user-interface development. In my 22 years in this field, I've encountered a few of each kind. Let's be fair and admit there are all kinds of people, and no one profession, not even medicine or law, is spared a distribution curve of competence.

So, let's take a look at what CHI folks might need to know about branding. I call it Branding 101.

16.3 Some Anecdotes

Let's start with some anecdotes.

Philippe Starck, a French product designer (you might know his innovative, single-piece, tall, metal three-legged juicer) who is internationally famous as a hotel, furniture, and appliance designer, has been exploring the possibilities of adding his design and branding expertise to lesser known Asian manufacturers. He believes that his new branding consultancy called "The Key" can transform these anonymous companies into global brands by adding "style." For him, this comes from a respect for the "elegance of engineering" (Cheng 2004).

Business Week regularly devotes attention to good design and in a recent cover story turned its attention to one well-known product development firm focused on "creating experiences, not just products" that have a brandable quality (Nussbaum 2004; Business 2004).

Currently, major marketing, advertising, and PR firms are busy developing the brand for China, not just for the 2008 Olympic Games, but also for China's presence in the world in general. Similarly, the *Financial Times* reports on discussions seeking to brand products manufactured in the European Union as "Made in the EU"

and to reduce the presence of individual national brands (Buck 2004). Clearly, branding concerns have risen to national and pan-national levels.

Considering the origins of branding, which goes back to the earliest shepherds marking their flocks, can be enormously instructive. One of my favorite brand books is my cherished copy of the 1967 *State of Nebraska Official Brand Book*, which lists all the cattle brands of Nebraska officially registered that year (Beerman and Harris 1967). (Omaha, Nebraska, was once the nation's leading stockyards and cattle processing center.) Some 860 pages depict the approximately 37,840 visual forms that were literally burned into the hides of cattle and, figuratively, into the minds of attentive cattle managers, cowpokes, and would-be rustlers, all stakeholders in the cattle business.

Speaking of burning brands into the mind, magnetic resonance imaging (MRI) used to scan the brain, now reveals exactly where memories and other impressions of Coca-Cola seem to shape preferences that can actually override taste buds and, in some blind trials, led subjects to make other choices than what their taste buds told them (Burne 2003).

16.4 Branding Summarized

So, what is this thing called branding? Many have attempted to explain it, as the bibliography and URL resources below attest. James Gregory, for one, briefly defines a corporate branding relationship among all stakeholders, including the consumer, as the following:

- Intentional, marketing-oriented communication across all business units, media, and audiences (users).
- Planned, inclusive strategy that sets communication (some would now say experience) standards and policies for all corporate groups for the cumulative benefit of the corporation.
- A declaration of "who we are," "what we believe," and "why you should trust us."
- A promise the company can keep to all its stakeholders: its customers, the trade, stockholders, and its own employees, and therefore a valuable investment in the company's future.
- Visionary, targeted, and controlled forms of all planned communication, advertising, packaging, architecture, vehicles, if "styled to create a specific impression" (Gobé 2001).

Gregory argues that the value of branding can be found in the stock price, simple as that. Some would disagree, but almost all recognize the value of well-known names and positive associations, emotions, and attitudes of consumers generally, both locally and globally.

Another approach is taken by Hugh Dubberly who uses the language of semiotics to speak of brands as "signs" that embody not only the name but also stakeholder

perceptions that grow out of experience with a product or service (Dotz and Morton 1996). Brand managers are called "stewards," and are responsible for maintaining and growing a positive experience in all forms of contact between products, services, and stakeholders. The details of the model Dubberly creates are quite complex and too numerous for this essay, but they constitute a taxonomy of all verbal, visual, personal, acoustic, even olfactory means by which the brand can be conveyed. Some examples are these:

- Graphic devices like Target's target, Corning's pink insulation, and Kodak's yellow, or Coke's and IBM's typography at various periods of time.
- Shapes, like those of the Volkswagen Beetle or the Apple iPod.
- Surfaces or tactile qualities, like Velour shirts, or Angora sweaters.
- Smells, like those for Shalimar, new BMWs, or McDonald's french fries.
- Spokespeople, like Martha Stewart for her own enterprises or Bill Gates for Microsoft.
- Words, like Coke and Coca-Cola.
- Auditory cues, like "Intel Inside," the telephone's dial-tone, or the sound of a Mercedes door closing.
- Words, natural or artificial, like Oracle, Apple, Kodak, Huggies or Wired, including ones that have passed into public usage like Kleenex, Xerox, and even Google to become generic nouns or verbs.
- People/characters, either real, like Ben and Jerry, or fictional, like Betty Crocker, Mickey Mouse, or Hello Kitty.

In fact, in relation to user-interfaces in particular, I have maintained for decades that all the key components of user-interfaces can be—and in many cases will be—branded: metaphors, mental models, navigation, interaction, and appearance. The above list exemplifies some, but not all of these components.

As with other theorists and practitioners, both Gregory and Dubberly suggest that brand efficacy can be measured:

- *Position*: the relationship of one brand to another, in terms of categories of competing brands, relevance to one's needs, and ranking within a category.
- *Reach*: the extent, in numbers, of people affected, in terms of recognition by a percentage of people in a given geography, the frequency of exposure, the frequency and duration of use, and market share within a category.
- *Reputation*: the positive (or negative) attributes assigned to the brand, in terms of emotional attributes (affinity, trust, respect, preference, liking, accepting, rejecting, etc.), rational attributes (value, consistency of experience, and clarity of the brand's purpose), and personality (sometimes called tone, character, or voice, such as young *vs.* mature, playful *vs.* serious).

As Dubberly notes, and as one can determine from other Web sites, there are other means of evaluating brands, such as Young and Rubicam's Brand Asset Valuator (see URL cited below), which measures brand value by using four general dimensions oriented to consumers that are similar to, but not always identical to the terms just mentioned above for all stakeholders:

- *Differentiation*: the ability for a brand to stand apart from its competitors. A brand should be as unique as possible. Brand health is built and maintained by offering a set of differentiating promises to consumers and delivering on those promises to increase value.
- *Relevance*: the actual and perceived importance of the brand to a large consumer market segment. This dimension measures the personal appropriateness of a brand to consumers and is strongly tied to household penetration (the percentage of households that purchase the brand).
- *Esteem*: the perceived quality and consumer perceptions about the growing or declining popularity of a brand. In part, Young and Rubicam relate this dimension to the brand keeping its promises. The consumer's response to a marketer's brand-building activity is driven by the consumer's perception of two factors: quality and popularity, both of which vary by country and culture.
- *Knowledge*: the extent of the consumer's awareness of the brand and understanding of its identity, which measures the "intimacy" that consumers "share" with the brand.

Young and Rubicam assert that differentiation and relevance taken together strongly determine growth potential ("brand vitality"), while esteem and knowledge determine the current power of a brand ("brand stature"). According to their Web site, they conduct an annual survey based on the Brand Asset Valuator, which contains data on about 20,000 brands based on the opinion of over 230,000 respondents in 44 countries.

Some Internet-oriented authors, like Schwartz (1999), have argued that branding on the Web is quite different, that "interactive, personal media such as Websites simply aren't good at burnishing an emotionally charged message into the minds of millions" because consumers "use the Web as a tool to accomplish a particular objective". Schwartz describes this as solution branding, not product branding, but it seems to be an evolution, not a revolution, of the branding of services. Branding of both products and services survives and thrives in ever more clever and forceful ways/waves as persuasive communication explores new media.

Other authors comment on the shifting focus of global brands, in which U.S. based brands are losing "power," while Asian and European brands have gained strength (Buck 2004; Cheng 2004). In global and local markets, brand awareness, competitiveness, and effectiveness are studied carefully by market leaders and their would-be supplanters (Buck 2004).

16.5 Branding and the CHI Community

This introduction to branding, like an introduction to all user-interface development in a few words, leaves out much. My objective has been primarily an exercise in "branding appreciation." What I have tried to do is to present some key terms and concepts on a complex subject, with varying historical legacies and competing

conceptual models. Is there one universal set of branding terms or one universally accepted model? Unlikely at this point, but if one were to ask the same of user-interface development conceptual models, one would likely enter into a similar lively debate. Perhaps what might be useful at this point in time is what a former staff member of my firm has done as a graduate thesis: Ask experts around the world what are the most "useful" dimensions to evaluate cultural artifacts, especially user interfaces, and then do a comparative analysis to determine the "best-of-breed" dimensions, which can be reduced to a few powerful, generally accepted dimensions. Valentina-Johanna Baumgartner and I recently published a summary of her thesis on this subject. Perhaps someone has already done such a study for branding models, but I have not yet found one. Doing such a study from a CHI perspective might be especially useful to help the CHI community understand the substance and benefit of branding.

As perplexing and distant as it may sometimes seem to some CHI community professionals, branding often must be accounted for in user-interface development, and it is often beneficial to get to know the local managers or stewards of brand identity. Good communication can improve stressful situations that arise when designs are submitted to the "brand police" and are rejected for various reasons. It is sometimes the case that brand concepts and standards have been developed for the world of print media, and the guidelines, as posted, are either silent, ambiguous, or dysfunctional when applied to many complex screen-based situations, especially in the lower levels of applications, whether Web, client–server, or mobile. In such cases, having already developed good communication paths, it may be easier to persuade and/or educate the brand managers about the new and complex requirements of data and application user-interfaces as opposed to content and document-oriented structures. It may be possible, with some coaxing and discussion, to jointly or unilaterally develop analyzes that show the relative increased cost of attempting to bring branding details down into deep lower levels of complex, hierarchical applications. There are numerous such research and business-oriented efforts that may need to be explored; they will require cooperation among user-interface, engineering, business, and marketing groups.

16.6 And in Closing…

I conclude with two additional anecdotes. Once, many decades ago, we designed a complete windowing environment user-interface for Eastman Kodak. We wanted to place the Kodak K with corporate colors as a primary icon in a featured top-left button at the top of the screen. However, Kodak's legal department, acting under brand protection policies would not allow us to do so, even though we felt we were trying to reasonably extend the current brand guidelines to a new medium: computer display screens. After giving up the fight, we reluctantly used another sign in its place. A few months later, we saw an exhibit of Kodak equipment at an industry trade show that featured the Kodak K on the screen. We asked the exhibit-booth staffers how the

product development group could do that, since we were told it was "illegal." They laughed and said, "Oh, we can do whatever we want, we're the programmers."

In many realms of the corporate world, it is no longer a laughing matter. Adherence to brand standards, however thorough and intelligent, or ambiguous and dysfunctional, are often published on intranets or in printed documents, and emerging products/services are monitored by the brand police for adherence. Once, several years ago, we were fortunate to be responsible for writing and designing an entire extension to Intel's branding documents that concerned a joint relationship between Intel and the Smithsonian in honor of the Smithsonian's 150th anniversary. Not a single detail escaped the eagle eyes of Intel's brand management, including screen display, animation, and sound qualities. This considerable, but not over-done attention to preserving quality is typical of many brand-conscience companies, and is not surprising for Intel, which discovered a decade ago the value to brand itself more thoroughly in the minds of consumers who had, before then, been generally unaware of "what was inside" their computers.

You can get away with the playful indifference of programmers (like the ones in the anecdote) for a while, but eventually official policy will probably catch up to you. I recommend knowing what the rules are, and if they seem inappropriate or incomplete, making the effort, admittedly sometimes unappreciated and unsuccessful, to help the branding folks understand the CHI folks' point-of-view, and vice-versa. We may not always get along or agree, but we might use our time more productively, and eventually achieve better branding guidelines and standards for the benefit of all stakeholders.

16.7 Postscript 2015

With Apple's success over the past decades, more HCI/UX development centers seem eager to adopt branding as important to their financial success, and design as a crucial factor in establishing leadership in innovation and brand identity. Every aspect of a products metaphors, mental models, navigation, interaction, and appearance are candidates for further development of brand elements.

The scope of branding varies from country to country, culture to culture. It is not unusual for North American and European products to have "mascots," for example, from Mickey Mouse for Disney to the Michelin Man for the automotive products company. In fact, Dotz and Morton (1996) has published an extensive depiction of twentieth century US advertising mascots or icons. However, some Chinese and other Asian countries take this a step further by providing mascot stores with extensive collateral marketing items related to the mascot and books about the history and heritage of the mascot.

One curious and intriguing aspect is the addition of even smells or fragrances to establish non-perfume brand identity. A recent article describes attempts to trademark the unique smell of oranges or its fracking liquids or a ukelele manufacturer's successful granting of a US trademark for its distinctive *piña colada* aroma (Gershman 2015). Can the unique aroma of a mobile phone be far behind?

References

Ball J (1999) But how does it make you feel? Wall Street Journal, 3 May 1999, p B1ff

Beerman AJ, Harris J (1967) State of Nebraska official brand book. Office of the Secretary of State Frank Marsh, Lincoln

Belson K, Bremner B (2004) Hello Kitty: the remarkable story of sanrio and the billion dollar feline phenomenon. Wiley, New York

Buck T (2004) First one currency and now for one label as Europe seeks brand status. Financial Times, 12 January 2004, p 1

Burne J (2003). Neuromarketing: a probe inside the mind of the shopper. Financial Times, 28 November 2003, p 13

Business Week (2004) The best product designs of the year. 04 July 2004. http://www.business-week.com/stories/2004-07-04/the-best-product-designs-of-the-year. Checked 14 Feb 2014

Cheng I (2004) It's all in a name and it's all in Asia. Financial Times, 8–9 May 2004, p W3

Dotz W, Morton J (1996) What a character: 20th century American advertising icons. Chronicle Books, San Francisco

Dubberly H (2001) A model of brand (poster). Dubberly Design Office, San Francisco, www.dubberlydesign.com

Gershman J (2015) Eau de Fracking? Companies try to trademark scents: some say smells deserve protected status, but others sniff at the notion. Wall Street Journal, 14 April 2015, p D3

Gobé M (2001) Emotional branding. Allworth Press, New York

Gregory JR (1997) Corporate branding: answers to the CEO's toughest questions. White paper. Corporate Branding Partnership, New York

Khermouch G, Brady D, et al (2003). Brands in an age of anti-Americanism. Newsweek, 4 August 2003, pp 69–71

Khermouch G, Brady D, et al (2003) The 100 top brands: here's how we calculate the power in a name. Newsweek, 4 August 2003, pp 72 ff

Marcus A, Baumgartner V (2004) A practical set of culture dimension for evaluating user-interface designs. In: Proceedings, sixth Asia-Pacific conference on computer-human interaction (APCHI 2004), Royal Lakeside Novotel Hotel, Rotorua, 30 June–2 July 2004 (in press)

Miller KL (2003) Brands on the run. Newsweek, 21 July 2003, pp 43–44

Murphy JM (1987) Branding: a key marketing tool. McGraw-Hill, New York

Nussbaum B (2004) The power of design. Business Week, 17 May 2004, pp 86–92ff

Perry A, Wisnom D (2003) Before the brand. McGraw-Hill, New York

Schmitt B (1999) Experiential marketing. Free Press, New York

Schmitt B (2003) Customer experience management. Wiley, New York

Schwartz EI (1999) Digital darwinism. Random House, New York

URLs

American Institute of Graphic Arts. www.aiga.org. The URL is a portal to the USA's primary graphic design association, where links to branding-oriented subsites, competitions, and documents may be found

American Marketing Association. www.marketingpower.com. The URL contains advertising articles and tips, lists thousands of companies and firms, and more from the official American Marketing Association Web site

Association of National Advertisers. www.ana.net. The URL is a portal to "brand builders"

Corebrand. www.corebrand.com. One of many branding companies, this URL offers documents evaluating brand assets

Corporate Design Foundation. www.cdf.org. The Foundation's URL contains branding-oriented resources as well as corporate design management

Oracle browser branding guidelines. http://otn.oracle.com/tech/blaf/specs/branding_spec_v21.html. The URL contains detailed specifications. This is an example of corporate branding guidelines for software applications that are publicly available on the Internet

Schmitt, Bernd. http://meetschmitt.com. Bernd Schmitt, a self-proclaimed leader of branding has branded himself and his publications at this URL

Young and Rubicam. www.valuebasedmanagement.net/methods_brand_asset_valuator.html. The URL explains their definitions and means of measuring brands

Chapter 17
It's About Time

17.1 Summary

How do we "capture time" in the user interface/user experience?

© Springer-Verlag London 2015
A. Marcus, *HCI and User-Experience Design*, Human–Computer
Interaction Series, DOI 10.1007/978-1-4471-6744-0_17

17.2 Introduction

What is it about time that fascinates us so much? Perhaps we are challenged because time is not resident in any particular object that we can hold, but we can see its effects when we stare at the sweeping second-hand, at leaves turning a color for another cycle of the seasons, or at the face of an old friend whom we have not seen in years. We become aware of time if we are forced to sit still, or look at speeded-up or slowed-down (time-lapse) photography, film, or video, but most often when we see the world in motion, dynamically evolving. Philosophers, poets, physicists, painters, and psychologists have spent their lives analyzing the etiology (causes and beginnings), ontology (essence), eschatology (end), and epistemology (what we can know) of time. Across most civilizations, cultures, and historic epochs, analysts and synthesizers (that is, designers) have tried to explore what we understand about time and how we can use this knowledge.

Einstein is famous for, among other things, making time a dimension like spatial dimensions and for introducing the relativity of time [Stix]. Recent studies of string theory and "theories of everything" (Greene 1999) even make time merely one of ten dimensions. Piaget (1969) wrote *The Child's Conception of Time*, in which he described our human acquisition of a sense of time passing, history, and future orientation. Some say that one of our distinctly human traits is to have a sense of the future, not only the past. Modern technology, i.e., our tools and media of communication, through which we interact and communicate via *user interfaces*, in part generating our *user experience*, affects our notions of time in many, and in some cases, profound ways. Consider some of these phenomena and trends:

- Media, channels, and products/services make it possible to capture and experience the past "directly" with significant "you are here" qualities. Music, film, plays, video, newspapers, radio shows and other events of past decades, in so far as they have been recorded with "high fidelity" media since the middle of the nineteenth century, enable us to step back in time and experience what our parents, grandparents, and great parents saw for their first time...or for that matter, listen to and see our ancestors talking to us. Let's not forget that the works of great past artists like Michelangelo or Poussin created sculpture, painting, tapestries, graphic arts prints and book illustrations that seemed vivid "high fidelity" captures of past times.
- Products like Tivo for television and Tivo-like products for radio enable users to experience past dynamic entertainment and educational media whenever they wish. Because of these products, as well as the electric light, 24×7 stores, and hot-house grown foods, we are not so bound to a particular time for anything, including sleep, meals, communication, learning, entertainment, and travel. What we do when may be more of job-related or community-culture-related phenomena.
- Animation, video-editing, and other presentation software applications enable general users as well as professionals to produce, design, and edit time-based storytelling. Users can record, back up, pause, play, and enhance the presenta-

tions at will with standardized or custom transitions, annotation, and other multimedia effects. Just as previous generations of users did not know the word "font," previous users were not as familiar with storyboards, scripts, timelines, etc.

- Time management applications enable users to schedule events into the foreseeable future as well as review diaries of the past with greater thoroughness and complexity than ever before. Not only can we schedule ourselves for a business meeting or a class, but we may be able, in that process, somewhat automatically to inform others appropriately of our intentions, organize resources to be available (food, media, rooms, etc.), shift communication networks to point to us, or to leave us alone and take a message.

- Users can sort, select, annotate, and retrieve collections of images and sound according to time stamp, subject matter/genre, geography, and other attributes. Making the annotations, storing them, cleaning up the images/sounds and their metadata, and retrieving them, can swamp our own time if we are not careful about what kind of library we are building and how we are constructing it for future maintenance and large-scale contents.

- The Internet, and specifically the Web, make it easier than ever to create and distribute life-time information about one's self and one's family. Web-based family and event albums, blogs, wikis, and other collecting points continue to increase. Eventually, "everything" may be recorded, even the grams of carbohydrates or sugar in the cookie I just sneaked into my tummy. What will we do with all of that data?

- Data visualization applications enable users to model the past, present, or future, and to display the data through increasingly complex or novel means, from picturesque or pictographic to very abstract. Among others, Marc Davis (2004) while at MIT proposed Media Streams to help envision the metadata that accompany time-based story telling.

- Because of multimedia telecommunication, people have the opportunity, and sometimes the necessity, to live in multiple time frames: religious *vs.* secular frameworks, constant awareness and semi-participation in multiple world time zones (like the workers who must be cognizant of the life patterns of clients or customers in far-removed geographical locations), past memories *vs.* present circumstances *vs.* future anticipations. Bear in mind: time zones, which we take for granted today, did not exist until the late nineteenth century, when they were officially proclaimed worldwide in order to lessen the chaos and danger inherent in individual municipalities declaring whatever solar time suited their needs (Bartky and Harrison 1979). National railway system s required more serious, standardized attitudes towards time for railway timetables.

- Asynchronous and synchronous communication compete in the world market for precedence via cost-effective technology. In the past, citizens lived within real-time shouting distance, or fires from hill-side to hillside announced the new moon for official holy-day time keeping. Now communication takes place "outside of real-time," and messages catches up with the receiver. In the meantime, the facts may have changed. In some professions, like emergency response sys-

tems, one needs to give special attention to when the communication originated. Was it 10 s ago, or 10 h ago?

- Despite time and labor-saving devices and software applications, because of speeded-up telecommunications, editable documents, and industry down-sizing, many industrial, especially service-industry, workers feel more and more stressed, with too little time (and in some cases expertise and experience) in which to do more and more, often completing tasks just-in-time with less-and-less care given to quality. Books, magazines, training courses, and Websites all offer advice on how to get more done in less time (e.g., Mackenzie 1972). Numerous article cite the increasing amounts of time required to edit and act upon the mountain of email that arrives daily.

17.3 Some Issues

As users explore and take advantage of application and media/content, user interfaces enable users to relate to time phenomena in more complex and innovative ways. Along with the added capabilities, some issues arise that the CHI community may want to explore further (and with which some research laboratories are already engaged):

- Can operating systems or suites of applications take advantage of known patterns of circadian (daily bio-) rhythms to encourage appropriate use of applications at peak performance times and to discourage use at inappropriate times? For example, applications used by teen-agers might facilitate enhanced late-night performance, or add cautions for exhausted students, parents, or seniors preparing last-minute word-processed documents. Just as vehicle systems might lock-out drivers with too much alcohol on their breath, so might future systems gage the best times of day to undertake certain projects and manage the user's schedule to make sure that they do their most important tasks at the best times for their psychosomatic profiles.
- How can/should user interfaces account for cultural variations in understanding/using time?

Analysts of culture, e.g., Hofsted, Trompenaars, and Hall (Hall 1969; Hofstede 1997; Trompenaars and Hampden-Turner 1998) have called attention to those people who are polychronic (doing many things at once) *vs.* monochronic (doing things one-at-a-time and sequentially), to those who view time as a line *vs.* those who see it as a circle or cycle. Gell [Gell] in his *Anthropology of Time* cites Gurvich's (1961) eight types of time based on different "rhythms, expansions, contractions, and irregular pulsations…generated by the patterns of events occurring in time…" (Gell 2001, p. 62). He describes these as Newtonian or Absolute time "bent out of shape" by local sociological factors:

1. "Enduring time of slowed duration (slowed-downtime).
2. Deceptive time (slowed time with irregular and unexpected speeded up stretches).

3. Erratic time (slowed-down and speeded-up by turns, neither predominating, without predictable rhythms).
4. Cyclic time (Gurvich equates cyclical time with 'motionless' [or] 'static' time.)
5. Retarded time (in which a given moment T1 in retarded time equals a later moment. T1+n in non-retarded time).
6. Time in advance (the inverse of retarded time, in which T1 in [time-in-advance] equals T1-n in non-advanced time.
7. Alternating time (time alternating between being retarded and in advance).
8. Explosive time (time very much advanced and also speeded-up)."

Gurvich asserts that any given sociological milieu, like modern mass society, peasant milieus, or classical nineteenth-century bourgeois society will be characterized by one or more of these time-types.

- What are the objectives of a "timepiece" that we strap on our wrists or carry on our belt or in our pockets? What are the design criteria? What are the likely contents? In the past, a watch was just a watch. It didn't watch us or watch out for us. We watched it. Now the tables are turned. More and more functions can be added to our universal timepiece, which make it a likely first-generation ubiquitous, pervasive, wearable, computing system. What should it do? What should it not do? What should *we* do? What should *we* not have to do? Conferences on ubiquitous computing, pervasive computing, wearable computing, and wrist-top devices are beginning to sort out how we might manage our time, or be managed by it. With enough careful consideration by CHI community professionals, time and our time-piece will remain friendly, helpful, dependable companions, not tyrannical busybodies.

- How can we enable more professionals and the general public to become active time designers/editors of media and activities rather than passive consumers? Time-based data, while sometimes hard to find and retrieve, make it possible to visualize more effectively "cognitive landscapes" and to comprehend phenomena that would otherwise be hard even to perceive. To be able to visualize the growth of human population or the use of natural resources like oil make as dramatic an impression as over-head photographic fly-overs of great cities and breathtaking spatial landscapes.

- Until recently, most people did not have much opportunity to become active "time-composers" not just "space-composers." Professional musicians, dancers, animators, and other time-based composers all know how challenging it is to monitor and manage time-based phenomena. Most have invented special annotation/scripting languages, like those of music or dance labanotation. New metaphors, navigation schema, and interaction techniques will be necessary to enable the casual time navigator to find the right moment, contents, media, and conditions for display.

- A related challenge is how to use time-stamped (and geo-stamped) media to manage more easily our communication media. Much of what we ourselves do can be and will be time-stamped, in addition to metadata that mark its position in

physical space and any number of conceptual (semantic) spaces. How can these items be semi-automatically related so that we don't inherit the awesome burden of "accounting" our time, linking it appropriately, so that, for example, messages to us can be routed to the right *place* depending on our *time* schedule. Few of us would wish to become "time-slaves" for temporal bean-counting.

17.4 Time and the CHI Community

This introduction to time is understandably brief. Perhaps there will arise special-interest groups or birds-of-a-feather gatherings at future CHI conferences, and sibling conferences, that will focus on time-keeping/marking/annotating, temporal metaphors, temporal mental models and navigation, temporal visualization/sonification, and cross-cultural studies of time in relation to human-computer interaction and communication. If such groups form, they will find a world-wide set of organizations ready to collaborate and/or assist them in their activities, including the Centre for Time, the Institute of Time, and the International Institute for the Study of Time (see URLs in the Bibliography), the last taking a cross-disciplinary, cross-cultural approach to the topic and founded in 1966 by one of the well-known students of time, J. T. Fraser (1987).

In closing, I am reminded of a former design student about 22 years ago who specialized in "time-time" works, not "space-time" artifacts. Steve Raven, who went by the *nom-des-plumes* of Ralston Purina (after the breakfast cereal), asserted that his designs had no particular visual or perceptual attributes. Instead, they were all about essentially "time-ish" or temporal experiences: surprise, memory, slowness, acceleration, speed, anticipation, cause-and-effect, etc. Our languages, and our tenses, are somewhat limited in relation to time, and this may limit our thinking about time. Already our everyday speech, even our written language, has lost many nuances of time, as in the disuse of subjunctive contrary-to-fact for rhetorical purposes, which expresses future conditions based on the nature of present circumstances (Example: "Were I to show/say X…but I shan't…I could tell you quite a story").

As sophisticated as we are in measuring the smallest duration of time, and in theories of the beginning and nature of time, I think we are just entering an accelerated phase in our software applications, and their user-interfaces, that will enable us to visualize and manage time in ways undreamed of in earlier eras. Rising to the challenge will demand of us more careful management of one of our most precious, and ultimately limited, resources, the roughly 2.5 billion seconds allotted to each of us.

17.5 Postscript 2015

Since first authoring this essay, the slow-food movement and other groups have advocating slowing down our busy high-tech lives, basically to stop and smell the roses. New devices like smart watches might cause us to become even more

hypervigilant and constantly interrupted by matters seemingly demanding our attention night or day.

Perhaps we need a "Chrono-Siri" assistant to better manage our time, to make more productive use of our best hours of consciousness, to take into account our age, our gender, our social/cultural roles, and, like a clever butler manage us efficiently without our seeming to notice how our time is being re-scheduled in a seemingly transparent manner.

Time will tell if we get the time-managers that we all need and want operating on our latest devices, in our clothing, in our vehicles, and elsewhere.

References

Arguelles J (1987) The Mayan factor. Bear and Company, Santa Fe

Aveni A (2002) Empires of time: calendars, clocks, and cultures. University Press of Colorado, Boulder

Bartky IR, Harrison E (1979) Standard and daylight saving time. Sci Am 240:46–53

Bender J, Wellbery DE (1991) Chronotypes: the construction of time. Stanford University Press, Stanford

Brooks FP Jr (1975) The mythical man-month. Addison-Wesley, Reading

Davis M (2004) Mobile media metadata: metadata creation system for mobile images (video description). In: Proceedings of 12th annual ACM international conference on multimedia (MM 2004), 10–16 October 2004, ACM Press, New York, pp. 936–937

Fraser JT (1987) Time, the familiar stranger. The University of Massachusetts, Redmond

Gell A (2001) The anthropology of time. Berg, Oxford

Greene B (1999) The elegant universe: superstrings, hidden dimensions, and the quest for the ultimate theory. W.W. Norton & Company, New York, Reissue edition (October 20, 2003). ISBN 0393058581

Gurvich G (1961) The spectrum of social time. Reidel, Dordrecht

Hall E (1969) The hidden dimension. Doubleday and Company, Inc., New York. ISBN 0385084765

Hofstede G (1997) Cultures and organizations: software of the mind, intercultural cooperation and its importance for survival. McGraw-Hill, New York. ISBN 0-07-029307-4

Huff S (1984) The Mayan calendar made easy. Merida De Yucatan, Mexico

Hughes D, Trautmann TR (1995) Time. University of Michigan Press, Ann Arbor

Johnson C (1964) Clocks and watches. Odyssey Press, New York

Kubler G (1962) The shape of time. Yale University Press, New Haven

Luce GG (1971) Body time: physiological rhythms and social stress. Pantheon Books, New York

Mackenzie RA (1972) The time trap. McGraw-Hill, New York

McCay JT (1959) The management of time. Prentice-Hall, Englewood Cliffs

Murayama Y et al (2001) Visualization of time in a message board system on WWW for on-door communication. Proceedings, 34th annual Hawaii international conference on system sciences (HICSS-34)-vol 1, pp 1036. The authors brought a message board on the door of a room in a student hall of residence into the WWW environment as a novel type of asynchronous communication system. The idea of this research came from the experience of an extensive use of such a messaging system in a post-graduate student hall

No Author (2000) "Telling time: to everything there is a season", exhibit brochure. Judah L. Magnes Museum, Berkeley

O'Neil B, Phillips R (1975) Biorhythms. Ward Ritchie Press, Pasadena

Ornstein RE (1969) On the experience of time. Penguin, New York

Perkins M (2001) The reform of time. Pluto Press, London

Piaget J (1969) The child's conception of time. Ballantine Books, New York
Reynolds H, Tramel ME (1979) Executive time management. Prentice-Hall, Englewood Cliffs
Scientific American Special issue: a matter of time, vol 287, 3 September 2002
Scientific American Special issue: beyond Einstein. vol 291, 3 September 2004
Stix G (2004) The patent clerk's legacy. Scientific American, special issue: beyond Einstein, vol
 291, pp 44–49, 3 September 2004
Thommen GS (1973) Is this your day? Avon Books, New York
Trompenaars F, Hampden-Turner C (1998) Riding the waves of culture. McGraw-Hill, New York.
 ISBN 0-7863-1125-8
Tunnicliffe KC (1979) Aztec astrology. L N Fowler and Co. Ltd., Romford
Wilson C (1980) The book of time. Westbridge Books, North Promfret

URLs

American Institute of Graphic Arts (AIGA) Center for Cross-Cultural Design. http://www.cross-
 culturaldesign.org
Centre for Time, Philosophy Department, University of Sydney. http://www.usyd.edu.au/time/
History of Time Zones. http://www.sizes.com/time/TZ_USA.htm
Institute of Time, Moscow State University. http://www.chronos.msu.ru/
Intermundo cross-cultural network. http://intermundo.net
International Institute for the Study of Time. http://www.studyoftime.org/
Labanotation, a notation system for body movement. http://www.uni-frankfurt.de/~griesbec/
 LABANE.HTML
Philosophy of time, including extensive bibliography. http://plato.stanford.edu/entries/time/
Time-visualization categories. http://xenia.media.mit.edu/~spiegel/classes/SocialVisualization
 1998/assignment08/

Chapter 18
User-Centered Design (UCD) in the Enterprise: Corporations Begin to Focus on UCD

18.1 Summary

What's new in the Land of User-Centered Design?

© Springer-Verlag London 2015
A. Marcus, *HCI and User-Experience Design*, Human–Computer Interaction Series, DOI 10.1007/978-1-4471-6744-0_18

18.2 Introduction

Computer interaction communities have been talking about user-centered design (UCD) for as much as two decades. Researchers, analysts, and designers have made much progress in understanding the terms, concepts, process, tools, and document resources that facilitate this process. What's new in this area? For the past 2 years, I have been talking with and working with major corporations seeking to establish user-interface design centers of excellence. What seems new in this concern for establishing such centers is stronger and more central to core competencies than ever before, as corporations discover they must be customer-centered, customer-aware, user-centric, value-centered (Cockton 2004), people-centered, or whatever corporate-culture buzz word turns business, marketing, and engineering leaders in this direction. This awareness is particularly keen among consumer-oriented product and service development. Alas, at the other end of the spectrum, *e.g.*, with specialized, professional or industrial systems development, there are still many companies or organizations for which UCD seems to be a relatively unknown, untried, or very new approach still needing careful nurturing.

18.3 What, Basically, Is UCD?

Some typical steps in the typical UCD process are the following: [problem – there isn't any "user" in any of these steps – it's the standard waterfall development process!]

- Plan project
- Analyze needs
- Gather requirements
- Design initial solution
- Evaluate design solutions (iterate with initial and revised design steps)
- Design revised solution
- Evaluate design concepts (iterative)
- Deploy product/service
- Evaluate product/service (iterative)
- Determine future requirements/enhancements
- Maintain and improve processes
- Assess project

User-centered development methods include the following techniques employed in initial, intermediate, and final stages of software? development. Many of these are the subjects of entire books focusing on one or more specific techniques:

- Card sorting
- Cognitive walkthroughs
- Developing and using design patterns
- Evaluation workshops

- Expert or heuristic evaluation
- Field studies
- Focus groups
- Interviews
- Rapid and advanced prototyping
- Storyboarding
- Surveys
- Task analysis
- Use cases
- Use scenarios
- User profiles or personas
- User tests
- Workshops

The choices of factors affecting which techniques are used may vary among the following:

- Availability of appropriate, suitable technology; equipment such as cameras or eye-tracking devices; testing rooms and other physical resources; users and usability professionals
- Budget balanced against the cost of specialized skills, equipment, or tasks
- Calendar schedule
- Experience of the team with different UCD methods
- Size of the project

The effects of user-centered design can be evaluated by criteria such as these:

- Customer satisfaction
- End-user engagement
- Impact on development process
- Improvements over benchmarks
- Increase of usability awareness in the development team.
- New understanding of users, their tasks, or contexts of user
- Project leader satisfaction
- Return on investment (ROI), as measured by metrics established at the beginning
- Suggestions for new design
- Team satisfaction
- Usability of the developed system
- Usability problems identified

18.4 So Far, So Good in Theory. Now for Reality

There are some practical steps to take better to ensure success of initiatives. I shall elaborate some recent experiences without naming names, to protect both the innocent and the less innocent.

Major corporations are seeking to establish or improve their own user-centered, user-interface design centers of excellence. UCUIDCE is a mouthful, so let's call them UIDC's or User-Interface Development Centers, using a more general term "development" to cover the activities of planning, research, analysis, design, implementation, evaluation, documentation, training, maintenance, and, yes, marketing, that is, marketing new UI technology or development solutions to corporate customers and/or outside business partners.

One major corporate client of ours started off well, trying to organize an internal group to be the UIDC, sponsoring kick-off tutorials on the subject, and building up an archive of best-practice documents. Some leaders emerged in this group to lead the internal evangelists across department lines and to attempt to bring best practices to as many disparate groups as possible. The internal Website, used as the basis for communication took many months to get designed and to go live. The Website was a good, small start, but the Website itself needed more attention to content, usability, and esthetics which are all important, especially for a center of excellence claiming others should come to the UCD for advice or collaboration.

One important factor was the attempt to align UIDC best practices with comprehensive, integrated software engineering methods, like the Rational Unified Process (RUP) or its competitor processes. While things started off well with great enthusiasm and a Website to represent the group, after several months activities quieted down seemingly almost to a standstill. Why? Because, in part, individuals had to "donate their time" to these UIDC endeavors. There was no official, sanctioned budget to which they could ascribe their UIDC tasks. The management seeking to develop these efforts assumed that it could survive as an informal, un-budgeted, volunteer effort out of the goodness of the hearts of the dedicated individuals.

That philosophy, if it ever flourished in corporate groups, withered away decades ago. Now, in a realm of overworked, understaffed teams, it becomes less and less likely that volunteer, grassroot efforts can take hold and make the desired impact, certainly not without significant seed capital to encourage start-up tasks. So, what is needed? Alas, there must be at least one brave high-level manager willing and able to fund the seed activities to make sure that some staff are officially assigned to UIDC activities and that there are budgets for meetings, supplies, intranet development and maintenance, *etc.* This attitude is no different than any other official corporate activity. Eager proponents may find such budgets in training or human resources, which might be re-oriented creatively to UIDC activities. But the funds *must* be there for group leaders to be able to concentrate enough time and energy to get fundamental activities started until there is momentum enough for independent entities to continue. The seedlings of UCD cannot grow in dry soil.

Within most medium to large corporations there are likely to be sizable numbers of staff (15–150 people, or more) working in isolation that all have similar aspirations and suffer from lack of officially sanctioned time, information resources, sharing of skill sets, trading expertise, cross-department communication, etc. A UIDC can help encourage the development and publication of best practices; it can also encourage that these best practices be followed. The UIDC also can make better known the local leaders, experts, or helpful? resources. The UIDC also can make

available skills and tools of which people are not aware. A simple example of the benefits of sharing experience is when one group does not know but quickly learns at *regular, sponsored* UIDC group meetings that another group has already researched and procured favorable site licenses for software tools, which can save sizable portions of operating budgets for other teams.

Another major corporation reports they are using the existing human factors group to improve the corporation's overall approach to user-centered design in what will be an effort stretching over a year or two. This is an interesting variant on allying UCD as the CHI community understands it with another professional group (HFES members, not SIGCHI members).

There are many such groups within the corporate walls whose members relate to many lines of business and staff support areas. Technical documentation (whose staff are often members of the Society for Technical Communication, or STC) is another candidate. Each kind of association has benefits and risks. If you are starting a UICD function in your company, you will need to explore the right partners for your own corporate culture.

Allying with the software engineering group is a very strong route, because their contributions are deemed essential. The challenge is offering competing processes, definitions, and established leadership to groups that may not wish to have HCI? entities mixed into the "purer" software engineering cultures, even though HCI? professionals could point out where there are certain missing components in user-oriented development processes and documents. A CHI 2004 Workshop organized by Bonnie John, Len Bass, Rick Kazman, and myself brought HCI and software engineering professionals together to seek better mutual understanding and use of sharable, communal documents at the shared boundaries of the two professions [and did it bring great results?].

The human factors professionals are also established within centralized or distributed groups. They, too offer personnel, budgets, practices, tools, and a culture to which the UCD philosophy could be attached. However, here, too, there may be differences of opinion about the value of cognitive, psychological, emotional, esthetic, and other analysis and design priorities. Each group presents challenges to cooperation and collaboration.

At a third major corporation with whom we are working now, UIDC professionals are both analysts and designers. There are significant differences in the use of terms (like "design" and "research") among professionals who come from the academic, analytical disciplines like cognitive psychology and behavioral studies who value quantitative results, and the practical design disciplines like visual design, interaction design, industrial/product design who favor more quantitative [do you mean qualitative here?] results. How does a new UIDC group apportion their practices, tools, budgets, personnel, etc., as they try to further UDC? There are already strong "cultural" differences within the UCD disciplines that, without careful planning, can lead to misunderstandings, hurt feelings, squabbles over resources and assignments of time. These conflicts, in turn, hurt the effectiveness of the UIDC to be a beacon of light, a helpful resource, and a source of expertise for internal and even external customers seeking its services. Recall that CHI itself in its confer-

ences and publications has attempted this same kind of culture merging (with less than stellar success) in an effort to be inclusive of all forms of design disciplines that shape the user's computer-based communication and interaction experience.

At this third corporation, we have been able to build collaboratively a dictionary of canonical terms, begin refining UCD concepts and processes, determine the skills required for each step, begin to audit the documents that exist, and build the new documents required for a best-practices archive. Such efforts typically require approximately 1 year of intermittent, but ongoing activity.

18.5 UCD and the CHI Community

There are many encouraging signs that make life easier for those seeking to develop improved UIDCs. The fact that the European Center for Design (see Bibliography) has produced a CD-ROM that it distributes promoting UCD and including case studies shows what it takes to promote UCD within the corporation and to its partners. The fact that IBM has made available an outstanding and extensive online document outlining the full UCD process (see Bibliography) from its perspective is an excellent resource. Unfortunately, we have found that this Website is almost too deep and broad to be used as a practical on-the job document; it is more like an archival reference document of best practices. All together, many fine resources are available that were not so easily found in the past.

Bear in mind that all UIDC teams will have to market their approach; not all UIDC groups realize this fact or put the amount of time into marketing themselves that they should. Nevertheless, storytelling efforts pay off in better materials at hand: presentation slides, intranet descriptions, case studies, and paper publications, e.g., an introductory leaflet as leave-behinds for face-to-face meetings. Making the case for UCD within the corporation and among key business partners is a never-ending activity. The Usability Professionals Association is undertaking a return-on-investment survey in order to build up information of value to usability and design professionals to back up the claims of benefits of UCD (see UPA URL reference in Bibliography).

We recently reviewed the user-interface for a complex mobile communication and emergency-response system purchased by a municipal government for police officers. Unfortunately, we learned that user-centered design was not carried out on behalf of these users. After spending several millions of dollars, many users were dissatisfied, and some were not using the new system. Those who did found the new system impeded their productivity significantly and could lead to dangerous, possibly life-threatening situations. In our own heuristic analysis, we cited over 30 significant issues, including erroneous map data, hard to read important text, and clumsy data input techniques. This is a dramatic instance of how the lack of UCD in user-interface (and software) development has a significant effect on the success of system development.

Fortunately, HCI professionals involved with establishing or improving UIDCs can breathe a little easier that many new tools, publications, and processes are now becoming more widely known and available to help them in their quest for humane user interfaces.

18.6 Postscript 2015

In the past decade, larger, smarter enterprises have made significant improvements in the scope and depth of their commitment to user-centered design. The kinds of advertisements that circulate on the Internet announcing new jobs, new roles, new groups increase in number. Thanks to the subsiding of the recessions of the past decade, many development groups are busy and expanding, which is good.

However, I know from personal experience that not all prospective clients seem to get the message. There are still occasional entrenched managers who are not convinced that extra budgets, extra people, and extra tasks are returning on the investment of money, people, and time. Many of these people will become wiser over time, and the developments of centers of excellence will continue to grow; in any case, a younger generation will eventually replace them, a peer group with greater awareness and commitment to user-centered design.

References

Publications

Cockton G (2004) Value-centred HCI. In: Hyrskykari A (ed) Proceedings, NordiCHI 2004, 23–27 October 2004, Tampere, pp 149–160

European Design Centre (2004) User-centred design works (CD-ROM). IOP Human Machine Interaction. www.edc.nl. This CD-ROM presents a case for user-centered design including case studies and information resources

No Author (2004) Software development: best or bust (Test of best practices). Software Development Magazine, November 2004, special insert, unpaged

Schaeffer E (2004) Institutionalization of usability. Addison-Wesley, Reading

Vredenburg K, Insensee S, Righi C (2002) User-centered design: an integrated approach, Software quality institute series. Prentice Hall, Upper Saddle River

URLs

AM + A. http://www.amanda.com/services/approach/approach_f.html

Carnegie-Mellon University. http://www-2.cs.cmu.edu/~bam/uicourse/special/

EFFIN. http://www.effin.org/. EFFIN is a multi-client sponsored project to tailor user-centered methods to the development of electronic government services and to investigate these methods

in practice. The project is financed through the FIFOS program of the Norwegian Research Council

IBM. http://www-3.ibm.com/ibm/easy/eou_ext.nsf/publish/1996

UPA (after 2013 UXPA). http://www.upassoc.org/upa_projects/usability_in_enterprise/index.html>http://www.upassoc.org/upa_projects/usability_in_enterprise/index.html. The project, sponsored by the European usability community seeks to gather information on usability practice in the enterprise and evidence of return on investment (ROI) of usability

UPA (after 2013 UXPA). http://www.usabilityprofessionals.org/upa_publications/ux_poster.html

UPA (after 2013 UXPA). http://www.usabilityprofessionals.org/usability_resources/guidelines_and_methods/methodologies.html

Usability Net. http://www.usabilitynet.org/tools/13407stds.htm

Chapter 19
Dreaming of Robots: An Interview About Robots with Bruce Sterling

19.1 Summary

In past times, not only today, human beings have dreamed of "human-machine" hybrids, which, or who, could help, hurt, collaborate with, and/or challenge us.

© Springer-Verlag London 2015
A. Marcus, *HCI and User-Experience Design*, Human–Computer
Interaction Series, DOI 10.1007/978-1-4471-6744-0_19

19.2 Robot Dreams: Past Tense

Aaron Marcus: *Looking back through history, how did people define "robots?"*
Bruce Sterling: The term comes from theater. It was invented by Karel Capek's brother Josef, who was a painter. Karel Capek introduced the term in his satirical drama "RUR or Rossum's Universal Robots" in 1921. This play is basically an anti-capitalist satire warning against greedy technocrats debasing the working class into mere money-making machinery.

The play was an international hit. It is still probably Capek's best-known work and may be the most influential work out of Czech drama.

AM: *Do you think concepts of robots differed substantially in different times and different cultures?*
BS: Yes, they differed, because robots are basically theatrical devices, and theater is very modish.

Robots are a metaphor for the human relationship to technology. It's as if technology has assumed human face and form and can speak to us, as if we can finally have a personal and social relationship with infrastructure. "Technology" means different things to different epochs; basically, the word "technology" is a catchall term for any kind of ingenious contrivance invented since you were born. So robots reflect their own period—1920s robots, 1950s robots, and so on.

AM: *You collected information about "dead media" in an archive for many years. What would you put in a "dead robots" collection?*
BS: There are precursors aplenty here. Golems, the talking bronze head of Albertus Magnus, one of DaVinci's self-propelled mechanisms, Japanese karakuri puppets, the Maelzel chess-playing Turk, most anything tinkered up by Vaucanson, the Steam Man of the Plains—even Capek's own robots are better described as "androids" nowadays. Capek didn't depict his original "robots" as mechanisms, but as some kind of soulless biotech contrivance.

AM: *Any comments on some of the classic science-fiction magazines and their views of robots?*
BS: Science fiction always loves fantastic technology more than real-life technology. There are tons of science-fiction material about faster-than-light travel, time machines, and intelligent robots. You don't find a lot of sci-fi written about, say, birth-control pills, even though their impact on society has been colossal.

I think the key issue for robots as a classic sci-fi theme was, "Who can replace a man?" Or maybe, "Do androids dream of electric sheep?" These are ontological and philosophical issues. It's a literary exercise in looking into the dark, smoky mirror of technology and trying to find a face there—what are we humans, really? Do we have free will, or are we artifacts? We use robots as *gedanken* experiments to mull over our own identity.

AM: *What do you think of as the most successful or surprising innovation in robotics in the past?*

BS: Well, robots are *always* meant to be "surprising," because they are basically theater or carnival shows. A "successful" robot, that is to say, a commercially and industrially successful one, wouldn't bother to look or act like a walking, talking human being; it would basically be an assembly arm spraying paint, because that's how you get the highest return on investment out of any industrial investment—make it efficient, get rid of all the stuff that isn't necessary.

But of course it's the unnecessary, sentimentalized, humanistic aspects of robots that make robots dramatically appealing to us. There's a catch-22 here.

You can go down to an aging Toyota plant and watch those robot arms spray paint, but it'll strike you as rote work that is dull, dirty, and dangerous—you're not likely to conclude, "Whoopee, look at that robot innovation go!" When it's successful, it doesn't feel very robotic, because it's just not dramatic.

AM: *Of the many movies made about robots, which do you think were the most insightful?*

BS: Probably the *Terminator* series and some of the awesome technorganic hallucinations in the first *Matrix* movie. At least, you can really see where the special-effects money went in those efforts—they're a lot of fun to watch as graphic presentations.

I'd also cast a vote for the gynoid robot Maria in "Metropolis." The key to that evil robot is that she's so much more authentically human and psychosexually attractive than the blasé, virginal, Christian-socialist schoolteacher that she replaces (Fig. 19.1).

Fig. 19.1 The female robot from Metropolis (Source: http://www.arthouse.ru/german2003/metropolis.asp. Fair use source)

Fig. 19.2 Track robot demo, from 2 May 2000 (Figure source: original drawing by the author, based on http://www.srl.org/yard/)

AM: *Whom do you think best described/analyzed robots and robot issues in the past?*

BS: Probably Mark Pauline. I think this guy has bitten closer to the bone than any other artist working with performance mechanisms. You can go to a "Survival Research Labs" show, and, if you survive it, it really makes you feel that most other people who trifle with robots are missing the point (Fig. 19.2).

AM: *What was missing from these concepts of robots in the past that has emerged today to challenge us?*

BS: We've got to get over this notion of artificial intelligence. It's extremely seductive and exciting, but it's just got no traction on the ground. We've got no robot brains. We're not gonna get robot brains. This renders a whole host of the earlier issues moot.

19.3 Robot Dreams: Present Tense

AM: *How would you define robots today? Does the Mars Rover qualify?*

BS: I'm a purist—I find it hard to call autonomous vehicles [like the Mars Rover] robots unless they've got some kind of anthropomorphic mimicry going on. The way I see it, a chatterbot program on the Internet that pretends to engage in human conversation is closer to Karel Capek's definitive vision than, say, any self-navigating submarine.

AM: *What about the effort required to set up, manage, maintain, repair, and instruct a robot? Isn't it like the amount of effort to raise a child?*

BS: As a futurist, I'm a great believer in people having children. I think that robots are a way to "kid ourselves," because robots are basically theatrical inventions. I don't doubt that managing a Mars Robot could consume somebody's life, but you could say much the same for a life in the theater. There are plenty of people who think that a theater life is the only way to live. They are willing to sacrifice almost anything and everything for the thrill of the actor's craft and the joy of being on stage. The Show Must Go On—and by the way, Robotics Must Advance! Don't ask me why, or what I expect to gain—it just must be!

That might be a good choice for some people, but investing all your energy and conviction in a career pursuit cannot give you what a child can give you.

AM: *Where will robot innovation arise? In government? In private industry?*

BS: NASA always likes to paint itself as furiously advanced even when its organization is clearly elderly and sclerotic. They'll give you money—but then, oh Lord, you've got to fill out all the NASA forms. Over and over. Forever.

DARPA really is pretty advanced, but DARPA lacks bureaucratic clout, and so it has trouble budgeting and following through—they fling a lot of stuff out of DARPA labs that just sort of dies in a no-man's-land of "not invented here."

Everybody always figured it was Japanese industry that would really carry the can in robotics. ASIMO is really a nifty gizmo, but what happened to Japan? They're like an entire society that suddenly turned into a dusty, beaten-down version of NASA: a host of abandoned gantry cranes and a bunch of lonely state contractors wondering where all the big funding went (Fig. 19.3).

AM: *Do you think all the ads in popular publications enabling people to buy robot vacuum cleaners are enriching or impoverishing people's understanding of robots?*

BS: Robots are popular culture. There isn't any "knock-off" possible there; it's been knock-off from the get go. It's like worrying about somebody "knocking-off" cowboy movies.

AM: *With all the accessories now offered by Sony for AIBO, the robot dog, have robots come into mainstream consumer culture?*

BS: No. They're still plenty weird.

AM: *What are the growth areas for robotics?*

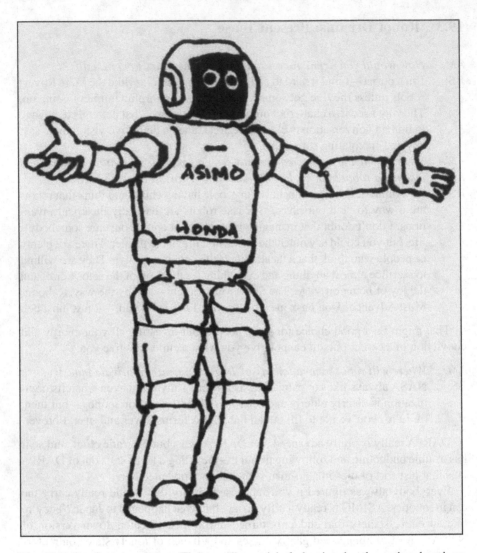

Fig. 19.3 Hondo Asimo robot (Figure source: original drawing by the author based on http://www.roboticmagazine.com/wp-content/uploads/2011/11/honda-asimo.jpg)

BS: Entertainment. It's always been entertainment. Caretakers for seniors might pick up some momentum as the Baby Boomers get creaky. Certainly a lot of Japanese robotics guys get their grant money using that excuse, and I think they would like to deliver.

AM: *Do you see any culture bias in robot R + D?*

BS: There are some culture biases in the research and production of all technologies. Not just in cultures, but historical epochs too. In a period of Global War

on Terror the U.S. military thinks it's really nifty to kill carloads of terrorists with remote-controlled missile-launching Predator drones. That activity sure doesn't have much to do with Isaac Asimov's Three Laws of Robotics.

AM: *Do fleets or swarms of communicating sensors qualify individually or in a group as robots?*

BS: I have no opinion on that, although I consider robot bugs a very sexy and interesting notion. Distributed swarms are a real obsession these days.

AM: *What do you consider the key issues for robotics researchers today?*

BS: Where's the money? And where's the academic infrastructure? There's no such thing as a Nobel for Robotics.

AM: *What are the top issues in your opinion?*

BS: I'd be guessing that the number-one risk is rich countries with dwindling populations trying to build autonomous minefields, battlefields, security zones, gated communities and prisons to maim, detain, or kill terrorists and/ or dissenters. The problem there is "mission drift"—that once you've got the new technical capacity, you may see that American suburbs come to resemble the Baghdad Green Zone.

The top benefit will be what it's always been: that robots are entertaining, really fun to watch and think about.

AM: *If robots are to be "controlled" or managed by human beings, what do you consider the "user-interface design" issues?*

BS: I'm all in favor of people having system-administration jobs. What are all those new Indian and Chinese engineering grads supposed to do with themselves? Let 'em patch user-interface crises until they retire.

19.4 Robot Dreams: Future Tense

AM: *How do you think robots will be defined in the future?*

BS: I'd be guessing that redefining human beings will always trump redefining robots. Robots are just our shadow, our funhouse-mirror reflection. If there were such a thing as robots with real intelligence, will, and autonomy, they probably wouldn't want to mimic human beings or engage with our own quirky obsessions. We wouldn't have a lot in common with them—we're organic, they're not; we're mortal, they're not; we eat, they don't; we have entire sets of metabolic motives, desires, and passions that really are of very little relevance to anything made of machinery.

AM: *Where do you think the key centers for robotics research will be?*

BS: I think robotics is likely to remain a hanger-on of better-established disciplines like electrical engineering and computer science.

AM: *How would you define the differences among the categories of robots, versus human beings?*

BS: Does it use plumbing? If so, it's human.

AM: *Do you think of mixed silicon and carbon androids or human-robots as an inevitable evolution of humankind?*

BS: I think silicon is probably a period artifact. Artificial diamond would be better at practically every function performed by silicon. Also, mixing silicon with human flesh is like trying to mix human flesh with shards of broken glass.

AM: *What's in the future of robotics that is likely very different from most people's expectations?*

BS: Robots won't ever really work. They're a phantasm, like time travel or maybe phlogiston. On the other hand, if you really work hard on phlogiston, you might stumble over something really cool and serendipitous, like heat engines and internal combustion. Robots are just plain interesting. When scientists get emotionally engaged, they can do good work. What the creative mind needs most isn't a cozy sinecure but something to get enthusiastic about.

AM: *To return to our starting point, is one way to think about the future of robots to study the past?*

BS: I'm a great believer in historical analogy, but point of view is worth 80 IQ points. We could have had a nice discussion of this robot question in the 1930s, and if those questions are all still relevant 80 years later, that suggests that there's not a lot actually going on there. These may not be "future developments" at all. They may simply be enthralling period notions that still have a strong emotional appeal for technologists and their cultural hangers-on.

AM: *When will robots be allowed to vote?*

BS: At this point, I'd be thrilled to see humans allowed to vote.

19.5 Bio of Bruce Sterling

Bruce Sterling is a 50-year-old cyberpunk science-fiction author who is currently "Provocateur-in-Residence" at the Art Center College of Design in Pasadena. His many works of science fiction include a number of robots, especially the novel and short-story cycle *Schismatrix Plus*.

19.6 Postscript 2015

Today, robots, including drones, seem always in the news. One recent article reports that China may have the most factory robots in the world by 2017 (Aeppel 2015). Another article reports that humanoid customer-service robots are entering service in Japan (Hongo 2015). Still another reports on robots being deployed to serve next to human "co-workers" in factories (Hagerty 2015), perhaps to re-assure human workers that they will not be completely replaced. Humanoid robots like the Japanese Honda Asimo have captured the imagination of enthusiasts worldwide.

Movies seem to have focused on robots as well, sometimes turning them into lead characters, as in "Chappi" and more recently "Ex Machina." These automatons

are a far cry from those depicted first in "Metropolis" or in "Forbidden Planet." Movies have been "humanizing" and "cutifying" robots for years, ever since George Lucas made us laugh in the "Star Wars" movies with R2D2 and C3PO. In Wall-E, this was taken to new heights of "adorablenous"…perhaps to soften us up, making us think of them as friendly and non-threatening up, allowing us to forget more ominous representatives from the "Terminator" series, or "I, Robot", perhaps preparing us for the coming wave of robots everywhere.

Although much of moviedom has focused recently on friendlier robots and some news focuses on convenient use of drones to deliver packages to our homes, other more ominous signs have emerged. A recent public radio program focused on ethical issues. These included the rise of "killer robots" being developed by military in several countries and the use of sex robots in Japan, currently a "harmless" entertainment for men. The discussion of the latter did recognize the potential for encouraging a-social or anti-social behavior in people. The possibility of sex/emotion robots for those unable to have "normal" relations with people some argue might be helpful, but the discussants debated the value of offering child-aged sex robots for pedaphiles. Ethical review, discussions, and potentially new laws seem in order. Such strategies are discussed in (Blum and Witten 2015).

There seems likely to be growing interest and need for human-centered, sophisticated solutions to Human-Robot-Interaction (HRI) in all phases of their deployment (Fig. 19.4).

Fig. 19.4 Photo of Bruce Sterling. Provided by Bruce Sterling and used with permission originally (Figure source: original drawing by the author based on the photo)

References

Aeppel T (2015) Why China may have the most factory robots in the world by 2017. Wall Street
 Journal, 1 April 2015, p D1
Blum G, Witten B (2015) New threats need new laws. Wall Street Journal, 18 April 2015, p C3
Hagerty JR (2015) New robots designed to be more agile and work next to humans: ABB intro-
 duces the YuMi robot at a trade fair in Germany. Wall Street Journal, 13 April 2015
Hongo J (2015) Robotic customer service? In This Japanese store, that's the point. Wall Street
 Journal, 16 April 2015

Chapter 20
The Out-of-Box Home Experience: Remote from Reality

20.1 Summary

You cannot even begin to imagine the pain of achieving high-definition pleasure.

20.2 Stepping into the Unknown and Unexpected

A recent national radio news broadcast in the USA announced that what most American men wanted as a year-end holiday gift was a giant, high-definition television with appropriate accouterments, presumably for watching and recording sports

© Springer-Verlag London 2015 161
A. Marcus, *HCI and User-Experience Design*, Human–Computer
Interaction Series, DOI 10.1007/978-1-4471-6744-0_20

events. Although I don't exactly qualify for all the attributes of this demographic group, I decided it was the appropriate time to increase my expertise in the area of home consumer electronics and explore in greater detail the user experience (including user-interface) issues of home-media systems. I got more, and less, than I paid for and expected. Let me recount the acquiring of this user experience. Please excuse the more personal style of this column's comments; I feel like an "embedded reporter" on the frontline of the home-consumer-electronics battlefield.

I decided to set up a non-PC-based home media system as a research tool for examining the details of purchase, out-of-box, set-up, and maintenance experience for the home consumer, in addition to details of user-interface design for viewing and recording media. Although I was not a viewer of cable/satellite television (I barely have time for such browsing given many other tasks and deadlines, like this column's), and I did not yet own a video hard-drive recording device, I felt it was my "professional obligation" to become as typical a consumer of video and audio media as possible under the circumstances, in order to understand better what consumers were experiencing, and to look especially at the user-interface and information-visualization issues.

First, I began researching likely equipment on the Web, in print, and at local electronics stores. *Wired*, magazine published an excellent review of some 250 products, including high-definition televisions, recording devices, etc., in late 2004, just in time for the end-of-year purchasing frenzy. Based primarily on *Wired*'s recommendations and some actual viewing of large-screen displays at Costco, I had decided on a Samsung 51" (diagonal) high-definition display. I had decided that space did not require a flat, wall-mounted or standing plasma display or liquid-crystal display (LCD). I could get a larger screen for less expense using a digital light-processor (DLP) rear-projection device. Trying to cross-compare the attributes of devices and to examine detailed technical specifications was mind numbing, and exceedingly frustrating. Detailed specifications of key factors, like brightness contrast-ratios of screens, spatial resolution, and price were not often in the same place at manufacturers Websites, were not often listed in recommended lists in printed publications, and key attributes were missing from cross-comparison lists. Just dealing with one piece of equipment, the primary viewing device, was challenging enough. Imagine the mental exhaustion having to cross-compare three or four related devices, such as home recording-systems, also. The poor, pitiable consumer is left with much cross-referencing activity to do, and there is, to my knowledge, no stand-out winner of comparison Websites or other tools to assist.

At another store, Good Guys, I was persuaded by a knowledgeable sales person to abandon my previous choice and select a Misubishi 62" device, which was a behemoth. One of the primary and unique benefits seemed to be an all-purpose device master remote-control unit, to which all other devices could be connected. Even *Wired* admitted this was a powerful, positive feature, although complex. I decided to take a deep breath and plunge into the unknown abyss of high-definition and home media centers. I could not imagine what it was going to do to my schedule, my mental health, and my life in general.

For one thing, after all other reviewing and analysis, I had to spend four hours in a sales showroom with numerous sound systems and video displays pounding out sound and blasting my eyeballs with high-definition movies and canned displays. By the end o f the final sales rituals, I had a painful, splitting headache. I thought this was not a good sign.

The next stage was delivery. The vendor promised a four hour window, and, surprisingly, the delivery crew kept to their schedule. The main device, the television, required two people to lift it. A world had come to an end for me: a lifelong expectation, that, if I needed to move a television from one location to another, even from one corner of the room to another, I could do it myself. From now on, I would have to hire a moving crew. This device, this monarch with its attendant princes and princesses, is larger in square front-face footage than the refrigerator, and weighs almost as much. It is curiously interesting that the storage device for food and food for thought, or at least entertainment, are such two giant home appliances, the center of the kitchen and the center of the living room or home media room.

Now came the out-of-box and set-up experience. Here is what finally had to be connected in the central viewing "pod," the home living-room or home theater-room, and elsewhere in the house:

The big kahuna:

- 62″ Mitsubishi DLP rear-projection high-definition television

The supporting characters:

- Samsung DVD player
- Mitsubishi High-definition VHS recorder with built in NTSC tuner
- Direct-TV satellite signal decoder plus Tivo with 250 gig drive
- Additional 2 Direct-TV satellite signal decoders for two other rooms
- Terq Satellite dish on the roof

The system already had:

- Sony Surround-sound analog AM/FM receiver and AV hub
- Sony VHS recorder with built in NTSC tuner
- Sony CD-ROM player with 6-CD changer
- Sony Audio tape player with two decks for copying
- 27″ Sony TV now being used in master-bedroom with satellite decoder
- 19″ Philips TV being used in a home-office with satellite decoder

I was amazed that the sales representative had to pay three 4-h visits to my home in order to connect and set up all of this equipment, which was part of the purchase price. Twelve Hours. I could have flown from California to New York and back in that time. He, too, had a family that waited for him, and I learned some personal details about his family history and home situation. I had not realized that when one buys a device like these giant systems, that one actually inherits two new family members: the television, and the sales/set-up person. When I related this experience to my son and fiancé, who were to be marrying soon, my future daughter-in-law kindly asked if I wanted to invite him to the wedding!

At last, after many hours of dedicated, persevering effort by the sales representative, not only with wiring, but going through all of the set-up screens of all of the devices, the main system was more or less ready to test with regular antenna ("off-air") signals. I had noticed and appreciated that the 20 or so set-up screens for the Mitsubish Net Command, featured much seemingly clear English text to guide the user in every step, using what some would hyperbolically call wizards. In general, the Mitsubishi NetCommand master control system was impressive. It featured intelligible English sentences that guided the user through the necessary steps. Nevertheless, the terminology of inputs and outputs, of acronyms, of unexplained technical terms, and the overall daunting complexity makes me marvel that the average "couch-potato" user could cope with this massive, monolithic user experience.

Unfortunately, the expert sales person, had little incentive or time to guide me through all of these screens, skipping over entry of Zip codes that assist in positioning the satellite dish antenna properly, for example, and I was left to look back through them at another time. I estimate, had I needed to do this set-up all by myself, that it would have taken approximately 1.5 times to twice as long to accomplish than the 12 h he spent.

I clearly gave up early and let the sales rep click his way through the set-up. I tried to understand and take notes of what he was doing. The wires in back of the cabinets looked like some Rube Goldberg folly, and I wondered if I ever would be able to replace or adjust them without requiring technical help should some unit require replacement. I was amazed and appreciative that this sales person devoted so much time and energy to helping me. I could not have made it through set-up without him.

I sat and contemplated the 18 or more remotes (see Figure) that are now going to be active in the house to run all TVs, radios, DVD players, VCR players, etc. Many of these frequently are upside down as I vainly try to switch channels in the dark. I realize that almost all of them, even TiVo's, are hard recognize in the hand merely by the shape of the general object, some surface treatment, or button clusters.

Even before the DirectTV satellite dish and decoder installer scheduled another, separate visit, I examined some of my new companions. In addition to the devices themselves, I am confronted with the following:

- Seven new remote controls, one of which claims to be able to take over most of the others.
- At least four new on-screen menu systems, all different in content, style, navigation, even terminology.
- Two hundred and twenty-five Buttons on these controls, approximately, many of them redundant, some of them unique, most in different physical locations, and some with different shapes and labels, even coming from the same manufacturer.
- Three hundred pages of new user manuals, in addition to the previous ones, including just one "User Guide" document from DirectTV that is 176 pages in length. What can be happening with typical home consumers? Are they reading these manuals? I would guess not.

The sales representative spent many hours programming the universal control of the Mitsubishi, which claims to take over most of the control of most of the other systems. The procedure required at times painstaking, annoying, double entries into the system for each button of each remote not registered with the master system in order to "learn" the "foreign" remote. Having done this once for all of the other devices, the master Mitsubishi system failed to register the DVD player because it was an "Other" system (Samsung). Confronted with going through this ritual for a second demanding time, the dealer sales representative urged me to replace the Samsung DVD player with a less expensive but equally capable Mitsubishi DVD player "in the family," which registers automatically. In the end, we kept the Samsung, and he had to go through the process a second time.

Despite all of this effort, several weeks later, the master remote seems to have failed to "catch on" and the other devices turn off and on at the wrong times, seemingly randomly at times. Consequently, I have to have at least four remotes in front of me to make sure that all systems operate properly. For example, a tape recorder set to record an off-air video must be in a power-off state to operate properly; if it is accidentally left on, the desired programs will not be recorded. It is very easy to not notice that the universal remote has failed to turn off that device when various devices are put to sleep when the system closes down.

Much time has been spent just to get to this point in systems set-up and operation. In terms of time, I estimate the following:

Purchasing the system required:

- Four hours at least studying product literature.
- Five hours spending time in show rooms.

Installing the system has required:

- Two hours for removing the old TV and preparing the wires and space for the big new system.
- Four hours with a first visit of the sales rep bringing the DVD, HIgh-D VCR, and the DirectTV and Tivo units and doing initial wiring of those devices.
- Four hours of waiting in the 4-h delivery window for the arrival of the giant TV, including asking the installers to hide the box so my neighbors don't see, because I am a little embarrassed by this whole adventure, and watching the installers connect the TV, DVD, and HD VCR the AV sound system.
- Four hours with a second visit of the sales rep to complete the wiring and set up of the master control system, which proved impossible to compete, and seemed to require a replacement of the DVD because there is a conflict of input/out connections and an over-needs quality connection for digital surround sound that is currently not used on the DVD.
- Four hours, for final visit of sales rep to complete the installation and checking of all audio and visual components and controls.
- Two to six hours estimated for reading any of the instruction manuals in detail.

I was impressed by some of the high-definition off-air channels that I received even before the 120 DirectTV channels were installed. I now had to choose from

about 25 channels. I did not even realize that a local PBS channel broadcasts five additional channels, including four additional HD channels with alternate programming. Even to view the regular channels now requires me to view the channel listing (graciously supplied by Mitsubishi technology) that shows what all the recognized channels are and what they are showing. Unfortunately, scrolling quickly through this list is not like the experience using a computer; it is slow and cumbersome for line-by-line scrolling and page-by-page shifting. The list itself does not actually scroll but page-shifts, as do many other such lists, making it sometimes confusing to pick the right stations. The numbers are in ascending order downward and cannot be changed to descending. In my experience generally, the navigation techniques familiar to most PC users are clumsily adapted to home-consumer use if at all.

Also confusing to the consumer are likely to be all of formats available for viewing high and standard definition images, including 480-line interlaced images both analog and digital, and varieties of high-definition screens. The Mitsubishi manual shows a page with 16 different video display formats that may be encountered. Is the average consumer expected to distinguish, account for, maintain, and decide among these frequently? I am also startled by the distorted wide-screen expansions of some TV formats that take the outer left and right edges of the video image and artificially expand them to fill the space, causing people on the screen to look like they are suffering from rare forms of elephantitis, as one side of their bodies balloons in size to twice the normal width. What were they thinking?

When the satellite dish installer arrived, he had to spend 13 h trying to get the dish aligned properly and then connecting the three decoders in three different locations in the building. Alas, only well into this process did he reveal the existence of something called "diplexers" which can combine and uncombined off-air and satellite signals within one co-axial cable, making it unnecessary to install additional wiring to two distant locations within the house. I myself had to make three emergency runs to local electronics stores before acquiring enough of the right kinds of devices.

Two weeks into this process as I write this compendium of woes, the two secondary televisions still do not get the proper satellite signals, and future visits must be scheduled. Most disconcerting was the fact that the local electronics store that sold me the DirecTV system had contracted with another company to supervise installation, which had contracted with at least one other local company to actually do the installation. This necessitated calling at least four different entities to complain about improper service or poor service, or to ask technical questions. One of the companies even refused to tell me where in California it was located according "to company policy," apparently because of some "immediately hostile" customers." This did not bode well for an over-all good customer experience on my part.

As I have begun to explore the various remote-control-based on-screen user interfaces of DirecTV, Mitsubishi, Philips, Samsung, Sony, Tivo, and others, I am struck by how lacking many are in many of the basic features of usability to which computer users have become accustomed. Lists must be scrolled in tedious ways. Customization is complex, but possible in some situations. Terminology among the vendors differs. Even DirecTV is accessed through two different kinds of remotes

because of two different business partners involved (TiVo and RCA). In some cases, when viewing lists of choices, the numerical buttons no longer work to simply pick stations, as one might wish to at any time. The varieties of local channels are not available through the satellite system, which therefore requires my still using the off-air access, which in turn requires device switching, which in turn requires different screen guides, and, in my situation, different remotes. Off-air channel changes of the Mitsubishi are quite slow, seeming to take about a half-second to a second to switch from one channel to another. Gone are the days of rapidly twisting a dial to see what's on (although one can, I admit, sample-view nine different channels simultaneously in addition to one being viewed via a special picture-in-picture function).

I am amazed that my mind, though numbed by this experience, can remember of some of the key buttons that enable me to keep my sanity. Perhaps out of dire necessity, I have remembered, almost unconsciously, a few key controls for channel, volume, jumping back to previous station, etc. Most annoying is the fact that DirecTV itself does not make alphabetical lists of channel providers easily available or even available at all. On its own Website, the vast number of stations appears in one list only in numerical order, making it almost impossible to keep track of favorite brands of channels, like Turner or HBO. Instead, the consumer is required to remember anonymous, ad-hoc numbers when looking for contents.

Life has become exceedingly complex. Maybe it will seem less enervating after a month of use with all the connections in place and 120 channels safely categorized and scheduled. I worry about the precious, and no doubt expensive, Xenon bulbs that must be cooled by a fan and how much they will cost when they eventually fail. I begin to long nostalgically for my little 13-in. Sony desktop television, now relegated to my basement workbench, which was my faithful desktop companion since 1968 and is still going strong. Already I notice my habits are changing. With 19 movies playing simultaneously, and the ability to record at will, I feel almost burdened by all of the options requiring further decision-making, but I also drop in and out of movies, leaving them in an instant if scenes, scripts, actors and actresses, or scenery become uninteresting. They will be around again. How different from the precious "movie-palace" of the last century (which survives in some theaters today), which made the movie viewers' experience an occasion for dressing up in fine clothes and marveling at the Egyptian-style décor of half-columns, hieroglyphics, and starry ceilings.

Now, I am drawn more and more to want to customize my viewing and look at varieties of simultaneous content lists to decide what to watch and when, what to record and when. Alas, many of the manufacturers do a modest job, at best, of information visualization, especially for the large quantity of media metadata that needs to be communicated, by which viewers might sort their possible choices or preferences. Given the large displays and the high definition, the space seems underused for typographic tabular display.

Life is short, choices are many. A vague feeling of helplessness and slight depression balances against the pleasure of viewing a movie with a fine visual experience and occasional high-quality content of movies and television programs. I face a

world of complex, possibly undependable, expensive, partially unproven and clearly partially still unfriendly technology. Heaven help the user who chooses to experience today's home media centers. I have to admit, however, that having lived a short while with high-definition viewing of imagery, going backwards would seem a sensory deprivation; the high definition is eventually addictive. Perhaps in the future, things will be better. Maybe PC-based systems will help. Some reviewers of early entries are expressing their doubts.

20.3 Home Consumer Electronics and the CHI Community

This bleak report actually has a bright side. There is a tremendous opportunity for user-interface designers to improve the user experience of many/most of the manufacturers. With only a few outstanding success stories, like TiVo or Bose, there is ample room for improvement. We are witnessing a wild and wooly Western scenario of development of isolated, unintegrated systems. Although Jakob Nielsen has called the TiVo pause button the most beautiful pause button he has ever seen, the challenge is not isolated bits of beauty, but overall systems integration in an environment that is almost impossible control. If manufacturers won't share key specification data (as Apple for example keeps to itself), then others won't be able to co-relate access, and users will be left with tedious work-arounds, including the above-mentioned painful manual entry of button codes for devices.

The challenges are considerable and dauntying.

One head of the USA design office of a Japanese manufacturer commented a few months ago that the head office people in Japan felt they knew their territory, were very busy, could not take time off for even a one-day tutorial, and did not feel they needed outside help. This reminds me of some vehicle user-interface management of major automobile manufacturers in Europe who felt they understood all of the issues perfectly and did not need outside help, thank you. I beg to differ.

Another major US manufacturer labored intensively for a more than a year to develop a standardized user-interface guidelines document that, in the end, almost no one used. The document is now several years out of date. With staff turnover almost complete, there are few, mostly long-standing engineers, who actually know the heritage of design issues, design decisions, and corporate standards, not the user-interface design staff who are tasked to come up with new concepts, new solutions.

We are entering a realm of massive change in home media systems, and more evolution, even revolution, is coming from Japan, with local digital broadcasting, for example, or the use of the Web in conjunction with media delivery. All of this change challenges user-interface designers and analysts to get into mix of stakeholders to defend and support users to make sure their user experience is less miserable than mine was.

20.4 Postscript 2015

In the last 10 years, I have significantly reduced the number of home remote control devices I confront on a daily basis, and mobile phones, smart watches and other dedicated devices promise us ever easier-to-learn, easier-to-use solutions to becoming a Media Master or your Own Domain.

Nevertheless, the growth of devices that might be monitored and managed by remote access, especially through mobile and wearable solutions, continues unabated. Examples include heating-ventilation and air-conditioning, landscape irrigation systems, rooftop solar systems, refrigerators that order food when supplies get low, home security systems, home lighting systems, home healthcare, vehicle access and management systems, to say nothing of ever more complex home entertainment and information-systems. All of these systems, often provided by non-integrated, competing suppliers, almost guarantee us increasingly complicated user experiences that are not what we want, need, prefer, or expect.

There is much yet to be done (Fig. 20.1).

Fig. 20.1 The author contemplates the 18 or more remotes that now populate his home/office environment wondering if he can remember the on/off positions in each (Figure source: AM + A photograph)

References

Publications

Review of Products (2005). Wired Magazine. January 2005

URLs

The following URLs and email contacts, among others, are relevant to this topic: DirecTV: www.
 directv.com

Chapter 21
Usability Grows Up: The Great Debate

21.1 Summary

Is usability ready for prime-time? Two industry leaders go head-to-head on this issue.

Originally, copyright © 2005 by Aaron Marcus and Associates, Inc. (AM+A).

© Springer-Verlag London 2015 171
A. Marcus, *HCI and User-Experience Design*, Human–Computer
Interaction Series, DOI 10.1007/978-1-4471-6744-0_21

21.2 Stepping into the Ring

At CHI 2005, Eric Schaeffer, President, Human Factors International (HFI), who works from Mumbai, India, and Jared Spool, President, User Interface Engineering (UIE), Middleton, Massachusetts, invited me to moderate their debate about usability. Approximately 700 people showed up to witness a "wrestling match" between the Maharajah of Mumbai *vs*. the Motormouth of Middleton. Each is a knowledgeable, passionate, and articulate professional. Eric has published his step-by-step guide *Institutionalization of Usability* (Addison-Wesley, 2004), and Jared runs a well-known user-interface tutorial series nation-wide. I shall summarize the three segments of their debate.

21.3 Does Usability Scale Up?

Can usability groups get larger? Is larger better? Jared acknowledged many resources "proving" return on investment (ROI) for usability. However, citing a UIE study for The Gap's Website, he showed sometimes professionals don't know how to explain what's happening, which usability issues are most significant, or why things improved. He also noted that many large software companies have hundreds, even thousands, of usability professionals, but they do not necessarily have comparable increases in usability of their products when compared to smaller companies with smaller teams, but with extremely usable products like those of Google or Yahoo. His point: investing more people and money may not bring about greater usability.

Eric pointed to our being in a transition to the "third wave of the Information Age." Anomalies may exist, but proof is available, e.g., in a Nielsen Norman Group report about the ROI of usability. He asserted: we *know* how to do it, and we *can* do it at the larger scales needed for global, enterprise software solutions, and we don't have a choice about adopting these practices. Fortunately, he feels that his own company's evolved practices demonstrate his precise, reproducible method for achieving usability.

The audience questioned some of Jared's numbers. Jared countered that there is simply insufficient careful proof of the connection between usability and business success. He even conjectured that usability might not be crucial at all, in comparison to money spent and earned when considering marketing and other costs. He pointed out that usability experts cannot give guarantees about the bottom-line effectiveness of their services. Others questioned Eric's notion of a "usability factory," as opposed to "mom and pop" groups today. The factory concept didn't sound appealing. Eric admitted it might not be the best term, but likened it to the model of information technology (IT); it expressed the larger scale success of enterprise professionals, not village craftspeople.

21.4 Globalization, Offshoring

How is usability to be accomplished at a global scale to meet development needs? Eric mentioned a Jakob Nielsen pronouncement that India required 60,000 usability experts to cope with their software development. Eric asked: how *can* this be accomplished *without* a factory process? He believes all jobs will *not* go to India, but a "global harmony" can emerge that puts locals together with global resources efficiently with regard to time and task sharing. He has put theory into practice at the HFI Mumbai, India, office, in which a majority of HFI's staff work at greatly reduced costs of resources, but also according to systematic methods of work.

Jared waved away the offshoring issue and pointed again to the difficulty of predicting results with usability groups. He pointed to an experiment involving seven usability teams, each of which found different, crucial problems in a usability review. Would the client have had to purchase the services of all seven groups to be sure that all significant errors were discovered? Jared challenged the audience: are we a crafts group or an engineering profession? Why do different consultants get different answers? If we have such variability, what are we actually offshoring?

The audience challenged Eric with how one really could do usability evaluations that required deep understanding of local context. Eric countered that HFI had proved it could do all of its work from India, but admitted that best practice was a mix of Indian and local professionals, which could *only* work with a *systematic* usability process, not the *craftsperson's*. Another audience member challenged Jared's description of many professionals as craftspeople dependent upon their portfolio of past experiences by pointing out that many firms had sufficient depth in their staff skills that people *could* be swapped in or out of a project.

21.5 Craftswork Versus Engineering: Are We Certified?

Continuing on his theme, Jared asked: are usability professionals cobblers or engineers? Jared used the examples of graphic designers who rely on their portfolio *vs.* radiologists who have established basic knowledge required for practice (No one mentioned the issue of "license to practice," but it was just around the corner). What rankled Jared is usability professionals seem to *sell their services* as engineers but actually *conduct their practice* like craftspeople. He faulted organizations like ACM/SIGCHI and Usability Professionals Association (UPA) for not addressing this issue clearly enough. He asked: Where does either organization talk about either building up a portfolio and how to sell services, or how and where to state the basic requirements of knowledge to be a professional.

Eric responded that we *formerly* sold our services as craftspeople, but we are shifting. He sees the need for certification, which the major organizations do not choose to address, and which software vendors cover only in terms of "certified tool

users." For that reason, HFI decided to develop a certification program regarding its process and now has 272 certified professionals.

An audience member chided Jared for making a false distinction: Multi-layered professionals have many structures, terms, and processes. Hiring the best people means that a company *can* shift people or roles without a conflict between craft-oriented professionals and process-oriented engineers. In addition, CHI, UPA, and other groups *have* published some basic methods. Jared countered with the challenge: Do you sell a person or a process, an individual or a result? Can we really substitute one person for another and expect to get the same results? Clearly, he expected "no" to this last rhetorical question.

Another audience member critiqued Jared's implication that all engineers are equal; some of what they do is a craft, like when they are developing high-level designs. Jared claimed there was a qualitative difference in variability of results that made usability professionals seem far from engineers. What he demanded was *honesty* about how the profession sold its services. He used the example of magicians: They *know* their practices are "fake" and so do their audiences. At their conferences, they discuss techniques for putting on a show, an illusion. Perhaps this, he mused, should be SIGCHI's and UPA's approach to the profession maintaining its ability to perform magic. Eric closed with the counter that many other fields have gone through the transition in which he now sees the usability practitioner, from the days of selling magic, to the era of selling a process. For him, the systematic, process-oriented method is the right road to travel.

21.6 Conclusions

After the session, many acknowledged that, even with the shouting (from at least one of the speakers and some of the audience members), the debate was a highlight of CHI 2005. Others commented that it seemed as hard to get two great egos to tango as it may be to scale up usability. Some may complain that definitions and facts were given some "spin." Nevertheless, Eric and Jared addressed vital issues facing the profession today. Everyone was stimulated to think hard about where he/she stood on these issues that confront us today, issues that won't go away any time soon.

21.7 Postscript 2015

The protagonists of this event continue in their professional careers, with undiminished bravado, expository pronouncements, and accomplishments.

Meanwhile, among larger enterprises, usability continues to become an established institution in departments, whether in engineering or elsewhere, whether cen-

Fig. 21.1 Eric Schaeffer of HFI, moderator Aaron Marcus of AM + A, and Jared Spool of UIE in a quiet moment before the storm (Figure source: Photo by AM + A)

tralized or decentralized (the pendulum of this dimension seems to swing one way, then another every 5–10 years). Academic departments in the topics flourish, more and more books, ebooks, and Web-based documents proliferate, and competitor organizations have emerged to challenge previous human factors, ergonomics, usability hegemony (Fig. 21.1).

Chapter 22
Education and CHI

22.1 Summary

What would an ideal CHI education look like? An initial draft curriculum is shown.

© Springer-Verlag London 2015
A. Marcus, *HCI and User-Experience Design*, Human–Computer
Interaction Series, DOI 10.1007/978-1-4471-6744-0_22

22.2 Introduction

What would *you* select if someone asked you to develop an ideal professional education in CHI's essential subject matter? If someone were to ask me, first I would check the core CHI curriculum for computer science departments that an ACM SIGCHI committee (including Prof. Ron Baecker, University of Toronto, and others) put together about a decade ago when they were trying to get such curricula accepted within universities. However, the times, technology, and users have changed considerably since then. Another way to quickly assemble a set of essential topics would be to merge and purge the tables of contents for two leading *Handbooks of Human-Computer Interaction* published by Elsevier (Landauer et al. 2003) and Lawrence Erlbaum Associates (Jacko and Sears 2003). With apologies to the editors and authors (including myself), I have tried to do just that, somewhat quickly and informally. I contemplated simply listing the approximately 120 topics in alphabetical order, but I have tried instead to reduce seeming repetitions, use more consistent terminology, and maintain some of the original overall organization and sequencing, which suggests the sequence of topics in a curriculum. Here is what results:

22.3 Issues, Theories, Models, and Methods in HCI

- The Evolution of Human-Computer Interaction: From Memex to Bluetooth and Beyond
- Human-Computer Interaction: Background and Issues
- Mental Models and User Models
- Information Visualization
- Model-Based Optimization of Display Systems
- Task Analysis, Task Allocation and Supervisory Control
- Models of Graphical Perception
- Using Natural Language Interfaces
- Virtual Environments as Human Computer Interfaces
- Behavioral Research Methods in Human-Computer Interaction
- Perceptual-Motor Interaction: Some Implications for HCI
- Human Information Processing: An overview for Human-Computer Interaction
- Emotion in UI Development
- Cognitive Architecture
- Modeling Humans in HCI

22.4 Design and Development of Software Systems

- How to Design Usable Systems
- Participatory Practices in the Software Lifecycle
- Design for Quality-in-use: Human-Computer Interaction Meets Information

- Systems Development
- Ecological Information Systems and Support of Learning: Coupling Work Domain Information to User Characteristics
- Task Analysis's Role in the Design of Software
- Ethnographic Methods: Use in Design and Evaluation
- What do Prototypes Prototype
- Rapid Prototyping
- Scenario-Based Design

22.5 HCI Fundamentals

- Multimedia User Interface Design
- Visual Design Principles for Usable Interfaces
- Multimodal Interfaces
- Adaptive Interfaces and Agents
- Network-Based Interaction
- Motivating, Influencing, and Persuading Users
- Human Error Identification in Human Computer Interaction
- Design of Computer Workstations

22.6 Designing User Interfaces for Diverse Users

- Genderizing HCI
- Designing Computer Systems for Older Adults
- HCI for Kids
- Global/Intercultural UI Design
- Information Technology for Cognitive Support
- Physical Disabilities and Computing Technologies: An Analysis of Impairments
- Perceptual Impairments and Computing Technologies

22.7 UI Issues for Special Applications

- Documentation: Not yet implemented but coming soon!
- Information Visualization
- Groupware and Computer Supported Cooperative Work
- Online Communities: Sociability and Usability
- Virtual Environments
- User-Centered Interdisciplinary Design of Wearable Computers

- A Cognitive Systems Engineering Approach to the Design of Decision Support Systems
- Computer-Based Tutoring Systems: A Behavioral Approach
- Conversational Speech Interfaces
- The World-Wide Web
- Information Appliances

22.8 User-Interface and Screen Design

- Graphical User Interfaces
- Metaphors: Their Role in User Interface Design
- Direct Manipulation and Other Lessons
- Human Error and Use Interface Design
- Screen Design
- Menus
- Color and Human-Computer Interaction
- How Not to Have to Navigate Through Too Many Displays

22.9 Multimedia, Video, and Voice

- Hypertext/Hypermedia
- Multimedia Interaction
- A Practical Guide to Working with Edited Video
- Desktop Video Conferencing
- Design Issues for Interfaces Using Voice Input
- Designing Voice Menu Applications for Telephone
- Auditory Interfaces
- Applying Speech Synthesis to User Interfaces

22.10 Programming, Intelligent UI Design, and Knowledge-Based Systems

- Expertise and Instruction in Software Development
- End-Use Programming
- Interactive Software Architecture
- User Aspects of Knowledge-based Systems
- Paradigms for Intelligent Interface Design
- Knowledge Elicitation for the Design of Software Agents
- Decision Support Systems: Integrating Decision Aiding and Decision Training

- Intelligent Vehicle Highway Systems

22.11 Input/Output Devices, Human Factors/Ergonomics, and Design of Work

- Input Technologies and Techniques
- Keys and Keyboards
- Pointing Devices
- Conversational UIs Technologies
- Visual Displays
- Haptic UIs
- Non-speech Auditory Output
- Ergonomics of CAD Systems
- Design of the Computer Workstation
- Work Injuries on The Operation of VDTs
- International Ergonomics HCI Standards

22.12 Application Domains

- E-Commerce UIs Design
- The Evolution of HCI during the Telecommunications Revolution
- Government Roles in HCI
- UI Development in Health Care, [Finance, and Travel]
- A Framework for Understanding the Development of Educational Software
- Understanding Entertainment: Narrative and Gameplay
- Motor Vehicle Driver Interfaces
- Human Computer Interaction in Aerospace
- User-Centered Design in Games

22.13 Computer-Supported Cooperative Work (CSCW) and Organizational UI Issues

- Research on Computer-Supported Cooperative Work
- Organizational Issues in Development and Implementation of Interactive Systems
- The Organizational Context of Human-Computer Interaction
- Psychological Aspects of Computerized Office Work

22.14 Development Process: Requirements Specification

- Requirements Specification within the Usability Engineering Lifecycle
- Task Analysis
- Contextual Design
- Ethnographic Approach to Design

22.15 Design in Development

- Guidelines, Standards, and Style Guides
- Prototyping tools and techniques
- Scenario-based Design
- Participatory Design
- Unified UI Development

22.16 Evaluation, Including Testing

- Usability Engineering Framework for Product Design and Evaluation
- User-Centered Software Evaluation Methodology
- Usability Inspection Methods
- Cognitive Walkthroughs
- A Guide to GOMS Model Usability Evaluation Using NGOMS
- ROI: Cost Justifying Usability Engineering in the Software Life Cycle
- User-based Evaluations
- Inspection-based Evaluations
- Model-based Evaluation
- Beyond Task Completion: Evaluation of Affective Components of Use

22.17 Managing UI Development and Emerging Issues

- Technology Transfer
- Human Values, Ethics, and Design
- Cost Justification
- The Evolving Role of Security, Privacy and Trust in a Digitized World
- Achieving compatibility in HCI design and evaluation

22.18 Individual Differences and Training

- From Novice to Expert
- Computer Technology and the Older Adult
- Universal Design: UIs for People with Disabilities
- Computer-Based Instruction
- Intelligent Tutoring Systems

Noticeable in the original tables of contents was an absence of reference to financial systems, branding, marketing, semiotics, user experience, design patterns, legal issues, and professional licensing/standards (currently minimal or non-existent in the industry). Also missing is the notion that a professional might actually have to sell her/his services: thus, storyselling, portfolio preparation, and other marketing of services principles/techniques are omitted. In fact, the last of these topics often populate many Internet-based discussions and email threads, because every year there is a new crop of novice professionals who seek advice from elder mentors on everything from acquiring disability insurance to how to deal with clients who won't pay for services rendered. If I had to further disaggregate the above topics into undergraduate and graduate subjects, well, that is a major task that many institutions have already attempted with varying degrees of success.

If I were asked where might I place special emphasis, I would suggest the following:

I believe different regions of the earth, different countries, different socio-economic-political conditions may give rise to different needs and orientations to courses of study. For example, I was impressed recently by Prof. Gary Marsden's graduate student projects at the University of Cape Town, South Africa, which focused on somewhat unique, indigenous circumstances. Graduate student projects took on objectives of assisting nutritional training for young mothers suffering from HIV/AIDS, encouraging involvement of school children with aboriginal storytelling of Khoi-San bush people, and establishing mobile telemedicine capabilities in an east South African village where one of the first questions is: from where will a reliable source of electricity come?. While these projects also may involve UI development tasks involving high-technology virtual reality or mobile devices, they clearly and fundamentally relate to contexts that are quite different from those encountered in North America, Europe, Korea, or Japan, and are more like those appropriate for some parts of India, China, and similar contests.

One other special area of emphasis is in cross-disciplinary group exercises or student projects. One of my most valuable learning experiences in graduate school arose when I was forced to work with students from other disciplines. Coming to understand differences and similarities in our objectives, principles, and techniques were part of the benefits of the project, as well as learning how to work with others who had much different perspectives.

I would emphasize the importance of visual communication in scenarios, reports, portfolios, and other work products. One cannot underestimate the importance of

good storytelling in explaining initial, interim, and final solutions to others. Often the skills of this aspect of professional practice is not talked about or left as an informal, last-minute, ad-hoc component. However, learning the skills of visual rhetoric and how to make a strong case for what one believes to be important is sometimes half the challenge facing the professional.

As CHI concerns enter more and more into entertainment, including games, it seems likely that some curricula traditionally focused on productivity tools may have its objectives and/or sequencing stood on its head. Already curricula in games-oriented CHI/HCI/UI topics have sprung up at places like Carnegie-Mellon University in Pittsburgh, USA, and the Danube University in Krems, Austria. These innovative approaches may provide perspectives that will influence new sequences of courses and new subject matter entirely.

22.19 Conclusions

The discipline of CHI/HCI/UI is continuing to evolve and dramatically change its focus, from the solely productivity-oriented perspective of the past, to a much richer set of educational objectives that take account of the desire to produce useful, appealing products and services as well.

Watch for the new curricula to emerge and show the way ahead to fundamental shifts in the paradigms of CHI/HCI/UI/UX education.

22.20 Postscript 2015

The HCI/UX professions, platforms, processes, and people have continued to evolve in the past decade. New technologies, contexts, user communities, and content have emerged, and major centers of research and development have come into being on almost all the continents. In looking over the above lists, the following terms came to mind as likely additions or strengthened content for a revised "super-curriculum" for the most sophisticated HCI/UX education.

- Agile and lean methods: Coping with rapid development and incorporating traditional usability concerns
- Autonomous vehicles: Roles for all passengers in monitoring and managing information, navigation, and command/control
- Big data: What to show, to whom, when, where, and why?
- Drones: Managing fleets, missions, contexts, people, including ethical issues
- Ethics: Integration into mainstream curricula
- Gamification: Endemic usage throughout enterprise as well as personal applications

- HCI/UX outreach: How to get more women and African-related peoples involved in development
- Internet of things: Communication and interaction with almost everything
- Military applications: Who's doing what, why, where?
- Mobile devices: Specific issues that arise with mobile users
- Neuroscience: What can be learned and applied from a study of how our own brains work in terms of performance and pattern recognition
- Robot-Human Interaction: Specific issues that arise with robotic agents, especially ethical issues
- Smart homes, environments, appliances: Specific issues that arise with intelligent spaces
- Virtual reality: Specific issues that arise with the widespread availability of low-cost, ubiquitous virtual-reality devices and content
- Wearables: Specific issues that arise with the widespread availability of wearables of all kinds: wrist-top devices, jewelry, clothing, embedded devices, cosmetics

Of course, I probably have forgotten someone's favorite topic; hard to avoid, suggestions and corrections welcomed.

References

Jacko JA, Sears A (2003) The human-computer interaction handbook: fundamentals, evolving technologies and emerging applications. Lawrence Erlbaum Associates, Mahwah
Landauer MG, Helander TK, Prabhu PV (2003) Handbook of human-computer interaction. Amsterdam, Elsevier/North Holland

Chapter 23
When in Rome, Do as the Romans Do: HCII 2005 Recap

23.1 Summary

Human-Computer Interaction International (HCII) conference offers a useful alternative to CHI and UPA conferences.

© Springer-Verlag London 2015 187
A. Marcus, *HCI and User-Experience Design*, Human–Computer
Interaction Series, DOI 10.1007/978-1-4471-6744-0_23

23.2 What's Up with HCI International?

What a vibrant, slightly chaotic venue, but interesting. The 2005 Human-Computer Interaction International (HCII) conference took place in Las Vegas at Caesar's Palace during a heat wave. Fortunately, many attendees did not even have to venture outside with the thousands of slot machines, the indoor shopping mall, Elton John, and Celine Dion to keep them entertained outside of conference sessions (Fig. 23.1).

Earlier in 2005, when I mentioned HCII 2005 to a famous computer-science researcher in a USA university, he pooh-poohed the conference as beneath his dignity to attend because of its easy-going review process. This snobbish attitude has characterized the view of some CHI community and conference participants. So, why were such luminaries as Ben Shneiderman and Jenny Preece from the University of Maryland and Brad Myers from Carnegie-Mellon University in attendance? In the minds of many attendees, the HCII conference had "grown up" or "matured." The current conference was organized by HCII's founding father Prof. Gavriel Salvendy of Purdue University, USA, and Tsinghua University, China, together with his assistants. The previous one was primarily organized by Dr. Constantine

Fig. 23.1 Roman gladiators and Antony and Cleopatra with typical HCII participant for contrast. Caesar's Palace provided fitting accompaniment to the opening ceremonies with a much-heralded appearance of stand-ins for Antony and Cleopatra (Photo source: Photo by author)

Stephanidis, head of a computer-science research center near Heraklion, Crete, Greece, who will also be organizing the next conference in Beijing in 2007.

Perhaps after 20–30 years of conferences around the themes of CHI/HCI, it is time that someone wrote a careful socio-anthropological-technological analysis of these communal professional rituals, complete with analysis of cult objects (the exhibit-booth give-aways as well as the shoulder bags, pens, and proceedings). My commentary is *not* that study. What follows are informal and eclectic impressions gained from attending this HCII 2005 conference, in comparison to other similar conferences offered by CHI, UPA, SIGGRAPH, AIGA, the International Institute for Information Design (IIID), and other organizations, which I have attended on four continents in eight countries in the last few years.

23.3 HCII 2005 Stats

According to Dr. Salvendy, HCII 2005s 2300 registered attendees came from 63 countries. This international representation is, to my knowledge, a greater percentage than CHI and UPA can claim, and is one of HCII's chief attractions. It is possible to discover interesting, novel developments. A surprisingly (to me) large contingent came from France, while large European delegations from Finland and Germany and from Asian delegations from China, India, Japan, and Korea were more expected. At least one representative came from Saudi Arabia, which hints at the large market in Moslem countries spread throughout Europe, Africa, and Asia. The large attendance and diverse subject matter partly derives from six joint conferences, including virtual reality and augmented cognition. The last subject seemed heavily related to and endowed by DARPA, the Office of Naval Research, and the National Science Foundation, among other sponsoring organizations.

CHI in recent years, as well as UPA, were pleased to see conference attendance numbers and membership growing stronger in the past 2 years following the recession of 2002–2003 (interestingly, there seems to be a pattern of recessions: 1982, 1992, and 2002). HCII takes a longer view because of the 2-year build-up to its biannual conference, whose venue bounces around the world. While UPA ventured to go "international" for the first time by holding its conference successfully outside the USA in Montréal, Québec, and CHI has occasionally ventured abroad to Europe to hold its conferences in the Netherlands and Austria, and HCII has regularly featured worldwide and exotic locations in North America, Europe, and Asia. This international character is reflected in its attendance figures: 57 % of the 2005 attendees came from outside the U.S.A., a very high figure, and higher than for CHI and UPA, to my knowledge.

There were 62 exhibitors, 22 parallel sessions, and 230 posters. The CD *Proceedings* seems to contain 1672 papers. These figures alone are impressive. The exhibits and posters took me approximately 3–4 h to sample one by one, at least to pass by to determine if each held any specific interest for me.

The exhibits were surprisingly profuse and elaborate. Because of DARPA and other military-related funding sources, these exhibits featured a surprising number of rifles on display, some used as "mouse pointers" in virtual-reality games. There was even one military jeep-like vehicle perched at a angle on a small fake hill, with an anti-aircraft machine gun on top. I don't recall the exact subject matter of the exhibit, but the sheer cost of these exhibits called to mind the feeling of SIGGRAPH exhibits in the 1980s, when CAD/CAMCAE system vendors funded much of commercial product development, and budgets were ample for booths and give-away toys. In fact, the exhibits felt more like the robust SIGGRAPH exhibits of past and now, again, current years. One exhibit representative even commented that her group had debated whether to exhibit at SIGGRAPH or HCII, and had decided on the latter, because the SIGGRAPH exhibits seemed to her too narrowly focused on the film/animation industries.

Among the exhibits, I was intrigued to notice two booths featuring a four-aroma computer-controlled scent display developed at the Institute for Creative Technologies, University of Southern California, http://www.ict.usc.edu. The device was like a horse's harness placed on the shoulders, and several "thinking caps" monitored neural activity (see, for example, www.quasarusa.com and www.b-alert.com). The sheer cleverness and curious mixture of high technology, game simulation, and virtual reality recalled the excitement of SIGGRAPH's perennial experimental new technology exhibits, at which innovative prototypes, art works, and first-generation commercial solutions have been shown.

Posters varied greatly; some, as at CHI, looked no better than high-school science reports, while others were very professional in appearance and content. Among those that caught my eye, and mind, were Kim and Poggenpohl's Institute of Design, Illinois Institute of Technology, study of movement phenomena based on Werttheimer's 1923 gestalt principles of form (e.g., similarity, proximity, continuity, and good form). Their adaptation seemed intriguing and useful for distinguishing different kinds of motion phenomena. The extension to sound and even haptic display seems inevitable.

I was also pleased to see yet another augmented reality system being demonstrated with a single-hand chording keyboard that appeared to be comfortable and easy to use. The wearer, Kent Lyons, a Ph.D. student from Georgia Institute of Technology, said that he had been using a similar system for several years, as he entered my contact data into his database discretely with one hand while I verbally recited it to him.

In the conference program, DARPA-flavored augmented cognition topics were featured heavily. Dr. Gerald M. Edelman of the Scripps Research Institute and the Department of Neurobiology at the University of California–San Diego discussed progress with brain-based devices. His talk was followed by an Alexander Singer film about the future of augmented cognition. Much of this high-technology seemed oriented to military applications, with occasional spin-offs, e.g., to equipment that aided cognition-disabled children with input devices suited to their accessibility levels.

Mobile sessions also commanded significant attention. Dr. Martin Boecker, Siemens, Germany, presented three-dimensional, animated avatars for delivering SMS and email phone messages. They experimented with both realistic and more abstract, cartoon-like depictions of informal "agents." He commented that a particular green "cute" creature was unexpectedly interpreted as a dragon in China, but nevertheless was appealing. Dr. Boecker also made a presentation on behalf of a multi-company consortium including Siemens, Sony-Ericsson, and Nokia, which reported on emerging conventions in mobile phone user-interface controls and information display. This admirable example of coordination was a welcome piece of good news for the benefit of users worldwide.

Marta Ray Barbarra, in my session, reported on a successful launch of a BankInter, Spain, SMS–based banking system, which used simple password-code plastic cards to ensure security. The very high rate of satisfaction achieved was impressive for a solution that did not attempt the most radically innovative technology, but rather was satisfied with achieving a usable, practical approach to guarantee marketplace acceptance and use.

In the cross-cultural area, Dr. Nuray Aykin, The New School, New York, had chaired an impressive number of sessions in her track with international, global, and cross-cultural themes. Papers of interest included studies of users in different countries, differences of attitudes toward color and imagery, and different techniques used to gain user feedback. Among memorable presentations was Apala Lahiri Chavan's, Human Factors International, Mumbai, which discussed the value of adding "Bollywood characteristics" to spice up use scenarios to make them more attractive and involving for Indian users.

23.4 Conclusions, and Looking Toward Beijing

HCII 2005 was an impressive success in many ways. Although it suffered some logistics problems, the success of the HCII 2005 conference should give CHI 2006 planners something to think about. The continuity of the organizers of HCII conferences during the past two decades means that inherited wisdom of things done right, and avoidance of past mistakes, can be retained in organizational memory, unlike the annual leadership transplants that take place every year at CHI. As CHI and <interactions> rethink themselves, the operations and content of a successful conference like HCII 2005 should provide important evidence and trend information that could benefit the CHI community. HCII's 2007 conference in Beijing promises to be an attractive alternative to world CHI/HCI/UI/UX events.

23.5 Postscript 2015

Many more Human-Computer Interaction International (HCII) and now Design, User Experience, and Usability Conferences held in conjunction with HCII have occurred and are scheduled several years into the future. Their venues continue to feature international locations in Asia, Europe, and North America. Perhaps someday conferences in South America, Australia, and Africa will be held.

The DUXU conferences, which I have chaired for several years now, have grown in quantity and quality of papers. The latest Proceedings (The proceedings of this conference are located here) published by Springer is a four-volume set covering practically every topic of interest listed in the chapter on education. What continues to strike me about HCII as well DUXU is the international origins of the professionals, academics, researchers, and students who attend the conferences, which seem to be more varied consistently than many other regional conferences.

References[1]

The proceedings of this conference are located here. http://www.hci-international.org/index.php?module=conference&CF_op=view&CF_id=4

[1] The entire sequence of HCII conference Proceedings are available through Springer Publications.

Chapter 24
Dashboards in Your Future

24.1 Summary

What's happening? What's happened? What's going to happen? Check the dashboard.

© Springer-Verlag London 2015
A. Marcus, *HCI and User-Experience Design*, Human–Computer
Interaction Series, DOI 10.1007/978-1-4471-6744-0_24

24.2 Introduction

In the 1980s and 1990s, it was fashionable to speak of executive information systems (EIS) as a wave of the future. There were specific conferences on EIS applications. IBM, as well as smaller software companies, offered products to business markets that needed this information outside the military, which had established systems for intelligence analysis.

During that time, our own firm worked on an informal, "skunkworks" project at Pacific Bell (now SBC) that was to provide a state-of-the art workstation to all top executives (only the Pentagon, we were told, had similar equipment). We were able to interview some key stakeholders, usually the executive assistants, not the executives themselves, who prepared the documents needed by their bosses. Drill-down capabilities were to be provided, as well as access to outside news feeds. Alas, the project blew up before it could deliver, after consuming several million dollars in development, because the key project leaders failed to gain official support for the likely total development cost.

Another client sought to develop an EIS product, this one to be powered by an artificial intelligence engine that could analyze news feeds and extract key patterns. We proposed metaphors for the user-interface based on daily business newspapers, to which top executives were presumably accustomed. Alas, the business intelligence engine seemingly failed to deliver, and the product did not see daylight to my knowledge.

Nevertheless, others did succeed, and the concept of (and products offering the capabilities of) executive information systems became implanted in the business community. They were often embodied in the metaphor of the vehicle *dashboard*. I mention this bit of history because dashboards seem to have surfaced again, bursting out in all kinds of environments. A recent article in the *Wall Street Journal* by Carol Hymowitz, for example, calls the reader's attention to some key software providers and the related issues.

24.3 What Dashboards Do and Don't Do

Let's be clear: Data by itself is necessary but not sufficient. Dashboards must at least provide significant patterns of data, i.e., information. It's even better if the dashboards can provide significant patterns of information with action plans, i.e., knowledge. Best of all would be dashboards that, like the oracles of old, not Oracle presently, could provide significant patterns of knowledge based on real-world and theoretical modeling. We would call that wisdom.

Typically, business dashboards transform data from other, more complex, industrial-strength data-analysis engines, into information, providing key financial summaries. With today's database software, dashboards can provide real-time charts and diagrams based on revenue, costs, and forecasts of the company's future,

as well as of national and international economies. The power and speed of business dashboards make them a popular and powerful component of executive life. The *Wall Street Journal* article cites a study by Hyperion Software, a provider of dashboards, that claimed 50 % of 470 financial and information technology executives surveyed used dashboards and another 30 % expected to be using them within the next year. What a difference a few decades make!

Cautions are also provided in the *Wall Street Journal* report: Some people think that dashboards tend to focus the user's attention on short-term results while ignoring longer-term issues and trends that can lead to improved productivity and innovation. The dashboards themselves can lead to managers over-reacting to short-term phenomena and to themselves being monitored too closely.

Underlying this concern is a culture issue: whether dashboards are themselves biased to short-term versus long-term time orientation, a key dimension of many culture models. However, time orientation is not the only culture issue. Also relevant is the dimension of uncertainty avoidance. How much detail does one need to be comfortable making a decision? How much information density is comfortable or appropriate? Another significant difference is the privacy issue: Tracking devices can enable managers to watch their employees closely. Some cultures may find this constant scrutiny and surveillance more or less disturbing. I am reminded of Japanese corporate back-room offices I saw in the 1980s in which groups of three employees sat at desks butted against the others, facing three other employees. All six sat adjacent to a manager whose desk was butted against the end of their group of desks. The manager could see and hear everything that the employees did and said. This scene is very different from closed individual, private offices or even modern "open offices."

Some of these concerns about dashboards could be alleviated. For example, providers could make sure that dashboards encouraged reflection upon longer-term issues, e.g., including historical data that caused people to think about the relation of the current situation to different times and circumstances.

Hymowitz's article concludes that dashboards-makers and users must understand that information needs to be explored at deeper levels than the dashboard, although that is exactly what dashboards are supposed to help users avoid. She also cautions against the temptation of enforcing uniform criteria for a variety of locations. Hmm. Isn't that what makes it comfortable to leave one vehicle and enter another, knowing full well that one won't be confronted with incomprehensible dials and gauges? Finally, she concludes that "dashboards will be shifting more power to finance executives." If companies are tightly governed only by bottom lines, this trend may be correct.

24.4 The Rush to Deliver Dashboards

I mention dashboards because the Internet, mobile devices, and new players in global software are bringing into being dashboards for the masses, not only for finance-oriented executives. A CHI Consultants discussion thread (see Bibliography)

recently focused on what are best-of-breed solutions for Web-based dashboards. New Ajax-based Web applications, the asynchronous JavaScript and XML technology that allows for powerful client-side processing, makes appearance and interactions on the Web quite similar in capabilities to client–server user experience (see for example the Lazlo dashboard demos at www.laszlosystems.com/partners/support/demos). What takes place on desktop personal computer screens may also need to appear on mobile devices. Almost all mobile devices face the challenge of bringing the dashboard to the small screen, not only the Blackberry in the business community.

And what should be on that screen remains to be determined. Google has already stepped in to propose contents for an alternative display to the traditional desktop. Personally, my desktop is my email application; for others, it may be a preferred Web browser. Other major players, from Microsoft, to Yahoo, to Verizon's Iobi all seek to encourage the maximum number of users to keep open their own versions of a favorite set of displays, gauges, latest results, latest news, etc. The complexity of customization and possibly poor vendor- and user-driven choices seem likely.

24.5 Conclusion

We've seen this trend already for several years in the cable and satellite television news screens: The display is filled with crawling tickers, headlines of weather, news, and other key indicators of stocks and sports, crowding out the primary video image of a talking head or other news reportage. Perhaps this complexity will migrate to our desktops and primary applications: The actual "working real estate" may shrink to a relatively small portion, crowded out by what we ourselves or others have deemed appropriate to keep us informed or entertained.

It remains to be seen what will happen in the competition to help us make smarter decisions faster. One alternative solution is that the most valuable real estate on the screen, the main menu, which has been invaded by a limited number of gauges (telling us the time, our battery level, our wireless signal strength, etc.), may be a much fought-over territory to enable us to know the status of the most important matters of our personal and business lives. What are those items? Keep in mind that even a few key small, colored dots, properly coded, could enable us to monitor the proverbial 7 ± 2 key indicators of our lives. I am sometimes reminded of a Bible legend that the breastplate of the high priest-was adorned with 12 colored stones representing the 12 tribes of Israel. When questions about the future were addressed to the breastplate, the stones would glow in patterns, revealing the answers to the ancient searches for wisdom. Notice the resemblance to today's telephone keypad.

No doubt many product/service developers think they have the ultimate solution. We shall be seeing them soon enough. The presence of dashboards in your future seems, well, inevitable. Let us hope that user-experience analysts and designers have had a hand in interviewing those in need and preparing alternatives for us to choose among.

24.6 Postscript 2015

In the past 10 years, there have been a proliferation of dashboards, many of them excellent in terms of their usability, usefulness, and appeal. Mobile phone applications emphasize more and more the display of key information in a form that is legible and readable. Executive-style simplicity (rather than process-control-room complexity) often is apparent. This is good.

Alas, we have more and more to manage among many competing applications that compete for our time and attention. Consequently, the demands are high and the stakes are high.

One place that is extremely important is vehicle dashboards, which have become ever more complex and full of data types and data content. Here, our very safety and lives are at stake. Fortunately, many vehicle dashboards from the major providers have improved over the years. Perhaps the Tesla is the supreme leader in terms of large-scale screen display in a vertical format, with content, functions, and data that can be downloaded from the Internet in order to update the vehicle's user interface. More and more of these displays begin to resemble the fanciful concoctions shown in science-fiction movies.

One place that I have recommended dashboards consistently is in our Machine projects, concept designs that combine persuasion design with information design. Detailed case studies of ten projects, including their dashboards are described in (Marcus 2015).

References

Apple.com. (2005) Apple computer's dashboard programming guide. Apple computers, Incorporation, 29 Aug 2005. See: http://developer.apple.com/documentation/AppleApplications/Conceptual/Dashboard_Tutorial/index.html

CHI consultants. See: http://www.sigchi.org/connect/mailing-lists and also http://www.lsoft.com/SCRIPTS/WL.EXE?SL1=CHI-CONSULTANTS&H=LISTSERV.ACM.ORG

Few S (2005) Dashboard design: taking a metaphor too far. DMReview.com. March 2005. DM review magazine. 30 Aug 2005. http://www.dmreview.com/article_sub.cfm?articleId=1021503

Hymowitz C (2005) Dashboard technology: is it a helping hand or a new big brother? Wall Street Journal 26 September 2005, p B1

Lazlo Systems demo of Ajax dashboards. http://www.laszlosystems.com/partners/support/demos/

Lundell J, Anderson S (1995) Designing a 'front panel' for unix: the evolution of a metaphor. In: Proceedings, SIGCHI conference on human factors in computing systems, Denver, Colorado, ACM Press/Addison-Wesley, New York, pp 573–580, 26 Aug 2005

Malik S (2005) Enterprise dashboards: design and best practices for IT Wiley, Hoboken

Marcus A (2015) Mobile persuasion design: changing behaviour by combining persuasion design with information design. Springer, London. ISBN: 978-1-4471-4323-9 (Print)

Marcus A, Baumgartner VJ (2005) A practical set of culture dimensions for global user-interface development. In: Masoodian M, Jones J, Rogers B (eds) Proceedings of computer human interaction: 6th Asia pacific conference, APCHI 2004, vol 3101/2004, Rotorua, New Zealand, 29 June–2 July 2004, Springer-Verlag GmbH, Berlin, pp 252–261. ISSN: 0302-9743, ISBN: 3-540-22312-6

Mayhew DJ (1992) Principles and guidelines in software user interface design. Prentice Hall, Englewood Cliffs
Tufte ER (2001) The visual display of quantitative information. Graphics Press, Cheshire
Verizon's Iobi interactive flash demo. www22.verizon.com/ForYourHome/sas/sas_con_iobiland-ingpage.aspx#Pla

Chapter 25
Visualizing the Future of Information Visualization

25.1 Summary

It's not just what you know, it's what you know about what you know.

© Springer-Verlag London 2015 199
A. Marcus, *HCI and User-Experience Design*, Human–Computer
Interaction Series, DOI 10.1007/978-1-4471-6744-0_25

25.2 Introduction

"Information visualization" is a special category of user-interface design. Tables, forms, charts, maps, and diagrams also have to solve how best to use metaphors, mental models, navigation, interaction, and appearance to make themselves usable, useful, and appealing—the catechism for good user experience. Lately, with new search and retrieval techniques popping up from Google, Yahoo, and other major Web-oriented companies, it may seem that much progress is being made. In some ways this is true, but advanced visualization (and sonification) techniques have made the rounds for years—in some cases for decades—in specialized professional circles of finance, medicine, the military, and the sciences, without achieving widespread recognition or use.

There is much visual information available about information visualization. One report is Woolman's *Digital Information Graphics* (Woolman 2002), a graphically rich catalog of innovation, circa 2002. Some techniques are decades old, like Inselberg's parallel coordinates paradigm, which he first showed me at a conference in 1981. Professor Marti Hearst (IEEE symposium on information visualization conference 2005) from the University of California at Berkeley teaches a summary of techniques in her course on information visualization, similar to others taught around the world. Conferences that focus on the latest techniques include the symposia organized since 1990 by the IEEE and others like the upcoming Diagrams 2006. In some ways, information visualization is a healthy, robust subset of the industry. Nevertheless, we have a ways to go.

25.3 Progress

Even today, most computer users do not have a diagramming tool or advanced data representation tools as readily at hand as they do word processors or spreadsheets. That's unfortunate, because many people actually do their best thinking in nonverbal ways, and explaining and describing may best be done by verbi-visual or perhaps even verbi-sonic means, especially dynamic techniques. Admittedly, many PC users rely on Visio, a diagramming application, or one of its competitors, like SmartDraw. However, not all PC users are familiar with them, and they are not available on all platforms.

It is true that general-purpose, thinking tools are becoming more robust, sophisticated, and easier to learn and use. James Fallows reports on some of these in a recent *New York Times* article. He cites Devonthink Professional (Diagrams 2006), a data-collection and -retrieval system that enables one to enter information easily into a database of email messages, Web pages, text or number files, pictures, PDFs, and anything else that can be "copied with a keystroke or mouse-dragged into storage." One can tag or classify information as it goes in, or later. Retrieving information through fast searching is similar to the Apple Macintosh's built-in Spotlight, or

Google's desktop search utility, but its special feature is a "show also" button that displays files or text related to the search semantically in ways that are more sophisticated than those generally available for Web searches. Another product cited for special merit is Tinderbox, which shows visual connections among facts or ideas that one may have entered as quotes, themes, phrases, texts, pictures, diagrams, and other forms. One can view the spatial display as text, outline, flow chart, or link diagram.

Products like these just cited, the hyperbolic browser from InXight (Kaper et al. 1999), which is based on research developments years earlier at Xerox PARC, or some of the experiments developed in Microsoft's Research group, like the Data Mountain metaphor, reported on by George Robertson et al. (Smartdraw) all seek to provide new spatial syntax for displaying entities and relationships. Many of these techniques have concentrated on visual display without sound. Others have focused purely on data sonification, like Kaper et al., while a few have experimented using both. Alice Preston and Susan Fowler [Preston and Fowler] surveyed the sonic scene at a UPA workshop in 2004 and provide a good citation list of examples. Although many innovative approaches to information visualization/sonification have been tried, none has followed the path toward nearly universal, ubiquitous usage that, for example, spreadsheet software achieved during the 1980s.

25.4 What's Ahead?

What will bring these esoteric approaches into the mainstream? What tool will almost every person have on her/his computing/communication device in 10 years, one that is taken for granted and comes with almost every device? Whatever form it takes, it seems likely that it must account for several challenges.

The popular tools have some kind of historical precedent upon which to build new functions. Word processing, which far exceeded the characteristics of the familiar typewriter, was very much based on the metaphors of the established mechanical or electro-mechanical devices of earlier years. The same is true of the spreadsheet, which was built on the familiar ledger used for centuries by bookkeepers. Don't forget that when Gutenberg and others invented movable type and developed the printed book we know today, they considered that they were simply improving upon manuscripts, and the nature of the new invention as we understand it today did not take hold for some decades.

What can we find already in use that can be used as a basis for a new information visualization/sonification experience? Certainly Euler diagrams, flowcharts, and other basic diagramming techniques are a start.

Another challenge is the ability of the tool to make content entry, local editing, and global editing (batch mode) easy to accomplish. One of the frequent challenges is facilitating users' skills in making complex Boolean searches without a detailed knowledge of Boolean logic. How can the logic of querying be indicated more effectively by visual means?

Still another challenge is the tool's ability to handle large quantities of information. As a rule of thumb, I have considered the challenge posed to me several decades ago in a project for Professor Andries van Dam from Brown University in thinking about the future of hypertext: As a result of clever Boolean searches, no matter how clever, one may still be required to view and compare 500 retrievals. How can one view 500 entities displayed within one scene, in which each entity has seven, plus or minus two, attributes that may be in seven plus or minus two, states? Let's also assume that we have only a few seconds to evaluate this scene, make a decision, and move on to the next action. For me, this is an archetypal challenge of information display.

A final challenge is that the technique must be workable on a variety of platforms: both fixed desktop displays, as well as mobile environments. At the moment, this means big screens and little screens. All must be able to take advantage of the winning approach. Being compatible with Web 2.0 also doesn't hurt.

As we move forward, let us not forget Herman Hesse's fantasy novel, *The Glass Bead Game (Magister Ludi),* written originally in 1943 (Information complexity). He envisioned a future society in which all knowledge had been converted into music. Those who could hear and play appropriately were masters of the society, in control of its, and their own, destiny. It is my belief that those who have mastered superior information visualization and sonification techniques will be in a position to manage their lives, and others' lives, more powerfully and effectively. Let's hope that power is shared by many, not just a few.

My own fantasy of the future of information visualization, by the way, is one that I envisioned more than 20 years ago: I sketched a future technique that was simply an all-purpose mosaic of pixels that had been coded for spatial position, color, dynamic, and even sound characteristics. What resulted was an abstract representation of many entities in a general-purpose visualization display. Of course, one had to know and remember the semantics to be able to "read" the image. With careful design and training, it could be a workable solution—a simple, efficient mechanism displayable on most hardware platforms.

Whether this technique, or any other, achieves universal, ubiquitous status remains to be determined. One thing seems certain, however: Our future toolkit must employ a mechanism of revealing structures and processes that our current widespread software applications lack.

25.5 Postscript 2015

Tremendous advances in knowledge visualization, information visualization, and data visualization have occurred in the last 10 years. Books, journals, conference proceedings, professional magazines, and general-public magazines and newspapers attest to the ferment, achievements, and value of the latest techniques, whether they are for Googleglass, vehicle systems, on-board space-station controls, executive board rooms, government data centers, or the average consumer's latest health

management, traffic status, restaurant finder, wealth management, or other mobile application. The fact that the *New York Times, Bloomberg Business Week*, and the *Wall Street Journal*, and many Internet and video news programs, among other information sources, all rely on sophisticated charts, maps, and diagrams to communicate their particular structures or processes, all testify to an increasingly sophisticated or somewhat educated set of viewers that can take in, absorb, and process complex information visualizations.

Besides the technology challenges of designing effective information visualizations for t-shirts, coffee cups, smart watches, and other venues, there are the future challenges of making certain that these techniques are adapted to the less abled and the less educated, so that *everyone*, or at least as many as possible, besides the wealthier and more educated, can make smarter decisions faster. For example, how can one best communicate important climate or pricing information to poor, illiterate farmers in India or elsewhere, crucial to their remaining solvent, healthy, and happy. There is still much to be done.

References

Publicatons and URLs

Del.icio.us (a bookmarking site) visualization sites of interest: http://www.solutionwatch.com/252/visualizing-delicious-roundup/ (General roundup), http://www.ivy.fr/revealicious/index.html, http://www.browsedelicious.de/, http://kevan.org/extispicious

Devonthink. http://devon-technologies.com

Diagrams Conference (2006) http://diagrams-conference.org/cfp

Fallows J (2005) Mac programs that come with thinking caps on. New York Times (December):3–3

Few S (2004) Show me the numbers. Analytics Press, Oakland

Few S (2006) Information dashboard design. O'Reilly, Sebastopol

Flickr visualization sites of interest. http://www.nuthinking.com/did/tagged_colors_03/, http://krazydad.com/colrpickr/, http://marumushi.com/

Hearst M (2005) Information visualization and presentation. University of California at Berkeley Course Description. http://www.sims.berkeley.edu/courses/is247/f05

Hesse H (2002) The glass bead game (Magister Ludi). St. Martin's Press, New York

IEEE symposium on information visualization conference 2005. http://www.infovis.org/infovis/2005

Information complexity: a site dedicated to visualizing complex systems and networks. http://www.visualcomplexity.com/vc

Information Visualization Journal. http://www.palgrave-journals.com/ivs/index.html

Inselberg, Alfred. Parallel coordinates. Explained at http://catt.bus.okstate.edu/jones98/parallel.html

InXight. http://www.inxight.com

Kaper HGS, Tipei Y, Wiebel E (1999) Data sonification and sound visualization. Comp Sci Eng 1(4):48–58

Preston A, Susan F (2004) Workshop on sound in user interfaces, UPA 2004. Web summary at this URL: http://www.fast-consulting.com/upa%20sounds%20and%20graphics/UPA2004-AWResults.htm

Robertson G, Mary C, Kevin L, Daniel CR, David T, Maarten van D (1998) Data mountain: using spatial memory for document management. In: Proceedings UIST 1998, San Francisco, p 15. http://www.microsoft.com/usability/UEPostings/p153-robertson.pdf

Smartdraw. Comparison of smartdraw with visio. http://www.smartdraw.com/specials/visio-compare.asp?id=24520

Tinderbox. http://www.eastgate.com

Visio. Microsoft Corporation. http://office.microsoft.com

Visual blog, an example. http://infosthetics.com/

Visual Web2.0. http://www.oreillynet.com/pub/a/oreilly/tim/news/2005/09/30/what-is-web-20.html

Woolman M (2002) Digital information graphics. Watson-Guptil, New York

Chapter 26
HCI Sci-Fi at the Movies and on TV

26.1 Summary

Sci-Fi movies and television programs can help us appreciate HCI/UX in the present as well as the future. This topic is covered in detail in my book, *HCI in Science-Fiction Movies and Television* (Marcus 2012).

Can you remember the first science fiction movie you ever saw? What about the first science fiction program you ever saw on television? Can you remember what you thought about the user-interface design or user experience of any computer-based telecommunication system presented in these shows? And what about today? Do you cast a critical eye on the technology and its use whenever you watch the latest movie or video presentation about a world of the future?

© Springer-Verlag London 2015
A. Marcus, *HCI and User-Experience Design*, Human–Computer
Interaction Series, DOI 10.1007/978-1-4471-6744-0_26

I thought about these questions as I contemplated my own earliest memories. I am not the most dedicated sci-fi junkie, but I have been interested in visions of future worlds since I was small kid growing up in Omaha, Nebraska, more than half a century ago. Back then, I feasted on Marvel's *Weird Science Fantasy* comic books, *If* and *Galaxy* science fiction pulp magazines, and Ace double-novel science fiction softcover books (which had a front cover on each end of the book and half of the book printed upside down). It was also during this time that I discovered H.G. Wells's *War of the Worlds* and *1984*. Television was in its first decade and featured *Captain Video* and *Tom Corbett, Space Cadet*. Even then Buck Rogers had been featured in movies and appeared on television. Heroes and villains occasionally spoke to and from wall-mounted flat-video displays, although most of the communication took place with desktop microphones and the occasional loud speaker. Control panels consisted of elaborate dials and gauges. I remember during the days of live television when one of Captain Video's copilots accidentally knocked over the entire control panel (which probably consisted mostly of cardboard coated in metallic spray paint) and the entire desk-size apparatus fell over from the wall of their spaceship. Captain Video deftly picked it up and commented, "Luckily no wires were broken, Steve" (or whatever his copilot was named), then continued on with the show, as if nothing had happened.

These early experiences with *images* of future technology must have influenced my own early interest in user-interface design because when I was about 10 years old, I built a "rocket-ship control panel" in the basement of my house, complete with blinking lights, plus dials, gauges, and clicking knobs salvaged from old radios, my father's odds and ends, or local trashcan treasures. I don't recall thinking about usability in my design; I focused more on the emotional impact of blinking lights. With this "sophisticated apparatus," my brother and I could make fantasy trips to distant planets and communicate with extra-terrestrials, at least in our imaginary use scenarios.

26.2 Movies and Television, a 50-Year Run

The earliest science fiction movie was George Méliès's 1902 *Le Voyage Dans la Lune*. This magician-turned-filmmaker introduced innovative special effects: disappearances, double exposures, other photographic tricks, and elaborate sets. However, his user-interface innovation was modest. Most of us working now probably first encountered the images of computer-human interaction and communication as it was imagined in the science fiction movies of the '40s–'00s, depending on when we got started, as people and professionals. The experience growing up with television and computer games has been quite different for more recent generations.

For many past decades, Hollywood, which generated a majority of the science fiction fantasies of CHI, HCI, UI, UX, or whatever you might call it, often seemed somewhat timid about showing advances in communication/interaction. I do recall everyone marveling in 1968 that AT&T Picturephones had become a reality by

2001 (that was only one of the overly optimistic estimates of future progress). Later, we would look in awe at *Star Trek*'s communicators while marveling at the lapel-pin-based *verbal* communication with the main computer systems.

Throughout the decades, the background technology would change and slowly upgrade. In the 1950s and 1960s, twirling double magnetic tape reels and meaning-less arrays of blinking lights were the metaphor for computer power. The lights became more and more sophisticated over the decades, but the communication media remained essentially the same. The *Star Wars* series beginning in 1976 inno-vated by making everything gritty and somewhat broken down, unlike the clean machines of *2001: A Space Odyssey*. The control panels harkened back to earlier times by making some of the rocket-fighter stations reminiscent of World War II aircraft cockpits, much as the action itself was modeled on movie versions of WWII aircraft battles. Likewise for the *Matrix* series, which relied upon somewhat clunky old battle-station controls, the kind that were satirized effectively in *Brazil* (one of my favorite romantic but frightening views of the future). Even Ridley Scott's eerie view of Los Angeles in *Blade Runner* showed essentially the same old urban dis-plays, albeit larger, crustier, and more depressing than ever. One of the major visu-alization innovations was *Tron*, which didn't innovate so much in handheld communication devices as it did in trying to envision software environments themselves.

Only in the past decade have some notably different visions emerged, perhaps because some set designers have hung around SIGGRAPH and SIGCHI confer-ences long enough, or because SIGCHI consultants are actually working with the movie and video production teams to provide new concepts.

In terms of new approaches, I am reminded of Tom Cruise dancing with data in *Minority Report*, of advertisements following his movements and directing targeted commercial announcements directly to him as he flees through a future cityscape. Here represented are interaction and environmental graphics that seemed thoughtful responses to what technology could deliver in the twenty-first century, not the twen-tieth. These seem related to the transparent user interfaces of the recent television series *Farscape*, which also emphasizes more virtual than concrete physical equipment.

One exotic, memorable innovation in equipment was *eXistenZ*, a 1999 sci-fi crime thriller set inside a virtual-reality game world. Besides the innovative game-within-a-game-within-a-game premise of the movie, one of the more striking cre-ations of this film seemed to be the organic devices that looked like mutant protoplasm combined with some metallic components. For example, a gun might look partly like a dead chicken leg, partly like fungus, and maybe a little like a tra-ditional lethal device.

In the recent *AeonFlux*, we finally see ubiquitous computing products appear, like computation and communication built into clothing. One of the key figures actually talks into his sleeve, which lights up gently to let us know what is happen-ing. At least he doesn't talk into his shoe like Don Adams as Maxwell Smart in the *Get Smart* series from 1968 to 1970. In another *AeonFlux* scene, characters ingest tiny bits of chemical or mechanical substances (nano-pills?) that enable them to

communicate with other beings once the substances are absorbed. In another scene, a character's ear lights up and we are thereby informed that the communication devices have been built into the ear itself. These are considerably more exotic visions of hardware and software than many contemporary films and videos.

Today, there are vast resources on the Internet and in print concerning the history of movies and video, specifically for the subject of science fiction. Amazon lists 1400 entries for sci-fi movies and 2200 entries for sci-fi television. However, most of these deal with the actors and actresses, the story lines, the directors and producers, even the locations. Almost none of these resources focuses on the human-computer and the computer-mediated human-human communication and interaction of these works. Extreme details abound, like those of the Internet Movie Database and the data collections of the American Film Institute. However, the history of user-interface design in movies and television, specifically in the science fiction genre, remains to be collected, researched, analyzed, and made available. This subject will, I hope, be a subject for future books, Internet offerings, and university course offerings, to say nothing of CHI and sci-fi conferences.

26.3 Conclusion

As some of you may recall, I organized two CHI panels, called "Sci-Fi at CHI," to which I invited leading science fiction writers to comment on what the future held in store for human-computer interaction and communication. I remember Bruce Sterling's typically outrageous and funny remarks about the future, in which he imagined that the ubiquitous computing and communication device of the future would look like today's handkerchief. The material would provide for a dense matrix of light-sensitive elements, power elements, and display threads, etc. One could copy anything if the high-tech textile was placed over an image, and the material could present whatever images or sounds one wished. Also, one could connect to the Internet to provide all possible communication and computation support.

Hollywood is typically several generations behind the latest actual achievements of technology. Movies and television have the challenge of making hard-to-imagine scenarios make sense to people who often cannot imagine the full power of user-interface innovation and creativity harnessed to human-computer and human-human communication and interaction. Perhaps the CHI community could help educate the film and television community more effectively.

One recent collaboration is that of Alexander Singer, a Los Angeles film director who worked on *Star Trek*, with scientists and engineers to produce a short film sponsored by DARPA about augmented cognition. The film features elaborate scenarios using special headsets that can scan the user's brain and detect overload of certain regions, then shift the information media mix, say, from verbal to visual or from visual to acoustic, to enable the human being to think better. This represents a significant new direction for user-interface flexibility, somewhat reminiscent of the Japan Friend21 project in the late 1980s and early 1990s, which was reported on at

CHI 1994. In that project, the researchers experimented with metaphor-management software that would change the entire paradigm of information display, in that case per user preference, not because some meta-system had determined that the users were having cognitive or emotional overload.

By studying the film and video representations of past decades, we may not only gain a better understanding of past illusions and delusions, but we might gain a better understanding of how to present new concepts to the general public and bring them up to date on the future of human-computer interaction and communication.

26.4 Postscript 2015

In the past 5 years, and into the foreseeable future, I shall continue to monitor the HCI/UX techniques registered in the latest sci-fi movies and television offerings. This requires me to sit through many dreadful products, as well as delightful ones. I walked out half-way through *Chappie*, because the story progression was so slow and, for me boring. I got the basic ideas, however, about a robot learning, like a child, to become an active member of society, even if it were a "bad-people" gang society. Some interesting "human-robot-interaction" (HRI) moment occasionally, which seems to be a trend, with the emergence of *Ex Machina,* as noted in an earlier chapter.

In another direction, am happy to note that speculative fiction is becoming an official topic of design schools, as exemplified by Prof. Laura Forlano's courses at the Institute of Design, Illinois Institute of Technology, in which students attempt to envision the future of work, the incorporation of gaming into all aspects of products/services, and the nature of networked cities and objects. Such focus bodes well for designers who are able to grasp the future, not just gasp at the future. Her colleague Vijay Kumar, in his *101 Design Methods* (Kumar 2013), also advocates for speculative fiction in the education and practice of design professionals.

References

Kumar V (2013) 101 design methods. Wiley, Hoboken
Marcus A (2012) The past one-hundred years of the future: HCI in Sci-Fi movies and TV. Ebook available for free download from www.AmandA.com. Youtube video of lecture that led to the book: https://www.youtube.com/watch?v=D4i3iUsptyU

Further Reading

Dourish P, Bell G (2014) "Resistance is Futile": reading science fiction alongside ubiquitous computing. Per Ubiquit Comput 18:769–778
Sterling B (2014) Futility and resistance. Pers Ubiquit Comput 18:767–768

URLs

A Bibliography of Science Fiction in Film and Television www.geocities.com/Hollywood/ Lot/2976/SF2-crit.html

Internet Movie Database www.imdb.com

Museum of Television www.museum.tv

Science Fiction entry in Wikipedia http://en.wikipedia.org/wiki/Science_fiction_film

The Future of Augmented Cognition, an Alexander Singer Film showcasing techniques soon to be improving performance on an exponential level everywhere. http://interactive.usc.edu/members/sfisher/archives/2005/09/im_forum_speake_2.html

Timeline of Influential Milestones and Important Turning Points in Film History, Tim Dirks www. filmsite.org/milestones1900s.html

Chapter 27
Wit and Wisdom: Where Do We Turn for Advice?

27.1 Summary

Got a question? Who ya gonna call?

27.2 Introduction

Recently, I received the latest issue, the third edition, of *The Handbook of Human Factors and Ergonomics*, edited by Dr. Gavriel Salvendy (2006). I am awed and amazed by this massive tome, with its long and distinguished list of Advisory Board members (25) and even longer and more distinguished list of chapter authors (114). Do we need another 1654-page summary of everything we need to know, but about which we might be afraid to ask? Yes, but with some qualifications.

27.3 A Tome and Its Contents

This particular collection had some intriguing chapters, like Chap. 21 by Martin G. Helander in Singapore and Halimahtun M. Kalid from Malaysia: "Affective and Pleasurable Design." They discuss a framework for evaluating affective design, research in industrial design and esthetics, even theories of affect and pleasure, and measurement issues and methods. Surely a professional who hears all the buzz about emotion, pleasure, appeal, engagement, and other topics related to user-experience design, will appreciate the cool, calm, and collected summary of the topic, with extensive references. The very existence of such a chapter in a human factors text is a triumph of such catalytic authors as Patrick Jordan, whose publication about "the new human factors" is cited. The fact that both contributors are located in Asia is also worth noting. The Asian cultural orientation to relationships, not objects, as argued by Nisbett might suggest that authors writing from an Asian perspective may have novel and valuable insights to contribute to what seems to have been heretofore predominantly a Western topic of discussion in CHI/HCI circles.

Another interesting contribution is Chapter 46 by Chris North in the USA: "Information Visualization," a topic of great interest to CHI community professionals and almost an area of specialization within the world of human factors and ergonomics. His discussion of visual mapping and properties, of typical information structures, of strategies for navigation and interaction, and a peek into the future, make for solid, informative reading.

The table of contents, with its 61 chapters, is beyond the scope of this brief review. Please note: There are two other competing handbooks with almost identical titles: *The Handbook of Human-Computer Interaction*, by Helander et al. (1997), whose second edition published by Elsevier, with 1,582 pages, appeared in 1997, and the equally monolithic *The Human-Computer Interaction Handbook* by Jacko and Sears (2003), whose first edition of 1277 pages appeared in 2003 and whose next edition is scheduled for release in 2006. The second of these three handbooks features an editorial board of 14 and 104 contributors to 62 chapters. The third compendium features 23 advisory board members and 121 contributors to 64 chapters. Interestingly, some authors write or co-write more than one chapter of a handbook,

and some authors may contribute to more than one handbook. I must admit, for the sake of full disclosure, that I have authored one chapter in each of the second and third handbooks mentioned.

Other than giving a large number of people opportunities to expound on topics of their expertise, experience, and interest, are these documents worth their weight, to say nothing of their cost? I do not mean to propose some simple metric of measuring page count, number of advisory board members, or number of contributors. I have mentioned these statistics merely to convey the scope of some monumental publishing projects. I have no statistics on numbers of pages opened, read, used, or marked up in some institution's, corporation's, or person's library (as someday there would be for Web-site URLs visited). I can say that in our own firm, these documents have served "newbies" well and have figured prominently in some of our own major research projects—like collecting all of the human-factors issues relevant to the driver's experience for BMW, then prioritizing and summarizing them for executives and managers to absorb.

27.4 Other Sources of Wisdom

At some point, each of us is a "newbie." Where can one turn? These handbook documents aim to be canonical statements of wisdom, carefully digested and considered, milestones in the progress of knowledge within our field. They are something like biblical/Koranic archives of the West or Sutras of Hindu and Buddhist peoples, minus the divine inspiration. Perhaps someone someday will examine as a Ph.D. study in the history of HCI/CHI this march of ideas and discern patterns of wit and wisdom, as well as foolish oversights or blind-faith assumptions.

However, there are other resources from which professionals today can learn philosophy, principles, methods, techniques, and tools. The HCI bibliography edited by Gary Perlman is certainly an invaluable resource, but its massive contents (more than 32,000 entries) is more than one lifetime's reading. The Internet Wikipedia, among other URL resources, supports a number of topics that are both public versions of the traditional publishing system's more closed-editorial format and also explorations of topics that have not yet made it into the canon, a kind of Apocrypha. In addition, numerous blogs provide current views of the hottest, juiciest topics, disputed territory in the battle for ideological supremacy, and URLs from SIGCHI, UPA, and STC, among others, feature knowledge compendia.

Examples of debates include those about agile programming's rapid rush through iterative development *vs.* traditional usability cycles, ignoring completely the outmoded waterfall methods of past decades of large-project software development. One such site is http://groups.yahoo.com/group/agile-usability. Other debates swirl like hurricanes in global weather patterns of opinion, like those regarding which of many comprehensive, integrated software methods, such as the Rational Unified Process, or others, should be the supreme method for software development. Also debated: Given a winner, or candidates, how should user-centered user-interface

design be integrated with these approaches? Another example, more oriented to software developers than CHI professionals, is the set of Internet resources regarding Ajax, the school of thought and action concerned with asynchronous JavaScript with XML, which can give Web-based applications many of the features typically associated with client–server PC applications in the past. A recent article in *CIO* cites many Ajax online resources for budding developers. Here, interested actors as well as "bystanders" and "lurkers" can drink as deeply of the waters as they wish.

Still another level of incoming information can be derived from the numerous discussion groups that have provided debates about issues as well as resources of information. Examples are the discussion groups of the CHI Consultants, Anthropologists in Design, and the Interaction Design Group (IxDG), to name a few. It is fascinating, as a society-of-knowledge-seekers phenomenon, to watch the requests for information on a general or quite specific topic surface and sometimes repeat every 5 years or so as newcomers enter the profession, or as technology changes. Requests for help often trigger generally helpful replies from voluntary, good-natured, and presumably well-intended mentors, along with occasional cranky complaints. I have witnessed this directly, for example, in the discussion threads concerning "what are the basic books I should know as a newbie," "where to find usability labs in Boston," or "what are good search terms for the logical relations of 'and' and 'or'?" We are looking at the twenty-first century's version of ancient Platonic school-of-thought dialog, of rabbinic/priestly discussions, of Zen or other Asian monastic discussions that have delighted, highlighted, and stimulated learning over the millennia.

Finally, at the "lowest," and sometimes most valuable level, are all of the solicited and unsolicited for-your-information links sent by well-meaning colleagues. At the moment, I do not have an official "reader" either human or software-based, who/that can assess the value of these resources and file them as appropriate. In my own experience, they often have specific, useful content related to current challenging strategic and tactical issues, or they are useful for future reference. Sometimes they are trashed; at other times, I carefully file them away, if they seem potentially useful (often with no time to test suggested links) with relabeled subject lines in a document hierarchy that covers most of the major topics of interest to our firm. Others keep track of bookmarks via sites like www.de.lirio.us, and there is even a discussion of such sites at http://3spots.blogspot.com/2006/01/all-social-that-can-bookmark.html. For newbies, they may have to start a social process of giving and receiving to begin the sharing of "useful knowledge."

27.5 Conclusion

What seems possible now is being able to pick and choose from varying levels of "canonical" to "apocryphal" thought and discourse. I admit the deluge can be overwhelming. In such cases, the canonical documents come to the rescue. Who can say that one or the other type of resource is unnecessary? They all seem useful in an

ecology of professional story-telling and wisdom literature. However, I can surmise that the younger generations may grow increasingly fond of Internet-based resources and eschew the classic paper-oriented resources of the past. This is a process we have experienced before. Recall that Gutenberg's books were criticized as far less worthy than handwritten manuscripts. It is only a matter of time. In the meantime, rejoice in the richness of our wit and wisdom.

27.6 Postscript 2015

Although many major handbooks continue to be updated in print and on the Web, if I were asked today to name three recent books that could provide a starter-kit for HCI/UX wisdom, I would instantly list:

Hartson, Rex and Pardha S. Pyla (2012). *The UX Book: Process and Guidelines for Ensuring a Quality User Experience*. New York: Morgan Kaufman. This book provides a survey of all aspects of planning, research, analysis, design, and documentation relevant for all platforms, content, user communities, and context.

Kumar, Vijay (2013). *101 Design Methods*. Hoboken, NJ: John Wiley and Sons. This book provides an outstanding survey of methods covering almost all known to modern professionals, together with short case studies of their applications, and guidelines for putting each one into practice.

Marcus, Aaron (2015). *Mobile Persuasion Design: Changing Behaviour by Combining Persuasion Design with Information Design*. London: Springer-Verlag London. ISBN: 978-1-4471-4323-9 (Print). Pardon the self-serving reference, but these ten detailed, extensive case studies, even though focused on mobile products/services, show many of the topics in [Harston and Pyla] and [Kumar] put into practice in greater length than either of the two other books can accomplish because they have such broad agendas for content.

These above publications do not have the length and the breadth of some of the longer 600–1200-page handbook tomes, but they show in a more brief, practical, and well-illustrated way how to accomplish good HCI/UX design.

References

Hartson R, Pyla PS (2012) The UX book: process and guidelines for ensuring a quality user experience. Morgan Kaufman, New York

Helander MG, Landauer TK, Prabhu PV (1997) Handbook of human-computer interaction. Elsevier Science B.V, Amsterdam

Jacko J, Sears A (2003) The human-computer interaction handbook. Lawrence Erlbaum Associates, London

Jordan PW (2000) Designing pleasurable products: an introduction to the new human factors. Taylor and Francis, London

Kumar V (2013) 101 design methods. Wiley, Hoboken

Marcus A (2015) Mobile persuasion design: changing behaviour by combining persuasion design
 with information design. Springer, London (Print). ISBN 978-1-4471-4323-9
Nisbett RE (2003) The geography of thought: how Asians and westerners think differently…and
 Why. Free Press, New York
Pearlman G (ed) (2006) HCI bibliography. http://hcibib.org. This regularly updated bibliography
 contained more than 32,000 entries in 2005
Salvendy G (2006) Handbook of human factors and ergonomics. Wiley, Hoboken

Chapter 28
From KidCHI to BabyCHI

28.1 Summary

Issues of CHI/HCI related to children's use of technology are discussed.

© Springer-Verlag London 2015

A. Marcus, *HCI and User-Experience Design*, Human–Computer
Interaction Series, DOI 10.1007/978-1-4471-6744-0_28

28.2 Introduction

What do children want/need from human-computer interaction and communication (HCIC)? What are the long-term effects on them of mobile/computing devices? How early can and should we expose them to the latest technology?

ACM/SIGCHI organized the first CHIkids programs at CHI 1996 to explore some of these issues (CHIkids 1996). One Web search today returns about 90,000 entries around the topic of children and user-interface (UI) design, like the 1995 CHI design briefing on UI design for children (Piernot et al. 1995; Shannon et al. 1995).

The world of media is quite different from when I grew up. In 1958, I used to rush home to listen to my AM radio play the top-40 rock-and-roll tunes, talk with friends on the shared family phone, and watch a new television show with dancing teenagers from Philadelphia called *American Bandstand* hosted by Dick Clark. Thirty years later in 1988, I saved to a hard drive my son Joshua's first email communication, when he was about 15. About 20 years after that, my 18-month-old step-granddaughter Ava had already mastered the DVD player's remote control. At 3 years of age in 2006, she sends emails to her grandparents and is an avid digital-camera user, snapping surprisingly sophisticated photos.

Just how early are children becoming "masters" of instant messaging, video games, and animation? What is the appropriate age for introducing each technology? What are young minds and bodies capable of achieving? Alan Kay, a researcher at Xerox PARC in the 1970s, used to joke in the 1980s that all children were born knowing how to use the Macintosh computer, but some forgot that skill in the years after infancy. Today blogs, Web sites, publications, movies, video, and radio debate these issues.

These debates are not new. An Egyptian papyrus from about 3000 years ago laments that younger people seem not to respect their elders. Upon closer analysis, it might even have disparagements of "new media" and their toxic effects on the skills and behavior of the next generation. Because of my own life timeline, I missed the commotion in the early twentieth century concerning the dangers of movie-watching, but I grew up with 1950s parents and organizations condemning comic books and television, fearful that teenagers would be turned into mindless zombies. National Public Radio (USA) announced in May 2006 that a government conference had concluded that playing video games and using computer technology were such recent phenomena that long-term effects could not be determined; others disagree.

Many sources of analysis exist for the impact of media and technology on children and the family (Kaiser Family 2005; Pew 2006; Saveri et al. 2003). Unfortunately, these general studies do not focus on enough detailed issues of interest to the CHI community. Today, critical reviews appear with many attitudes. In March 2006, the theme of [Consumer Electronics'] *Lifestyles* magazine was "Kids & Technology: What's Best & When." Featured articles included how devices should be introduced to toddlers, grade-schoolers, tweens, and beyond. Presumably

more is better from their viewpoint. Taking the opposite approach, in the cover story for *Time* on March 27, 2006, Claudia Wallis asked, "Are Kids Too Wired for Their Own Good?" (Wallis 2006). She emphasized the mixed blessings of multitasking and multiprocessing, noting that 82 % of American children are online by about the age of 12, according to a Pew study (Pew 2006). Presumably studies in China, India, Japan, or Korea might show similar pros and cons regarding the early introduction of mobile communication and computers to children.

User-interface design for younger users seems to be fertile ground for many studies, much product/service innovation, and socio-technological change. Perhaps since many CHI professionals have children and grandchildren, these issues will loom larger in our collective consciousness. Many researchers worldwide already have engaged in specific studies, as citations in the HCI bibliography and other digital library resources indicate, but much more could be and should be done. Now is a perfect time to dive again into issues that could become a major theme of a future CHI conference or publication.

Among other topics, one might consider the following:

- How early can children grasp mobile devices physically, cognitively, and emotionally? For what purposes would they and should they be used and/or enjoyed? Safety? Learning? Communication? "Networking" with their peers as well as their parents? What are the developmental as well as the cultural, gender, and age-cohort challenges?
- Are there entirely new metaphors, mental models, navigation schema, interaction techniques, and appearance characteristics that would be preferable for young children even if not very usable, useful, or appealing for adults? What is the developmental path from younger to older ages?
- How can very young children appropriately be "user-tested?" How do the techniques for adults, with whom most user testers are familiar, need to be adjusted?
- How can children worldwide efficiently and effectively be incorporated into a participatory design process, as now happens with computer games and in Web search/portal development teams? Will this process evolve naturally as very young users form user communities and communicate among their peers, separate from adults?
- How does multitasking affect cognitive, emotional, and social development? Some children cite the need for music and video in the background in order study better. Is it a matter of individual preferences and capabilities?
- What are the larger social, ethical, cultural, and esthetic implications of the long-term use at increasingly early ages of devices such as camera phones, headsets, instant messaging, etc.?
- Will children increasingly abandon the natural world for the virtual social world? For whom would this trend be desirable, or not?
- How will family, education, work, and play change for our youngest users? Are we in fact simply encouraging them to join their addicted elders, determined to show them what is "best" and "right" for their own "good"?

The CHI community is changing its approach to children. Developers for children's games and educational software have shown us some directions. We could do more.

About 5 years ago, our firm began work on the UI design for an innovative Web application at Microsoft, an instant-messaging and file-sharing product targeted for teenagers, called ThreeDegrees.com. Microsoft had sequestered a group of teenage volunteers in a facility near its headquarters to be able to study in real time their behavior, needs, and wants. We had access to resultant ethnographic studies and extremely detailed marketing studies of American teenage preferences in designing specific prototypes. This kind of user profile, use scenario, and user-experience analysis may become more mainstream than in previous decades.

More recently, we've worked with the developers of Leapfrog's successful Fly pen-top computer for children as they think about other pen-top devices. The characteristics of their product suggest that solutions for children may shed light on successful approaches for older users. This argument also is promoted for universal access: Solving HCIC issues for a specialized group, like the less-abled or elderly, brings benefits to all.

In the meantime, media and user interfaces move step-by-step closer to the embryo/fetus and "prenatalCHI." Already BabyFirst TV, a new pay channel, has emerged, aimed at children 6 months to 2 years old. Consider: Can new in utero HCIC be far away? Perhaps a baby-in-waiting will signal to her mother what iTunes to play for her own listening enjoyment, or will suggest another prenatal educational program to play on bellyphones. Time will tell how quickly these products reach the marketplace… if they haven't already.

28.3 Postscript 2015

Products/services for young children continue to proliferate in the past decades. Designers of products/services seem to be getting younger and younger, as well. Perhaps we are not too far removed from a time when 5-year olds will design commercial systems for 10-year olds, or vice-versa.

Meanwhile, warnings abound regarding the deleterious effects of putting toddlers in front of screens. I have observed in my own grandchildren the seemingly dazzling, narcotic, and alluring effect of their looking at my own image on Skype screens. Are we causing irreparable harm by shoving the latest gadgets in front of their faces? A recent article promoted the value of old-fashioned card games like Canasta to build memory and decision-making skills, as well as engaging youngsters in deep, personal relations with family members and friends.

Are we inherently building into our children anti-social, or a-social tendencies by disconnecting them from people and real-world experiences? The debate rages on, perhaps to be resolved later this century, when most of us will not be around…:-)…, or merely in a position to say, "See, I told you so!"

References

CHIkids (1996). http://acm.org/sigchi/bulletin/1996.4/chikids.html

Consumer Electronics (2006) Featured topic: "Kids & Technology." 3:3. Sandhills Publishing, Lincoln

Itzkoff D (2006) TV moves a step closer to the womb. *New York Times*, 21 May 2006, pp 2–1ff

Kaiser Family Foundation (2005) Generation M: media in the lives of 8–18 Year-olds. Publication no. 7251, Oakland: Kaiser Family Foundation, 9 Mar 2005, www.kff.org/entmedia/7251.cfm. The Foundation surveyed media use by children in the USA ages 8–18 among a nationally representative sample of more than 2,000 3rd through 12th graders

Pew Foundation (2006) Pew internet and American life project. www.pewinternet.org. The Project studies trends in online usage, media access, mobile phone usage, Internet dating, etc

Piernot P, Felciano RM, Stancel R, Marsh J, Yvon MP (1995) Designing the PenPal: blending hardware and software in a user-interface for children. In: Proceedings ACM SIGCHI, pp 511–518

Saveri A, Jeffery L, Pang A (2003) New entertainment media: transforming the future of work. Institute for the Future, Menlo Park. ww.iftf.org. The authors have studied the likely future of new entertainment media and how it will transform work, with some implications for education and family

Shannon LH, Fernandes T, Thomas D (1995) Amazing animation: movie making for kids. In: Proceedings, ACM SIGCHI, pp 519–524

Wallis C (2006) Are kids too wired for their own good? *Time*, 27 March 2006, pp 48–55

Chapter 29
SeniorCHI: The Geezers Are Coming!

29.1 Summary

The chapter discusses issues of effective CHI/HCI for seniors.

29.2 Introduction

What do seniors want/need from human-computer interaction and communication? What are the long-term effects on them with mobile/computing devices? How late in their lives can/should we expose them to the latest technology?

© Springer-Verlag London 2015
A. Marcus, *HCI and User-Experience Design*, Human–Computer
Interaction Series, DOI 10.1007/978-1-4471-6744-0_29

In the late 1980s or early 1990s, Apple introduced its own Gray Panthers initiative by which it put into seniors' hands Apple Macintosh computers and modems. This equipment gift enabled seniors across the USA to communicate with others over the Internet. At that time, it was a significant advance for many elderly users. I recall my late mother using a computer provided by this program, which was her first computer experience. In the early 1980s, I hired a woman in her late 60s to become my office manager. She had never used computers, but rapidly she became a Macintosh fan and worked effectively until her retirement some years later. Today, two decades later, elderly users around the world are connected in ways that were unavailable then, including connected to their offspring and caretakers as well as their peers, sharing photos, life stories, carrying on with professional lives well beyond the traditional retirement ages, and more. What are the implications for the user interfaces of products and services for the elderly, which are being developed at an increasing rate?

This increase of attention to the elderly is no accident. Statistics show that approximately half of Japan's population will be over 60 by about 2030. Japan leads other nations in becoming a society of seniors. The rate of conversion is uneven among nations, with India and China less affected. What will be the outcome of this shift among the current billion users and the next billion users? Clearly changes in national economies, politics, society, education..... as well as user-interface design will result.

Even in 2002, as I reported on in an earlier chapter, a universal design conference (Universal Design Japan Conference) in Yokohama sponsored by many Japanese major corporations reported on innovations targeting the elderly, such as mobile phones with large displays that are easier to read and use. As well as the Japanese, some European countries have invested more time and energy into exploring devices and user-interface design solutions that target the elderly. As an example, Constantine Stephanidis (2001) in Crete has emphasized universal access to computers and published a guidelines collection by Maguire (1997) for kiosk design user interfaces that emphasizes designing for the elderly.

Many sources of analysis exist for the impact of media and technology on seniors, but not all CHI professionals are aware of them. You don't need to be a member of AARP in the USA (the American Association for the Advancement of Retired People) to start to find out. User-interface design for older users seems fertile ground for many studies, much product/service innovation, and sociotechnological change. Perhaps, as many of our CHI professionals reach their "golden" or "sunset" years, these issues will loom larger in our collective consciousness. Many researchers worldwide have already engaged in specific studies, as citations in the HCI Bibliography and other digital library resources indicate, but much more could be and should be done. Now is a perfect time to dive again into issues that, collectively, could become a major theme of a future CHI conference or publication, as it was a secondary theme of the recent UPA 2006 conference devoted to storytelling.

In the USA, according to Kelly Greene in the *Wall Street Journal* (Greene 2006) senior-savvy business developers are searching for new Web portals, content, and

other offerings to capture the $2 trillion in annual spending power of the 78 million people born from 1946 to 1964. The oldest boomers turn 60 this year (I'm already 63 and over the hill). My Space has grown quickly and phenomenally to become one of the most visited sites on the Web, but the over-50 users are "miniscule" as Jeff Taylor, founder of Monster.com points out in Ms. Greene's article. He is starting Eons.com, a MySpace for the 50-plus crowd. Bernie deKoven, aka Dr. Fun, a veteran game developer has commented on games specifically for the elderly in an article by Ellen Yan (2006). These suggest but a few the myriad opportunities for exploring not just content issues, but user-experience issues targeting the elderly.

Among other topics of interest to CHI professionals, one might consider the following:

- How early can seniors better "grasp" and access mobile devices physically, cognitively, and emotionally? For what purposes would they/should they be used and/or enjoyed? Safety? Learning? Communication? "Networking" with their peers as well as their families and caregivers? What are the developmental as well as the cultural, gender, and age-cohort challenges? Already in Europe at least one manufacture has begun offering a "simple" mobile phone stripped of the sophisticated bells and whistles so that those who wish can make use of the basic functions of the device unencumbered with extra menus and buttons.
- Are there entirely new metaphors, mental models, navigation schema, interaction techniques, and appearance characteristics that would be much better for seniors even if not very usable, useful, or appealing for adults or children? Is there an appropriate developmental path from adult to senior versions??
- How should seniors appropriately be "user-tested"? How do the techniques for younger adults, with which most user testers are familiar, need to be adjusted? For example, use in assisted living or senior care centers may be more of an important environmental factor in determining users' capabilities and behavior.
- How can seniors worldwide efficiently and effectively be incorporated into a participatory design process, as now happens with younger game and in Web search/portal development teams? Will this process evolve naturally as seniors form user communities and communicate among their peers, separate from younger adults and children?
- Some seniors have begun to lose hearing, vision, memory, attention, physical, and other abilities that "normal" UI solutions take for granted. How do these changes affect multi-tasking, which is a preferred mode of work and play for many younger adults and children?
- What are the larger social, ethical, cultural, and esthetic implications of the long-term use at increasingly late ages of devices such as camera phones, headsets, instant messaging, etc. Are suitably designed computer-based telecommunication systems able to actually diminish the onset of some forms of dementia, or to help keep seniors more physically active?
- Some seniors live increasingly isolated from friends, family, and the outside world. Will virtual worlds, virtual memory gardens, access to constant video,

music, or other sources, help them enjoy more what time they have left? Would this be desirable, or not?

- How will family, education, work, and play change for our oldest users? Are we in fact simply encouraging them to join in a final grand addiction, until time runs out, determined to show them what is "best" and "right" for their own "good"?

29.3 Conclusion

As you may note, some of these issues are variants of those I cited for an earlier essay regarding children. Questions about CHI and the beginnings and ends of life are perhaps linked more closely than one might imagine. The CHI community will unquestionably change its level of awareness and commitment to seniors as more of us become those very users. The Baby Boom of the last century in the USA plods onward in time inexorably to produce the Senior Boom of this century. CHI could do more by focusing more attention on these issues, and might be able to join with many senior-oriented organizations such as AARP in the USA to engage in research, to run joint workshops, and in other ways to cooperate and disseminate information of interest to a wide body of stakeholders. Those stakeholders include you, inevitably.

As we all grow older, the time to begin thinking about user-interface for the elderly becomes an issue to which all can relate. Perhaps that portends a boom time for seniorCHI. We shall soon see.

29.4 Postscript 2015

As with products/services everywhere, for all of the topics mentioned in these chapters, what we produce seems to get more sophisticate, smarter, and more effective, even if the prices seem more than merited. And consumers, in large part, become more demanding and smarter about what they want, need, and will accept.

But, every year moves us closer to that cataclysmic era in which machine intelligence gains self-awareness, robots take over all work, Bit-coins, or its successors, replace conventional currency, many nation-states break up into smaller groupings of less diverse groupings of citizens, and people everywhere live longer and grow much older, becoming a dominant segment of societies as demographics swells at the top. Are we prepared for such scenarios? I sometimes shudder at the contemplation of the future. My only basis for optimism is that we have been worrying about cataclysmic futures since....perhaps people first gathered together into groups and tribes.

I am hopeful that we can solve these challenges. As a famous designer friend said many decades ago, "the only way to get out of our current problems is to get into future problems."

References

California State University/Northridge (CSUN) Center for Disabilities, www.csun.edu/cod/; conference proceedings, www.csun.edu/cod/conf/2002/proceedings/csun02.htm

DeKoven B (2006) aka Dr. Fun. Writes about games seniors, as well as others, play. http://www.majorfun.com

GapMinder.com. Information visualization of world trends. http://www.gapminder.org/

Greene K (2006) Still sexy at 60? Wall Street Journal, 25 July 2006, p B5ff

Jacko JA, Hanson VL (2002) Universal access in the information society 2, 1. Special issue on universal access and inclusion in design, Springer Verlag (http://link.springer-de or http://link.springer-ny.com)

Maguire MC (1997) A review of user-interface design guidelines for public information Kiosk systems. In: Proceedings user interfaces for all 1997, FORTH conference, Iraklion. http://ui4all.ics.forth.gr/UI4ALL-97/maguire.pdf

Stephanidis C (ed) (2001) User interfaces for all: concepts, methods, and tools. Lawrence Erlbaum Associates, New York. ISBN 0-8058-2967-9

U.S. Department of Justice. Briefs on the Internet, Americans with disabilities act, and private business available at www.usdoj.gov/crt/app/briefs.htm

United Nations Statistics (2006) http://unstats.un.org/unsd/cdb/cdb_help/cdb_quick_start.asp

Universal Design Japan Conference. www.ud2002.org/en/program/prog.htm

Yan E (2006) Racing to play. Newsday.com, 22 July 2006. http://www.newsday.com/business/custom/retirement/ny-act2spd4823941jul22,0,2223829.story

Chapter 30
Taxonomies to Tax the Couch-Potato's Cortex

30.1 Summary

The chapter discusses media metadata issues of CHI/HCI design.

© Springer-Verlag London 2015
A. Marcus, *HCI and User-Experience Design*, Human–Computer
Interaction Series, DOI 10.1007/978-1-4471-6744-0_30

30.2 Introduction

Growing up in the 1950s, there were only three TV stations, one for each network, so checking the television listings in the newspaper was a relatively simple task. Knowing that I had to get back home in time for *The Mickey Mouse Club* on weekday afternoons and *The Milton Berle Show* on Tuesday nights at 8 p.m. was a straightforward matter of scheduling.

Today, the situation is different. The many choices in media, especially video programming, as well as details of content, cost, and timing, all create user challenges. Provider challenges include how to expose choices to the decision maker(s), i.e., viewers and/or purchasers, and designing how one navigates among choices before selecting the desired item.

One facet of this challenge involves selecting music. In the past, the choices were a handful of AM radio stations of known, limited brands, themes, content, and scheduling. As a teenager, I always knew when the Top 40 countdown would be played. Then came FM, then downloaded stations and music/audio files, and now satellite radio stations. Many different solutions have been proposed in the audio world, making the taxonomies, attributes, and choices evident in many ways. From the relative elegance of iTunes and a half-dozen major competitors for legal music, music is now categorized and searched in multiple ways. There are categories of music, lists of lists of lists, and novel display techniques, like that of the affinity diagrams of Live Plasma (Live Plasma music organizer), the mood-music organizer of Mood Logic (Mood music organizer) or the music research project of Lamere (2006). Users can find music using search boxes similar to those of general Web/ Internet search engines, with more or less sophistication, including Boolean-logic-based queries.

The situation becomes even more complex with audio-visual collections. They can encompass the contents of spoken word and music, but also contain all of the complexities of visual artifacts. Art-history databases have grappled with the visual challenges for decades; the searchable collections of the Getty Museum are a well-known example (Getty Museum visual archives). The University of Maryland long ago experimented with FilmFinder (FilmFinder and Plaisant 2004).

Many of the issues of verbal/auditory databases will eventually surface in the collections of video material. For example, one may use the following search term: "Find the scenes in a movie where Clark Gable and Marilyn Monroe are sitting together in a truck in the middle of the desert." In the future, consumers probably will want and be able to see snippets of favorite video material, much as they can now view sports highlights of the best moments of a chosen game or competition.

But leaving aside these search-and-retrieval questions, there remains the humble issue of how to present just a broadcast schedule of video material or the available contents of a large aggregator of video content. The former is an issue for such cable and satellite service providers as DirecTV or Comcast. The latter issue matters for YouTube and its competitors.

As it happens, I use three DirecTV decoders, each of which shows 800 or more channels of continuous content according to three different categorization, visual-display, and remote-control-interaction techniques. This challenge reduces the most dedicated couch potato's brain to a potato chip. The movie-content metadata beyond title, year of release, and essential story line (e.g., who are the actors/actresses, directors, production companies, locales, etc.) for these services is nowhere near the sophistication of Gracenote's music databases (Gracenote) or the film databases of the American Film Institute (American Film Institute).

The video archives of YouTube (reported to be adding tens of thousands of video clips per day and already containing approximately 100 million entries), Google, Amazon, and Apple attempt to provide some initial, brief categorizations of content. Armed with a search widget, the user is left to his/her resources in navigating vast landscapes of content. But how can one categorize YouTube's strange assemblages of video? Only tag words can lend some aggregate order to a relatively unstructured collection of content. Beyond this challenge are the language, jargon, and translation challenges of making the world's video production available to all.

It is true that social tagging systems *may* simplify the search process, but what if the taggers don't quite realize what you want or what you see in the content, or differ greatly in general cultural experience? How will you be able to "round up the usual suspects" when no one has thought to phrase the question in quite the way you need? Similarly, what happens when mindsets change significantly over generations, and the tags of yesteryear are meaningless to today's inquiring minds? Beloit College in Wisconsin has tracked this change in its study of what's on the minds of current college students in the class of 2010: students who have lived in a world with no Soviet Union, one Germany, and bar codes since birth (Beloit 2006). Perhaps Scott Jones's guide concept, actual live human beings, embodied in his ChaCha.com service, will come to the rescue (Kim 2006)… but then who will help them? And how many worldwide guides could possibly be recruited to help everyone struggling to find the right media selection?

When selections are returned, the challenge of visualization or sonification arises. Perhaps lists or tables are always a safe bet for effective visualization, provided one has the right language, labels, and layout. But even the most effective large-scale displays of possible content selections are a challenge when the screen-display area becomes the small window of a mobile device. Here, at last, we face the ultimate challenge. How, indeed, will we be able to scroll, pan, or otherwise manipulate a large collection of entities and relationships in a way that enables us to make a decision about what to view, what to experience? What will allow us to make that decision with, at most, something like 1.5 s, just in case we are driving, making a decision for others, and can't take our eyes off the road for too long?

Designing usable, useful, and appealing taxonomies, extremely fast navigation/browsing strategies, and efficient methods to select choices based on a review of key attributes, will challenge us throughout this growth period in available media content. Some people enjoy playing amidst plentitude; to others, it is anathema. Some

people are searching, others are browsing, and still others are primarily role-playing. For some people, knowing obscure references is a sign of status, if not wealth. Research issues include what strategies, search techniques, tag techniques, and display techniques to offer different generations, cultures, cognitive styles, emotional/psychological needs, and computing/communication platforms.

The collections are growing quickly. Services from AT&T, PCShowBuzz (PCShowBuzz, offering 1000), and others are now providing downloadable or streaming video content from PCs to home media display systems, offering, among other things, 1000-plus channels. We are only a short time away from a massive flood of video content. Already, Lee Gomes (2006), a feature writer for *The Wall Street Journal*, estimates that people worldwide have spent 9305 years watching the 45 terabytes of video on YouTube since it started. Are we ready for 10× or 100× versions? Like it or not, the onslaught is coming. Our brains are about to be deluged with more video content than most people could have imagined. Let's hope that many teams of CHI and other professionals will help solve this information design and visualization problem quickly and efficiently, so we can move on to the next level.

30.3 Postscript 2015

Managing metadata continues to be a challenge for most developers and users of computer-based products and services. With the rise of big data, with the proliferation of the variety of content and multiplicity of platforms, this challenge seems to grow even with more sophistication of offerings.

Many, if not most, people simply accept or get used to the drudgery of updates, of corrections, of changing metadata schema in new products/services, etc. We don't notice how much time is wasted searching for things, trying to understand new schema, or to repair, maintain, or upgrade whatever serves us in our applications and operating systems across products and services. Once, sometime in the 1980s, I think, there was a Japanese attempt to create an operating system (OS) that would work for all possible applications, platforms, contexts, content, and communities. I forget its name. It has disappeared into history. Perhaps Unix lovers thought that OS would take over the world. More recently, advocates of the Debian operating system (see Wikipedia entries for a start at considering this offering) consider it a universal operating system with, perhaps, a stable or managed set of metadata for all applications. Given the complexity of life, this seems a "Don Quixotian" objective. But, perhaps some surprise awaits us in the future that may help us tame the beast (Figs. 30.1 and0 30.2).

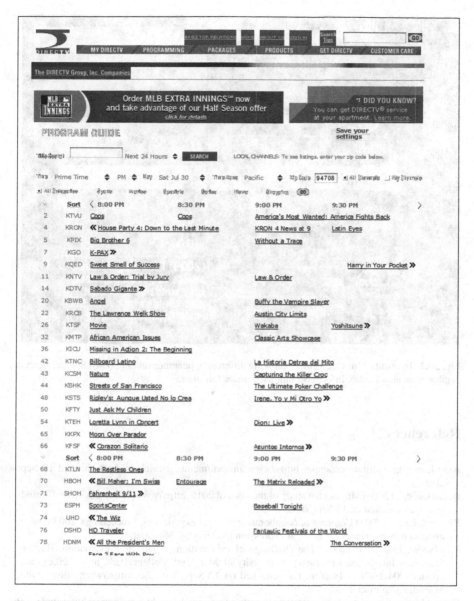

Fig. 30.1 DirecTV showed many ways to view current commercial programming through video guides. Each provided a different appearance, different ways of showing detailed information, and different remote controls with different arrays of buttons to access the information (Source: Website display from about 2005, used under fair-usage)

Fig. 30.2 Informitv.com video guide, showing different appearance (about 2006) (Source: Screen display from about 2006, Informitv.com: used under fair usage)

References

American Film Institute database. http://www.afi.com/members/catalog/. Last checked 10 Sept 2006

Beloit College (2006) Mindset list study of the class of 2010. http://www.beloit.edu/~pubaff/mindset/. Last checked on 12 Sept 2006

Blaine T, Fels S (2003) Contexts of collaborative musical experiences. Proceedings, 2003 conference on new interfaces for musical expression (NIME-03), Montreal

FilmFinder, Plaisant C (2004) The challenge of information visualization evaluation. Human-Computer Interaction Laboratory, University of Maryland, College Park. http://hcil.cs.umd.edu/trs/2004-19/2004-19.html. Last checked on 12 Sept 2006. See http://www.infovis-wiki.net/index.php/Film_Finder

Getty Museum visual archives. http://www.getty.edu/research/conducting_research/vocabularies/aat/index.html. Last checked 10 Sept 2006.

Gomes L (2006) Will all of us get our 15 minutes on a YouTube video? Wall Street Journal, 30 August 2006, p B1

Gracenote music database. http://www.gracenote.com/. Last checked 10 Sept 2006

Jiajun Zhu J, Lu L (2005) Perceptual visualization of a music collection. Proceedings of IEEE international conference on multimedia and expo (ICME05), 6–8 July 2005, Amsterdam, The Netherlands, pp 1058–1061

Kim R (2006) Rethinking Google's system: human-powered search premieres. San Francisco Chronicle, 4 September 2006, p C1ff

Lamere P (2006) Search inside the music. Project report posted on the web: http://research.sun. com/spotlight/2006/2006-06-28_search_inside_music.html. Last checked 10 Sept 2006

Live Plasma music organizer. http://www.liveplasma.com/. Last checked 10 Sept 2006

Mood music organizer. http://www.moodlogic.com/. Last checked 10 Sept 2006

PCShowBuzz, offering 1000+ channels. http://www.inklineglobal.com/adsales/yousendit/tvo_offer_728_broadcast.html?mcp=US. Last checked 10 Sept 2006

Chapter 31
Happy Birthday! CHI at 25

31.1 Summary

We've come a long way from 24 lines × 80 characters in 25 years.

© Springer-Verlag London 2015
A. Marcus, *HCI and User-Experience Design*, Human–Computer
Interaction Series, DOI 10.1007/978-1-4471-6744-0_31

31.2 Introduction

What did we think when some of us gathered in 1982 at the Gaithersburg, Maryland, conference on human-computer interaction? Did we envision all that CHI and the world of CHI, HCI, UI, UX, UE, as well as SIGGRAPH, UXNet, and other competitors for shelf space in our brains, view as their turf for human-computer interaction and communication? Some had an inkling, I'm sure, but others would not have known about the Apple Macintosh, which was about to be launched and were content to explore the challenges of thinking out the best way to present information in text screens of 24 lines by 80 characters. I can remember the days of punched cards and paper tape and job submissions of card decks, waiting 24 h or longer for the replies from the computer mainframes. In the years just before CHI started, I can remember hours of long debates about what typographic character should follow a command-line prompt: a colon or a question-mark or a period. Ah, the simple old days. I can remember in the mid-1980s when an HP staff member announced with amazement that the amount of code for input–output treatment had finally surpassed the amount of code that was devoted to actual data manipulation. A seminal moment.

31.3 Assessing our Progress

We've come a long way. There are many ways to measure how much has been accomplished and how much remains to be done. Some are pessimistic; others optimistic. I'm going to take the perspective of the glass half full, not half empty. What occurs to me is how much the general public and news media understand the issues of user-interface design, interaction design, information visualization, user/customer experience, or however you term it…even if the terminology is a little off or neglectful of all the aspects that dedicated professionals would consider relevant. When my firm interviewed California police officers (some of them graduates of universities) a few years ago, we found them quite articulate about the failings and achievements of the specialized software and hardware they were using.

Today the news media of television, magazines, and newspapers are filled with reviews that are sensitive to, and appreciative of, good design as well as innovation in products and services. As I write this essay at the close of 2006, numerous multi-product reviews give quite precise and starkly judgmental details about products'/services' user experience, screen design, button layout, ease of learning, and ease of use. These reviews appear not in the compendia of *Wired* or *ID* magazines, but for the general reader/viewer, whether general consumer or general business person.

Just as the media might regard a movie good or bad because of direction, photography, storytelling sequencing, performances, settings, action, dialog, content treatment, etc., so they review, for example, new music/video players, like the latest Apple iPod, Microsoft Zune, and other competitors, according to the mix of functions (or the absence of crucial applications, like fm-radio tuner, digital radio tuner, camera, or phone functions), the sleekness of hard-body design, the ease of use of

operation of the menus, the colors, the easily read/viewed screen fonts, screen size, the ease of social connectedness (or its absence), ease-of-customization, and many other factors.

Many specialized publications, like engineering or technology publications such as *PC World*, professional magazines like *CIO*, or the high-technology, high-fashion, high-design, or high-media publications like *Wired, Rolling Stone,* or *ID*, include product/service reviews for the cognoscenti (harrumph, like you and me, of course). About 40 of these cross my desk each month. There are, of course, detailed reviews in the blogosphere and many technology sites too numerous to mention. However, if one looks simply at the regular print reviewers for the general public, it is downright amazing what details are discussed for the benefit of the reader/viewer, with terminology and concepts that would not have come to one's attention in years past. It was in the 1980s that the general public learned the word "font" because of the rise of desktop publishing, heretofore a term typically known only to typographers and graphic designers. Today, the general reader/viewer learns about user/customer-centered design, user/customer experience, usability, social networks, RFID, ubiquitous computing, nanotechnology, windowing environments, avatars, menu hierarchies, multiple operating systems, remote testing, information-visualization techniques, search strategies, etc. Some publications even devote specific sections to technology alone, which was unheard of in earlier decades. Let's appreciate this difference. Presumably the reader/viewer makes decisions about product/service purchases and usage based on this knowledge…as well as price.

Among reviewers in the public eye are the following in print media that I typically see on a daily basis, just as an example:

- Lee Gomes, Lee Gomes column, *Wall Street Journal*
- Mark Morford, "Notes and Errata" column, *San Francisco Chronicle*
- Walter S. Mossberger, "Personal Technology" and "The Mossberg's Solution" (with Katy Boehret), *Wall Street Journal*
- David Pogue, technology review columns, *New York Times*
- Paul Taylor, "Personal Technology" column, *Financial Times*

I'm sure in your region of the world, there are other, similar writers who observe the technology scene and interpret it for the general reader. Increasingly their remarks include specific references to the user interface, icon design, ease of use, screen layout, etc., not only an analysis of the functions, performance, and price.

Generally, the world of CHI and its peer organizations has made significant progress in the mind of the general public of consumers and business people. In 1994, when my firm began its user-interface design work for Sabre, we could not assume that most travel agents were familiar with graphical user interfaces at work or at home. Much has changed. This is good news for everyone as CHI professionals. When the public demands/expects better products services and when manufacturers realize that there is a user-oriented process for producing better user experiences, everyone benefits. Still, I can't help but notice that *Business Week*'s annual awards for good product design have essentially recognized good industrial product design but rarely good user-interface design. The same with its new quarterly devoted to

innovation [Nussbaum]. Understandably, industrial product-design leaders and organizations have strongly influenced the objectives and discourse of this important influence on the thinking of business leaders (although its second issue seems to be including more diverse topics, like the importance of 3D virtual worlds like Second Life). I was surprised and delighted that the number one invention among *Time*'s "2006 Inventions" [Time] was YouTube, which relies on computer platforms, user-generated content, social networks, and good user-interface design (including information visualization of the results) for customer/user acceptance, rather than a physical object. At last, the realm of CHI's core concerns seems to be coming to front and center stage of business and consumer attention.

31.4 Conclusion

Admittedly, we've come a long way. Even Dilbert, the popular cartoon creation of Scott Adams, makes jokes about bad user interfaces causing people to become ill and die (Adams 2002). This is good for our business. But we do have a ways to go. The real test will come when user interface design becomes the subject of soap operas and sitcoms, when the *Parade* magazine insert in USA Sunday newspapers features regularly user-interface designers of note, not just television and movie stars. We can dream can't we?

31.5 Postscript 2015

Now, more than three decades since the first HCI conferences began, we can pat ourselves on the back for HCI/UX becoming a familiar topic, reported on in the evening news, on television, in newspapers, on the Internet, as subjects of countless "BuzzFeeds" and other social media. The earlier few major organizations, like Human Factors and Ergonomics, Special Interest Group for Computer-Human Interaction, and Usability Professionals Association (now User Experience Professionals Association) have given rise to many other organizations and countless MeetUp groups on every conceivable topic and subtopic of our professions. Probably this is good, necessary, and inevitable in our age.

In some ways, the situation of HCI/UX becoming a fractured, foaming mixture of amateur and professional practitioners, researchers, teachers, is a distinctive sign that HCI/UX has gone mainstream, instead of being the rarified set of disciplines it once comprised. Let us be thankful, and attend to our splintered, detailed or broad, general areas of interest and practice with passion, perseverance, and compassion.

References

Adams S (2002) Dilbert cartoons. http://www.unitedmedia.com/comics/dilbert, especially 24 Sep 2002, http://www.gui.com/images/20020924.gif

Fortune magazine editors (2006) The future of design. Fortune, 13 November 2006, pp 130ff

Gomes L (2003) Google is most popular search site, but others sometimes do it better. Wall Street Journal, 18 August 2003, p B1

ID magazine (2006) Numerous publications and online version. www.idonline.com

Marriott M (2006) When beige won't do: computer makers looking for an advantage pay more attention to styling. New York Times, 23 November 2006, p C7

MIT Technology Review (2006) Numerous publications and online version. http://www.technologyreview.com

Morford M (2006) Apple computer has made the world a better place. Notes & errata column, San Francisco Chronicle, 17 November 2006, p E6

Nussbaum B et al (2006) In: Quarterly insert, Business Week, November 2006, 40pp

Pogue D (2005) From apple, a tiger to put in your Mac. Circuits section, New York Times, 28 April 2005. http://www.nytimes.com/2005/04/28/technology/circuits/28pogue.html?ex=1272340800&en=c153cdf456d0d073&ei=5090. Last checked 23 Nov 2006

Serpick E (2006) MicrosoftZune Fiasco: iPod challenger face label battles and terrible reviews. Rolling Stone, 30 November 2006, p 20

Taylor P (2006) Zune the iPod-killer is a bigger, heavier but friendlier beast. Financial Times, 17 November 2006, p 8

Time magazine editors (2006) Time best inventions 2006. Special section, Time, 13 November 2006, pp 61ff

Chapter 32
Big Spaces, Big Lives, Big Challenges

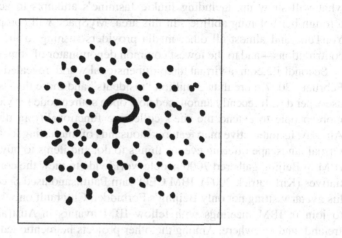

32.1 Summary

This chapter discusses new approaches to Web 2.0 design.

© Springer-Verlag London 2015
A. Marcus, *HCI and User-Experience Design*, Human–Computer
Interaction Series, DOI 10.1007/978-1-4471-6744-0_32

32.2 Introduction

Web 2.0 initiatives are growing along the Internet highways like orchids in Hawaii. MySpace.com, the "next-generation portal" built around social networking, provides access to user-generated content for blogs, chat rooms, movies, music, music videos, classified ads, comedy, on-demand TV, and videos, along with access to games, horoscopes, jobs, MySpace instant messaging, and so much more. The phenomenal growth of MySpace (at last count, 140 million members in November 2006) has led to struggles simply to keep its server-farm back-end alive and functioning (Carr 2007)—especially difficult for a system that did not have the engineered basis that Yahoo, eBay, or Google provides. As the space continues to add users and viewers (not always the same thing), it seems that the issues will grow more numerous as the content grows more diverse. Of course, one can never tell what will show up, including Junkie Jasmine's attempts to achieve world fame through her belching abilities. In this area, MySpace will compete with Google's YouTube and almost all other media providers rushing to the widest number of contributions—and to the lowest common denominator of content.

SecondLife.com, a virtual three-dimensional world, revealed at the beginning of February 2007 more than 3 million "residents" and more than $1 million spent by users per day. It recently announced how open source code for viewers enables even more people to extend the site's collective functionality in diverse applications. Already, its interactive map features thousands of interesting locations in a complex virtual landscape offering events, things to do, and items to buy. A recent event by IBM in Beijing gathered 7000 people worldwide to view the company's global initiatives (Kirkpatrick 2007). IBM CEO Sam Palmisano used Second Life to control his avatar visiting not only Beijing's Forbidden City built on virtual real estate, but to join in IBM meetings with fellow IBM avatars in Australia, Florida, India, Ireland, and elsewhere. Among the other projects he mentioned was a $10 million endeavor to help build out the 3D Internet that Second Life represents. Also available on Second Life are videos, much like the offerings of Google, YouTube, and MySpace, and photo galleries (based at Flickr.com), providing the typical related images and tags to help viewers navigate through the content.

Collections of opinions, topics, videos, photos, and more are growing by leaps and bounds. Have we seen this before? Yes, every decade or so, but now it's coming faster and faster. One major change is that, finally, virtual spaces seem set for prime-time availability with real world access, some 10–20 years after the first excitement of such environments gained a foothold in our reality. Another major change is that powerful, large corporations like Rupert Murdoch's News Corp. and Google are backing these adventures in social networking and media access. A third change is the growth of user-generated content including applications in open-source environments.

All of these developments lead to a sea change: When everyone jumps into the pool, what happens?

32.3 The Countdown to the Big Splash?

Where does this lead us? Some say the advent of Web portals and user contributions leads to new forms of social networking and cohesion, even to new notions of worldwide (nationless, presumably) democracy powered by the Internet 2.0 and later versions (Gaian Democracy; Worldwide Democracy).

Wherever we turn, it seems that portals and applications of all kinds are moving ever more quickly to larger and larger collections. Maxtor and other vendors already offer multipetabyte hard drives, and soon to arrive peer-to-peer video applications may consume many petabytes of data. As these uses emerge from the rare research laboratory environment to the sunlight of everyday experiences, more than ever we urgently need breakthrough techniques for perceptualizing (visually and sonically) structures and processes. I have mentioned this need in earlier columns. What is striking is how rapidly we are approaching a threshold beyond which we shall need user interfaces with metaphors, mental models, navigation, interaction, and appearance different from anything we currently see or hear.

As often happens, human invention may come to the rescue to get us out of our current challenge and into the next one. The mother of all data loads seems to require new theories and new techniques to find a search-and-retrieval solution that works in many use contexts, across multiple content domains, for multiple applications, and most platforms. Perhaps we have a glimmer of this approach in the developments of (mathematically oriented) Princeton University's musical composer Dmitri Tymoczko, who has applied equations from string theory (normally used to explain subatomic particles and cosmological phenomena in the search for the Theory of Everything) to explain patterns of all possible musical chords and to visualize them in a graphical form (Lemonick 2007; Tymozko 2006). Perhaps a similar application of seemingly far afield theories can bring insight to our own world of human-computer interaction and communication.

As Tymozcko through an article by Lemonick (2007) explains, the musical technique helps scholars, teachers, and composers to see relationships that were not previously apparent and to compare and contrast structures, discovering principles that describe these artifacts.

With sound and especially the human voice (Vizard 2007) now being added to applications, we may be on the verge of new ways of navigating, communicating, and even thinking, which will let us cope with all the petabytes that are assaulting our computer and communication devices. Let's hope help arrives soon, before the waves hit us.

32.4 Postscript 2015

The enormous growth of social media, of varieties of multiple platforms, and multiple media, have made it more necessary than ever for good HCI/UX solutions to help people manage larger amounts of data, functions, contexts, platforms, and participation in multiple communities.

One can only hope that the larger numbers of people entering HCI/UX fields will be able to assist in solving how to make the experience of all this content a humane one, that avoids turning us into slaves of our own creations.

References

Carr DF (2007) MySpace. Baseline:35–38. Jan 2007

Gaian Democracy, www.gaiandemocracy.net and publications by Roy Madron and John Jopling via www.amazon.com

Kirkpatrick D (2007) What's next? It's not a game. The 3-D online experience second life is a hit with users. IBM's Sam Palmisano and other Tech leaders think it could be a gold mine. Fortune:56–58. 5 Feb 2007

Lemonick MD (2007) The geometry of music. Time, 5 Feb 2007, p 57

Tymozko D (2006) The geometry of musical chords. Science 313:5783, 7 July 2006, pp 72–74. See also the chord geometries website: http://music.princeton.edu/~dmitri/ChordGeometries.html

Vizard M (2007) Giving applications a true voice. Baseline:33. Jan 2007

Worldwide Democracy, www.wwdemocracy.org

Chapter 33
Fun! Fun! Fun! In the User Experience

33.1 Summary

We just wanna have fun…Don't we? This chapter discusses incorporating fun into
the user experience.

© Springer-Verlag London 2015
A. Marcus, *HCI and User-Experience Design*, Human–Computer
Interaction Series, DOI 10.1007/978-1-4471-6744-0_33

33.2 Introduction

A funny thing happened to me on the way to writing this chapter. I began to ask myself, what exactly constitutes fun in the user-experience of products and services?

Naturally games and play come to mind. The topic is explored and demonstrated in depth at the major game conferences like E3, and even at more sober gatherings like the IBM Almaden Laboratory's New Paradigms in Using Computers (NPUC) conference for 2001, which devoted its entire agenda to the theme "What can E-Biz learn from E-Games?" I recall that one of the founders of SimCity presented, and another presentation seemed to turn usability on its head in terms of how to have just the right amount of challenge, early reward (not too much, not too little), and continual lure of partial success to guarantee addiction. Just like a slot machine, or the megabucks lottery for many losers and a few winners.

Or, things funny come to mind. As a recent article by Karnitschnig (2007) pointed out in the *Wall Street Journal,* network television marketers, trying to take humor shows like Comedy Central's offerings into other countries know they have entered challenging cultural waters. What people laugh at or about in one country is not thought funny in another. For example, German television viewers don't like Seinfeld, which was wildly popular in the USA for many years and continues to be shown in reruns. The funny Apple Macintosh commercials currently being aired that feature a personification of Steve Jobs talking with a personification of Bill Gates have to be changed dramatically to work in countries other than the USA where the ad campaign originated (Fowler et al. 2007).

But, fun is more than games and jokes. In fact it has a long history, a broad definition, and a deep connection to human experience.

33.3 On the Nature of Fun

It is often thought that children have all the fun, at least in first-world, highly developed countries, where children are allowed more times, toys, and spaces with which to play and enjoy themselves for many years before taking on the roles and responsibilities of adults. Such freedom and leisurely assumption of maturity is a relatively modern phenomenon. The topic is explored in depth in an engaging history of childhood (Aries 1962), in which Aries notes that for millennia, many children did not survive for long, most children were born and raised as spare workers, and were quickly introduced to the world of adult toil and obligations. Although archeologists have unearthed children's toys, adults might engage in play and use toys as much as children. Today, numerous gadgets and even the Sharper Image catalog attest to the enduring role of toys through all ages and all eras.

In *Magister Ludi*, Johan Huizinga (1950) explored the evolution of toys and games, play within cultures, and the role of play in art, law, poetry, philosophy, science, and war. Herman Hesse's masterful novel of the same name, *Magister Ludi* is

a philosophical sci-fi fantasy in which all knowledge has been transformed into music that high priests alone could appreciate, manipulate, and manage. Playing music, for some a deeply "fun experience," became a central experience of civilization, something for the leaders of the society to master.

Speaking of humor, Paulos (1980) theorizes an underlying mathematics and geometry of humor, which might lead to intriguing humor visualizations other than Dilbert cartoon comics. Traditional printed compendia of jokes provide categories of humor. Lieberman's collection of 3000 jokes for speakers (Lieberman 1975) lists fifteen topics, such as family and business, children, friends, money, sports, and travel. Even an old resource like Prochnow's treasure chest for speakers (Prochnow 1942) contains 1207 jokes/jests, 543 wisecracks and epigrams, and 212 amusing definitions, all of them individually numbered. Perhaps some audiences knew them by number, like one old joke goes. Web resources today, both text, audio, and video, provide access to thousands more. Clearly many resources are available for adding humor to any written, audio, or video statement. One no longer need rely on programmers to write jokes for the user. On the other hand, most professional producers of communication and interaction know how complex and challenging humor is for different ages, educational backgrounds, environments, cultures, and audience contexts. Yet this kind of humor can make for a powerful "fun experience."

I have written before about Gardner's theory of multiple intelligences (Gardner 1985), actually, about 7 ± 2 dimensions of them, including the verbal, the physical, the social, the graphical, etc. It seems likely that for each of these dimensions there is a specific world of play and fun, which is also deeply affected by cultural preferences that differ around the world. We have just begun to untangle these threads in the user-experience space and to apply professional design skills to their synthesis.

One specialist who has devoted decades to exploring the meaning of fun, especially in group play and within corporate as well as consumer groups, is the professional funster named Bernie DeKoven, who used to go by the moniker Dr. Fun, and now calls himself a funsmith. He has written reviews of games, created games for Mattel and other companies (CBS Software, Children's Television Workshop, Ideal Toys), and written about games (DeKoven 1978), especially the so-called new games philosophy that emphasizes cooperation among groups rather than competition, and games that enable a large number of people to play, which seems appropriate in the era of Internet-based, vast multi-player domains that derived from multi-user dungeons (MUDs) of decades past. If you want to find out more specifically about DeKoven's approach to "Deep Fun," there is his Website /www.deepfun.com), at which he provides many URLs for further exploration. Fun topics include games, health, family activities, society, and work.

33.4 Desperately Seeking Fun

It was about 10 years ago that one of our clients first asked us to make a business-application user-interface "happier" or more "fun-like." A few years ago, psychologists at a vehicle manufacturer invited me to consult on how one might make the

vehicle rider experience more fun. Today many researchers are looking for break-through techniques that provide the user experience with greater pleasure. Making the experience more fun is one key objective.

Does this mean making the experience more amusing (taking us away from thinking) or more entertaining? These are cognitive and emotional issues. For some, playing chess or go is fun. For others, fun is being a couch potato and watching video passively, or checking the latest jewelry on the Home Shopping Network. Some prefer physical activities, sports, and/or challenges. The sheer movement, as well as challenge, risk, and social interaction are the sources of the endorphins that eventually suffuse our body, from which we derive great pleasure. No wonder the anonymous author in a recent *Economist* article (No Author), speculates that Exergaming in Silicon Valley (as one can do with the new Wii game batons) will spread as a new phenomenon. Ten to fifteen years ago, I had speculated myself that dancing with data was a future solution to lives lived with two little movement parked in front of CRT display screens; such applications would require the careful skills of the movement therapist or personal trainer to make sure that all of our muscle groups were challenged during the course of a 9–5 work day, and we would emerged refreshed, not exhausted.

33.5 Conclusions

It seems likely that we have a world of fun to explore, across all design disciplines, platforms, technologies, markets, communities, and user-interface paradigms. Making user-interfaces fun is a comprehensive, integrated process that emphasizes diverse disciplines, from perceptual design to usability analysis, disciplines with very different skills and oriented to different groups. One might describe the challenge as one oriented to the whole person, the whole brain, both left and right hemispheres, and the person not only alone, but in context, with people, community, and environment. There is a need for thinking about usability, but also usefulness and appeal, as vital objectives for fun-oriented computer-based products and services.

Some R + D centers have focused on fun, like the Viktoria Institute in Sweden, which has been exploring fun and play for decades. Other centers in Europe, North America, Asia, and elsewhere are active, and new centers are arising. I have sketched briefly some of the directions of fun these centers are exploring. Every major user-interface component, the metaphors, the mental model, navigation, interaction, and appearance offers rich territory for new dimensions of fun. There are ample historical and cultural precedents to consider in adapting them for the latest technology… and ample cautions about thinking that what is fun will be universally accepted. Perhaps someday we'll have tools to help us tune our fun correctly for the task at hand, whether it is for work or leisure, for this culture or another, or a little of both.

33.6 Postscript 2015

Several years ago, Mario Herger, then at SAP, organized one of the first enterprise gamification competitions at SAP, for which I served as one of several judges. Later, he left to found his own enterprise-gaming consulting organization Enterprise Gamification, USA, and has produced many valuable white papers and reports on the progress of enterprise gaming, which seeks to introduce "serious gaming" or "serious fun" into enterprise applications and contexts. His efforts are but one example. Another is Dr. Pamela Kato, Professor of Serious Games, Serious Games Institute, Coventry University, Coventry, UK.

The existence of such professionals and academics devoted to applying the lessons of gaming and fun to serious challenges of learning, healthcare, finance, information technology management, and other areas of complexity bodes well for providing breakthrough solutions to some of the challenges now engaging us in enterprise and complex-systems development worldwide.

References

Publications

Aries P (1962) Centuries of childhood: a social history of family life. Random House, New York

Arnold P (1985) The book of games. Exeter Books, New York

Csikszentmihalyi, Mihaly (1990) Flow: the psychology of optimal experience. Harper and Row, New York

DeKoven BD (1978) The well-played game: a player's philosophy. Anchor Books, New York

Fowler G, Steinberg B, Patrick AO (2007) Mac and PC's overseas adventures: globalizing apple's ads meant tweaking characters, clothing and body language. Wall Street Journal, p. B1ff

Gardner H (1985) Frames of mind, the theory of multiple intelligences. Basic Books, New York. ISBN 0465025102

Hesse H (1949) Magister Ludi. Frederick Ungar Publishing Co., New York

Huizinga J (1950) Play orbit: a study of the play element in culture. Roy, New York, p 220

Karnitschnig M (2007) Comedy central export aims for local laughs: viacom's german channel is part of plan to establish global brand to join MTV. Wall Street Journal, p B1ff

Lieberman GF (1975) 3,500 good jokes for speakers. Doubleday, New York

Mosston M, Ashworth S (2002) Teaching physical education 5. Pearson Education, New Jersey

No Author (2007) Let's get physical: videogames: 'excergaming" which combines on-screenaction with physical exercise, shows that gamers need not be couch potatoes. The Economis Technology Quarterly, pp 6–7. See also, http://www.ebusinessforum.com/index.asp?layout=rich_story&channelid=3&categoryid=9&doc_id=10271. Checked 13 Mar 2007

Paulos JA (1980) Mathematics and humor. Chicago University Press, Chicago

Pentagram Design Ltd (1990) Pentagames. Fireside, New York

Prochnow HV (1942) The public speaker's treasure chest: a compendium of source material to make your speech sparkle. Harper and Brothers, New York

Sackson S (1969) A gamut of games. Pantheon Books, New York

The Diagram Group (1974) Rules of the game. Bantam Books, New York

The Diagram Group (1975) The way to play. Bantam Books, New York

The Diagram Group (1982) The sports fan's ultimate book of sports comparisons. St Martin's
 Press, New York
Tierney J (2007) What's so funny? Well, maybe nothing. New York Times, 13 March 2007, p D1ff
Turner (1982) Victor from ritual to theatre: the human seriousness of play. PAJ Publications,
 New York

URLs

http://www.almaden.ibm.com/cs/npuc2001/. IBM NPUC conference on games
http://www.deepfun.com
http://www.deepfun.com/masterclass.html. DeKoven's "master class in fun"
http://www.junkyardsports.com
http://www.majorfun.com
http://www.deepfun.com/about.html, background about DeKovenBernie
http://www.deepfun.com/funflow.htm. DeKoven's article about flow and fun (citing
 Csikzsentmihalyi)

Chapter 34
Am I Pushing Your Buttons?

34.1 Summary

The ultimate in simplicity, clarity, and consistency is just one button. Is this the right approach? The chapter discusses the CHI/HCI/UX issues.

34.2 Introduction

Why does the one-button solution to life's challenges seem so appealing? Such simple, clear, consistent solutions appeal, perhaps, to the child in each one of us.

© Springer-Verlag London 2015
A. Marcus, *HCI and User-Experience Design*, Human–Computer
Interaction Series, DOI 10.1007/978-1-4471-6744-0_34

Recent advertisements for Staples, a USA office-supplies chain, emphasizes their signature red Easy Button (sm) and offers on their Website a downloadable "one-stop link right on your desktop to everything Staples" has to offer. Customers can get the supplies they need quickly and easily. Members can check their rewards purchases, points, and earnings "with one quick click." (Recall Amazon's achievement of the one-click shopping technique). They suggest we think of it as a "helping hand for your desktop that makes your workday a little easier." Of course, if we have one button for our office needs, one button for our travel needs, and one button for our financial needs, well, you get the picture. Our desktop would look like it had broken out in chicken pox (Fig. 34.1).

On-Star™ offers a one-button solution in General Motors cars to solving navigation challenges, auto malfunctions, even traffic congestion. According to their Website, the world's "most comprehensive in-vehicle security, communications, and diagnostics system" can provide safety, directions, connections, vehicle diagnostics, turn-by-turn navigation, hands-free calling, even crisis assistance, all at the push of a single blue button. Forget complex graphical user-interfaces and arrays of physical buttons that still populate many car dashboards like goose-bumps on a frightened child's arm. The simplicity of calling a real Some One who has the answers is very appealing (Fig. 34.2).

In fact, single-button ignition-devices, that is, push-button vehicle starters, have begun to appear on 55 cars and trucks, including luxury models from Audi, BMW, and Mercedes, as well as inexpensive cars like Nissan's Versa, and the hybrid-electric vehicles, like the Toyota Prius according to Maynard's article on the subject (Maynard 2007). These devices date back to 1913, but have found new life now that the remote control "fob" that one must have in one's pocket controlling security to the car can also help start the engine. I have such system in my new car, and I must admit: it makes me feel quite like a royal personage to simply reach out and with an imperial gesture, press a single button to have the car spring into action. Ah, the simple life. In fact, the user experience of such a device, like that of the OnStar button, seems to both denote and connote a life of executive ease, royal power, and pain-free solutions to life's problems (Fig. 34.3).

About a decade ago, long before the Apple i-Pod's navigation circle dominated the surface of a music-listening device, Sony produced a small portable radio measuring about $5 \times 8 \times 0.5$ cm. The most striking aspect of the user interface and product design, was that the sleek metallic front surface was almost completely covered with a single large black disk, a single on-off button. After setting the station with tiny controls at the edge and plugging in the ear-piece, my typical use of the device was to listen to a favorite classical radio station (but one could substitute any other genre), and all I had to do was to touch that one large area to instantly get the musical satisfaction I expected. A very clever feature the designers had thought out was that if the ear-piece were removed, the button could not turn on the radio, thereby removing accidental touches while the radio was in one's pocket, purse, or briefcase, which would otherwise have drained the batteries. My own small portable radios that I carried around in my briefcase often suffered this fate.

Fig. 34.1 The figure shows the simple single "Easy" button used by Staples to advertise the ease of shopping at this office-supplies franchise's stores (Figure source: Original drawing by the author based on http://www.hydrous.net/photoblog/wallpaper/50e7b552c45ad275.jpg)

Fig. 34.2 Drawing by author of On-Star in-car emergency call system provides a simple single choice to call for assistance (Figure source: Original drawing by the author based on http://www. motorsportscenter.com/uploads/push_the_blue_button.jpg, Fair Use)

Fig. 34.3 An example of a single button to turn on vehicles, which simplifies entry and start-up procedures (Figure source: Original drawing by the author, based on http://www.edmunds.com/media/ownership/audio/going.keyless/infiniti.m35x.ignition.500.jpg)

Part of the iconic visual appeal of the iPhone in recent ads and news articles is the striking simplicity of an array of buttons. Not one button, to be sure, but an orderly array of 20 buttons, each button representing a single-button solution to our communication, entertainment, and information-processing needs. Is the look of this screen simplicity something like the appeal of the single button? A group in Japan has even jumped ahead of Apple's current products and produced spoof-designs for the iPhone Nano and the iPhone Shuffle, which reduces the iPhone's user interface to its ultimate: a single button (Fig. 34.4).

The one button approach even extends to a patent for one-button wireless tele-phony (Kravitz). All of these kinds of solution emphasize directly or indirectly a search for simplicity. The "Laws of Simplicity" or elucidated in Maeda's treatise on the subject (Maeda).

But is there something else here? Is the single button look somehow related to the look of large-eyed cartoon figures of childhood? Recall that Walt Disney's Mickey Mouse went through a transition from its earliest incarnations to the more familiar, wholesome, cuddly rodent of today by getting large eyes and large simple ears…that look almost like three large buttons! In fact some Disney-sanctioned graphic designs have reduced Mickey to just three connected circles. Some theorists have begun to suspect that hiding behind this desire for simplicity is a desire to return to the simpler, clearer notions of childhood.

Fig. 34.4 Examples of Apple's simple button user-interface design (Figure source: Original drawing by the author based on http://www.informationarchitects.jp/wp-content/uploads/2007/01/iphone_2.png)

34.3 Conclusions

Is the one-button solution a viable approach to user-interface design and the user experience? Certainly in some situations, it can be a quick, effective, productive, appealing solution to alternatives that require more complex navigation of menus. However, in the OnStar case, the menu navigation is simply shifted to human-human communication and interaction. For some people and in some situations, human-human contact is far more desirable, even if more costly in terms of human servers rather than machine servers.

Even if more costly, and in some cases, provably dysfunctional, the appeal of a single-button solution is so powerful, that one-button, one-touch, one-choice solutions are likely to find their way increasingly into a world filled with too many icons, too many menus, too many choices.

34.4 Postscript 2015

The desire for one-button, or at least few-button, simple solutions continues to grow, especially among older people. Some products are providing simplified solutions to HCI/UX mental models, navigation, interaction, and appearance, especially if confronted by the small size of a smart-watches screen. Perhaps this size constraint will force some developers to think more about such less-is-more functionality and HCI/UX.

Of course, voice interaction for both input and output, as well as tactile/haptic solutions provide a work-around to the one-button objective. It remains to be seen how multiple modes of input and output can work together to simplify our interaction with complex systems of functions and data…but we are making progress.

References

Print Publications

Maynard M (2007) With button ignition, car keys could go the way of tail fins. New York Times, 14 Jan 2007, p A1

URLs

Kravitz S (2000) Patent on one-button wireless telephony. http://www.patentstorm.us/patents/6035217-description.html
Maeda J (2006) The laws of simplicity. http://lawsofsimplicity.com/category/laws?order=ASC
OnStar: http://www.onstar.com
Staples: http://www.stapleseasybutton.com

Chapter 35
The Sun Rises in the East

35.1 Summary

Developments in Asia cause us to rethink the future of CHI/HCI.

© Springer-Verlag London 2015

A. Marcus, *HCI and User-Experience Design*, Human–Computer
Interaction Series, DOI 10.1007/978-1-4471-6744-0_35

35.2 Introduction

When I first visited China and Japan in 1975, I was there to lecture about the coming age of computer graphics to designers in Hong Kong and Tokyo. I gazed at China from a guarded border lookout at the northern edge of Hong Kong, which then still belonged to the British Empire, and the Japanese yen exchange was more than 300 per US dollar, almost three times the present number. But since then, much water has flowed under Asia's traditional curved bridges—the world has changed greatly. I recently spent a week in Tokyo and a week in Beijing. The teenagers in Tokyo's Shibuya area may still dress crazy, and the pollution seems worse than ever in Beijing, but I return convinced of a sea change around the Pacific Basin regarding HCI.

Throughout the past two decades of CHI and during the present history of *Interactions,* Asian developments took a third seat to those in the U.S. and Europe. Based on my experiences visiting Asia for the past 32 years, I think CHI needs to recognize that major technology innovations are not only happening in Silicon Valley and other American centers, but also in Asia.

In Tokyo, the Human-Centered Design Network is now several years old. The organization has the backing of many Japanese corporations; its focus is on universal access and universal design of computer-based systems. Dr. Masaaki Kurosu, formerly one of the key people at the Hitachi Design Center and more recently a leader of the National Institute of Multimedia Education, has been prominent in founding and promoting the organization. The group has sponsored many conferences, lectures, get-togethers, and exchanges of communication in Japan, the U.S., and China, among other locations.

Japan produces many studies and information resources that may not be well-known to those not fluent in Japanese, which would include me. In my case, I use "informants" in my own firm from Japan, Taiwan, and Korea to find relevant literature discussing examples of new products, services, and technology developments. Yes, this is available on the Web through searches, *if one knows the respective languages.* Even though I have some knowledge of technology developments, it was an eye-opener in Tokyo actually to observe the high quality of a Fujitsu mobile phone receiving superior-quality broadcast television on a wide-screen handheld display, or a Sony television in the kitchen of a colleague receiving super-high-quality images of a baseball game.

Some of the previously untranslatable information is making its way into English for others in the West to discover. For example, Fujitsu's guidelines for Web design and color-selection tools that are oriented to universal design can be accessed online. Some companies and organizations have only recently developed user-centered software practices including user experience design, so literature is often not as extensive as Western resources. However, professional development in this area is expanding rapidly, and the level and quality are constantly and quickly rising.

I attended the 12th conference of Human-Computer Interaction International (HCII) held this past July in Beijing. This conference series is notable for eclectic

programs, being less selective than CHI's conferences, and for being much more international in nature. In fact, HCII was a kind of *shouk*, or bazaar, of a broad spectrum of technology, products, and services. I was exposed to a wealth of new talent, insights, and developments. Absorbing all that is going on in China from more well-known centers of development in Beijing, Dalian, Shanghai, Hong Kong, and elsewhere is almost overwhelming. One notable theme was the awareness of culture differences between Western and Asian approaches, and even those within Asian cultures. At HCII 2007, of the three dozen sessions, approximately two dozen included cultural and universal access themes. There were even sessions focused specifically on user-interface design issues in Latin American countries and customizing the user experience for the Chinese market. I was impressed by the awakening of awareness and the public discussion of philosophies, principles, and techniques.

To cite one example: Professor Kun-Pyo Lee, head of the Industrial Design Department at the respected Korea Advanced Institute of Science and Technology (KAIST), and his colleagues reported on the results of comparing the way Korean and French users looked at websites. Their results show that Koreans move around the screen in a somewhat circular fashion, checking many relations among parts of the screen. The French viewers focused quickly on specific markers/monuments and then picked their goals. The differences seem to conform to the predictions of Nisbett as defined in his book, *The Geography of Thought: How Asians and Europeans Think Differently... And Why* (Nisbett 2003).

One other example of the differences between the East and West is the user-interface attributes of Taobao, a Chinese auction website that is viewed more favorably than its competitor in China, eBay/China. Professor Zhengie Liu, director of the Sino-European Usability Center (SEUC) at Dalian Maritime University in China, and his colleagues reported on the differences in Taobao's payment method with respect to trust. The Chinese version's payment method (via AliPay, as opposed to eBay's PayPal) demands that payers put their payment into the hands of a mutually trusted third party that will release the payer's funds to the seller only when the buyer has confirmed that he/she has received the purchase, and it matches the agreed-upon conditions.

A paper from authors in Namibia was provocatively titled "Assumptions Considered Harmful: The Need to Redefine Usability." This attitude reflects sentiments among some that usability, usefulness, and appeal discussions have been too biased toward Western assumptions. Another notable theme of the hundreds of posters shown (one of the largest collections I have ever seen at a CHI, HCI, or user-experience conference) was the attention to culture and international, global issues, such as studies of design for non-Western writing systems and pictograms.

One other significant attraction at this conference was the presence of at least a half-dozen usability consulting firms in the exhibit booths, not only from the U.S. and Europe, but also from China and Japan. Clearly, the usability business has discovered China as an important market that needs to be considered. In a country like China, where recent statistics show that there are more than 500 million mobile

phone users, and 200 million people have been added to the growing middle class, the inevitabilities are evident.

Other future conferences will continue to explore CHI community issues in Asian, and specifically China-based, venues. User-friendly conferences have grown in just a few years from 50 to 500 participants. The next is to be held again in Beijing later this year from November 23 to 25, and is sponsored by UPA China, of which Jason Huang has taken charge. He is a key figure among new leaders in the organization, training, and consulting fields. An additional meeting of the International Association of Societies of Design Research is scheduled for November 12–15, 2007, at the Hong Kong Polytechnic University, which will be of interest to CHI community members.

Businesspeople and academics alike are realizing that China, Japan, Taiwan, and Korea are sizable markets to be reckoned with. Likewise, the CHI community will encounter increasing depth and breadth from our colleagues in the East. We are likely to be in for many surprises and fresh insights in human-computer communication and interaction.

35.3 Postscript 2015

China continues to amaze and dazzle HCI/UX professionals worldwide, with the growth of computer-based products and services of increasing quality as well as quantity; with the growth of professionals, organizations, conferences, and schools; and the growth in awareness of massive challenges faced by Chinese society.

I have referred earlier to the possible emergence of specific Chinese solutions to HCI/UX challenges, which are detailed in a recent article (Marcus and Baradit 2015). I am certain we shall continue to see numerous breakthrough products/services emerge in the coming years as China locations become a balance to the output of Silicon Valley and other Western centers of innovation.

References

Print Publications

Marcus A, Baradit S (2015) Chinese user-experience design: an initial analysis. In: Proceedings, design, user experience, and usability conference, 2–7 August 2015. Springer-Verlag London, London, pp. TBD (in press)
Nisbett RE (2003) The geography of thought, why Asians and Europeans think differently. The Free Press, New York

URLs

Fujitsu Corporation (2007) ColorDoctor. http://www.fujitsu.com/global/accessibility/assistance/cd/

Fujitsu Corporation (2007) ColorSelector. http://www.fujitsu.com/global/accessibility/assistance/cs/

Fujitsu Corporation (2007) Fujitsu accessibility assistance (FAA). http://www.fujitsu.com/global/accessibility/assistance/. PDF download: http://www.fujitsu.com/downloads/US/GND/web-accessibility-guide.pdf

Fujitsu Corporation (2007) Fujitsu web accessibility guidelines. http://www.fujitsu.com/us/accessibility/

Fujitsu Corporation (2007) Web accessibility inspector. http://www.fujitsu.com/global/accessibility/assistance/wi/

Human-Centered Design Network (HCD) (2007) http://www.hcdnet.org/en/

Human-Computer Interaction International (HCII) (2007) Conference in Beijing, 22–27 July. Conference program announcement: http://www.hci2007.org

Usability Professionals Association (UPA) in China (2007) Organization website: http://www.upa-china.org

International Association of Design Research (IASDR) (2007) Conference. Conference description: http://www.sd.polyu.edu.hk/iasdr/

User-Friendly (2007) Conference in Beijing, 23–27 November 2007. Conference program announcement: http://www.upachina.org/userfriendly2007/default_en.htm

Chapter 36
HCI Goes Mainstream in the Comics

36.1 Summary

HCI issues now appear in the content of comics and comic books, signalling a greater awareness of HCI/UX concerns, terminology, and accomplishments, and shortcomings.

In the history of civilization, the role of a court jester, or jokester, has a long, colorful, and significant role. With humor, things could be said that might present issues or concerns that could not be expressed in other ways. Former USA Vice President Al Gore stated as much in praise of Jon Stewart, a comedian with a nightly cable "news" show, who often pokes fun at government, social, and cultural issues of the day. Another realm of humor lies in the daily cartoons of newspapers as well

as Internet-based publications. <*interactions*> itself has turned to this medium on occasion as a way of commenting on frustrations with technologies, products, and services.

I mention cartoons because, in an earlier Fast Forward essay, I stated that CHI concepts and concerns would definitely have achieved mainstream status if there were a sitcom or soap opera that dealt with issues and content near and dear to our hearts on a frequent, perhaps daily basis. I have also referred in the past to Dilbert's explicit use of the term "user interface" and his whimsical (?) notion that bad user interfaces can cause death, or at least dementia.

Well, we may have come closer to achieving this status of contemporary comment than I realized, at least in the form of cartoon humor. I've noticed in recent months that topics closely related to the CHI community have often appeared in newspapers' daily cartoon strips. The frequency, variety, and topics were quite noticeable during a daily inspection over a few weeks' time in the syndicated comic strips that appear in many newspapers in North America and in other parts of the world. I think the phenomenon is noteworthy and deserving of as much attention as the presence of specific user-interface techniques of communication and interaction in movies or on television.

36.2 What Some Comics Are Showing

Let's take a closer look at a few examples. (Additional Reading will take the interested reader to appropriate URLs where, in most cases, the cartoon strips themselves can be viewed.)

The "Elderberries" cartoon strip of 3 February 2007 (Troise and Frank (2007)) mentions specific terms that one might not expect to find in a cartoon strip directed to the general public, or more likely, elders in the community, or even baby boomers who will soon be elders. The concept of a geriatric cartoon strip set in an elder-care facility was already an innovation of content when the cartoon first started to appear. Somewhat surprisingly, terms like "focus group," "Blackberry," "keypad," and "GPS" are emphasized. The context of a phone/PDA focus-group meeting is not exactly the situation one might expect to find in comics. The humor is poignant. Mr. Brown wants not just a GPS system but also a GPIS (global positioning *and* identity system) because symptoms of Alzheimer's or other forms of dementia may at times challenge him even to know *who* he is, not only *where* he is.

The follow-up cartoon in a subsequent edition of the strip of 22 February 2007 (see Appendix, Note 2) introduces further concepts of evaluation in user-interface development, namely testing and participatory design. Quite realistically, the author/artist of the strip shows a prototype or nearly ready-to-market version of a device oriented specifically to the senior market. Alas, the ElderBerry (a funny, and not too poor, pun), is the size of an accordion, as one of the characters notes, pointing out the dangers of simple-minded adherence to focus-group opinions without considering counter-balancing human factors and ergonomics considerations, heuristic/

expert evaluations, and other sources of insight that go unmentioned in the strip. Well, considering the cartoonists have only four frames to get across their message, they accomplish a surprisingly cogent, thorough, and charming exploration of user-interface development issues.

Within a few weeks, another cartoon strip, "Blondie" of 15 March 2007 (Appendix, Note 3) by Dan Young, appeared that again focused on technology and seniors. "Blondie" first appeared in print on September 8, 1930, and is a "senior citizen" of the genre. The content has focused primarily on Dagwood Bumstead's eating and napping habits, his office struggles with his boss Mr. Dithers, and his interactions with his wife Blondie and their children. For nearly 80 years, the hardly aging family has witnessed many social, cultural, and technology changes. In this cartoon strip a sales clerk questions whether a person of Dagwood's apparent advanced age can master the controls of a modern video camera. Naturally, his ego eggs him on to take the challenge and demonstrate he is *not* a senior citizen. The subtext is based on the increasing complexity of cameras, phones, and high-technology devices of many kinds that bewilder not only seniors, but also many folks over the age of adolescence.

A contemporaneous "Dilbert" cartoon of 2 February 2007 (see Appendix, Note 4) by Scott Adams addresses the subject of added, perhaps unnecessary functions and features. Dilbert's boss complains about a useless button in the user interface (a term mentioned explicitly), only to be reminded that it was he who insisted the button be there in the first place to create "an illusion of added value." When Dilbert is subsequently commanded to remove the offending button, Dilbert admits that the design the boss is reviewing is "only for his eyes" and that the rest of the team has apparently already ignored the first command anyway, which they probably thought was useless. The issues of features added by management for idiosyncratic or purported marketing/sales value, the tensions between design teams and management, to say nothing of the tensions throughout the Dilbert strip between engineering and marketing, are richly explored through Dilbert's clever, nuanced frames.

Another view of the patience and dexterity differences of adults versus teenagers in relation to instant messaging is explored in a "Zits" comic strip of 14 March 2007 (see Appendix, Note 5) by Jerry Scott and Jim Borgman. The father asks, incredulously, how a teenager can thumb IMs so quickly. The teenager brushes off the amazement: "It's not that hard, really." The father considers his own thumbs depicted as giant, balloon-like appendages, his obvious lack of skills, and decides to pass. In many other editions of this strip, the differences of generations are played up, often with technology as a focus. The ergonomics, skill sets, and age-related differences of different classes of device users are clearly emphasized, all encapsulated within a few frames.

An even more extreme and seriously funny exchange about mobile devices takes place in "Garfield" of 2 February 2007 (see Appendix, Note 6) by Jim Davis. The eponymous cat's owner wonders why he never gets any calls on his cell phone (he is always lonely and in need of a date). Garfield sighs, looks at us, the readers, and in classic understatement explains that the lack of calls may be due to the fact that

his owner is attempting to get calls from his electric razor. How many of us have confused our razors for our phones, or would be courageous enough to admit it? I have certainly foolishly punched at remote controls wondering why nothing was working, until I realized I had the devices upside down and had not noticed. With devices taking on more and more functions, with buttons and other interactive components becoming more and more complex (even if simulated on large LCD screens), it is not far from the dilemma facing many new users of all ages and skill sets as they confront new, daunting technology.

This small sampling from these USA cartoon strips cannot prove that the phenomenon of comics addressing fundamental user-interface design, evaluation, usability, and user-experience topics is worldwide in nature, but I would guess that in many other publications, languages, and nations, similar content can be found. In fact, if you have an example (and can kindly translate it), I would be interested in seeing it. The presence of these discussions of challenges to usability, usefulness, and appeal makes me think that the cartoonists are expressing discussions, debates, irritations, and concerns about issues that reflect what is on the mind of the general public, namely, specific frustrations with the user experience of technology, products, and services. The CHI community should be interested, and I think pleased, with this development. At the very least, we can have a good laugh, sigh, and return to our current challenges a little refreshed and perhaps enlightened.

36.3 Postscript 2015

Recently, I had the pleasure of listening to a lecture by and talking with Neil Cohn, Postdoctoral Fellow, Institute for Neural Computation, University of California/San Diego. He was lecturing on the visual language of comics (Cohn 2013) at the Information School, University of California/Berkeley. He summarized his own professional career as a comic-book artist who turned to academica, linguistics and neuroscience, then gave charmingly illustrated examples of how cartoons seem behave and exhibit characteristics of our familiar natural verbal lingistic constructs. He has even devised clever tests to show the underlying neural cognition phenomena that seem to be present as we contemplate and decode comic-book stories.

His work as well as other researchers and professionals, as well as the proliferation of graphic novels, animations, and Asian interest in comics and cute characters, all point to increasing literature, study, and product/services that focus on comics.

Additional Reading

1. Troise and Frank (2007). "The Elderberries". Universal Press Syndicate, 3 February 2007. The United Press Syndicate (UPS) comic strips cited in the text can be viewed and purchased at http://www.amureprints.com/SearchAdvanced.

asp. Current versions of the UPS comic strips can be viewed at http://www. gocomics.com

2. Troise and Frank (2007). "The Elderberries". Universal Press Syndicate. www. amuniversal.com/ups/features/elderberries/index.htm. 22 February 2007. The Universal Press Syndicate (UPS) comic strips cited in the text can be viewed and purchased at http://www.amureprints.com/SearchAdvanced.asp. Current versions of the UPS comic strips can be viewed at http://www.gocomics.com

3. Young (2007). "Blondie" King Features Syndicate. http://blondie.com/dailies/index.asp?month=3&year=2007&comic=2007-3-15. 15 March 2007

4. Adams (2007). "Dilbert." United Features Syndicate. http://www.dilbert.com and http://www.unitedfeaturesse.com. 2 February 2007. Note: image of this date seem not readily available; only recent cartoons are available for viewing

5. Scott and Borgman (2007). "Zits." King Features Syndicate. 14 March 2007. http://www.kingfeatures.com/. Note: image of this date seems not readily available; only recent cartoons are available for viewing

6. Davis (2007). "Garfield." Universal Press Syndicate. http://www.amuniversal.com/ups/features/garfield/index.htm. 2 February 2007. The Universal Press Syndicate (UPS) comic strips cited in the text can be viewed and purchased at http://www.amureprints.com/SearchAdvanced.asp. Current versions of the UPS comic strips can be viewed at http://www.gocomics.com

References

Baecker R, Marcus A (1990) Human factors and typography for more readable programs. Addison-Wesley, Reading, Each chapter begins with a cartoon image by Aaron Marcus that treats the subject matter of the chapter

Cohn N (2013) The visual language of comics: introduction to the structure and cognition of sequential images. Bloomsbury, London

McCloud S (1993) Understanding comics. Kitchen Sink Press, New York, Scott McCloud discusses semiotics, visual storytelling, and comics through the form of a graphic novel or comic book

URLs

http://www.visuallanguagelab.com. The visual language lab managed by Neil Cohn at the Univeristy of California/San Diego

http://www.cartoonart.org/links.html. The cartoon museum of San Francisco, California, USA, is a major repository of cartoon and comic strip art (but there are others worldwide, like that in Sardinia). The Cartoon Museum's Website has many links to relevant content

Chapter 37
Saving the USA, and So Can You: FaceBucks to the Rescue

37.1 Summary

A "simple design-thinking solution" could significantly improve the US financial situation: customized currency.

As ever, fiscal challenges seem always to loom large in the US psyche, or at least in US media, and are the subject of endless Congressional *vs.* White House debate and dithering. At one time, a few years ago, it was sequestration, intended to take effect 1 March 2013. At stake was $85 billion dollars of cuts, potentially furlowing a 100,000 governmental employees, bringing down the air traffic controllers and our nation's flight system, to say nothing of the harm done to schools, student loans, and many other aspects of our daily lives.

© Springer-Verlag London 2015
A. Marcus, *HCI and User-Experience Design*, Human–Computer
Interaction Series, DOI 10.1007/978-1-4471-6744-0_37

Both Congress and the White House have been deadlocked for years in their attempts to find solutions to cutting government spending and/or increasing revenue through tax changes. What are can be done?

A simple "design-thinking" change in our "money policies" could increase significantly US Treasury revenues, significantly reduce the need for increased taxes, and/or significantly decrease cuts in important expenditures within our educational, healthcare, social, and humanitarian services. Here's how. We could issue *FaceBucks*!…not to be confused with Facebook (tm).

The US Treasury could decide next week that it is perfectly legal, financially advantageous, and *ethically required* to achieve fiduciary responsibilities and objectives, to enable all people and companies (remember, corporations are now considered to be "persons" anyway) that wish to have their own personal or corporate, institutional, or even product/service images appear on the face of our official one-dollar bills, our hundred-dollar bills, or any denomination in between. Their corporate or organization logos could appear on the back. I mention the one-dollar denomination in particular, because recently proposals have been made to eliminate this bill, and to issue one-dollar coins instead, thereby saving about four to five billion dollars (over 30 years!). However, that proposal completely overlooks the public relations and brand value of our familiar and much beloved cultural artifact, our most "populist" denomination.

Persons or groups wishing to buy FaceSpace on one-dollar FaceBucks, for example, would have to pay $100 million per image, or $200 million per set of sides. Don't let the price deter you....

There are about three billion one-dollar bills in circulation, the most of any denomination. These bills last about 21 months, which means that every 2 years, the US Treasury Department could issue *new editions*. If there were only 500 sponsors of these two-sided images/logos, the US Treasury could quickly raise $100 billion over a 2-year cycle. In ten cycles, this translates to $1 trillion, or more than twice the current (2014) national deficit. Quick reminder: there are 400 billionaires in the USA alone, and corporations are sitting on the largest-ever piles of cash in human history.

This "*design-thinking*" approach to *disruptive innovation*, acknowledges that one-dollar bills (as are our other denominations) constitute a valuable medium of communication, one that has significant cultural, media, and *brand* value.

Think about it.

Apple might sponsor iCash, with an image of their latest iPhone or "iWatch" (if Samsung or others don't beat them to it with their own products).

Sanrio might sponsor Hello Kitty Kash. Hello Kitty now exceeds Mickey Mouse in the number of image results on a Google search.

Disney might sponsor MickeyMoney, or any other of its more recent Pixar animation or movie branded characters.

Stephen Colbert could have asked all the several million members of his "Colbert Nation" to send in donations to sponsor his face on Colbert Cash. He has already successfully promoted a painting of himself in the Smithsonian, located between the men's room and the women's room. Then he could have claimed that

"Stephen Colbert Saves America, and So Can You!" Perhaps his new Letterman comedy-replacement late-night television show could kick off a campaign for ColbertCash.

Wealthy moguls might like to feature their spouses, children, or grandchildren, which might enable the first women to be featured on US currency (since Martha Washington was featured on an eighteenth-century currency).

There many companies and organizations (worldwide) that would line up to see their favorite person, persona, or symbol conveyed worldwide in a way that has become acceptable in other media. If NASCAR vehicles and municipal stadiums can do it, when even hotel plastic door-key cards contain ads for Macy's, why can't the US Treasury "get with the program"?

People, characters, and companies/organizations within and outside the US might contribute to the cost of these FaceBucks, thereby enabling wealthy individuals or groups to contribute to the reduction of the US deficit. How patriotic!

Our US currency has been undergoing significant graphic re-design. Now is the perfect time to make this historic change in "outside funding" of our currency. The cost of printing and detecting such bills would not be prohibitively expensive.

These FaceBucks might become highly desirable outside the US as well, much like our movie production, which might bring further sponsor contributions and collectibles desirability and additional value. Perhaps the US Post Offices could handle distribution, just as they do with commemorative stamps, thereby adding economic value to their established buildings and people, which have long been threatened by being de-commissioned as economically non-viable.

While people complain about money spent to buy elections, wasted on pork-barrel projects, or debatable entitlements, let's make a radical shift in thinking. Taxing the wealthiest corporations and individuals is always challenging. They always find ways, with the aid of their professional assistants, to outwit the tax laws. This simple carrot-not-a-stick suggestion gives sponsors with wealth a tangible benefit in return for their funds: something desirable, valuable, and noteworthy. FaceBucks also recognizes that our currency is one of our valuable remaining iconic worldwide communication "products" that we ship.

Remember: If we don't do it, others might beat us to it: like China. They've been very innovative in creating capitalist enterprises. With a middle class larger than that of the USA, and much greater control of currency, publications, and distribution, it would not take much effort to bring about this revolution in money and design.

FaceBucks would allow the US government to use money to make money. We can't ignore this opportunity (Fig. 37.1).

Fig. 37.1 Examples of FaceBucks: Hello Kitty dollar, or Hello Kitty Kash; Marcus Money; BabyBucks, etc. These customized currencies were designed by Aaron Marcus using public domain imagery wherever possible, or images for which the author has permission, e.g., Lily Sonia Marcus, shortly after her birth. The author claims Fair Use of images for non-profit artworks. The Hello Kitty image is copyright and trademarked by Sanrio, Inc., and appears under Fair-Use practice for educational and artistic/design usage

Afterword

I hope you will have enjoyed these chapters. I acknowledge that some of the bibliographic references are old, and the world has changed. However, I believe there is still much worthwhile content and valuable citations. I hope you will agree. Your comments are welcome: aaron.marcus@amanda.com.

© Springer-Verlag London 2015
A. Marcus, *HCI and User-Experience Design*, Human–Computer
Interaction Series, DOI 10.1007/978-1-4471-6744-0

Index

© Springer-Verlag London 2015
A. Marcus, *HCI and User-Experience Design*, Human–Computer
Interaction Series, DOI 10.1007/978-1-4471-6744-0

Printed in the United States
By Bookmasters